Travelling images

MANCHESTER
1824
Manchester University Press

rethinking
art's histories

SERIES EDITORS
Amelia G. Jones, Marsha Meskimmon

Rethinking Art's Histories aims to open out art history from its most basic structures by foregrounding work that challenges the conventional periodisation and geographical subfields of traditional art history, and addressing a wide range of visual cultural forms from the early modern period to the present.

These books will acknowledge the impact of recent scholarship on our understanding of the complex temporalities and cartographies that have emerged through centuries of world-wide trade, political colonisation and the diasporic movement of people and ideas across national and continental borders.

Travelling images

Looking across the borderlands of art, media and visual culture

Anna Dahlgren

Manchester University Press

Published by Manchester University Press
Altrincham Street, Manchester M1 7JA

www.manchesteruniversitypress.co.uk

British Library Cataloguing-in-Publication Data
A catalogue record for this book is available from the British Library

ISBN 978 1 5261 2664 1 hardback

First published 2018

Typeset
by Toppan Best-set Premedia Limited
Printed in Great Britain
by TJ International, Padstow

Contents

Illustrations

Figures

Every effort has been made to obtain permission to reproduce copyright material, and the publisher will be pleased to be informed of any errors and omissions for correction in future editions.

Acknowledgements

In a sense this book is the result of my own disciplinary travels during the last thirty years. I took my first academic steps in business and economics. I quite quickly realized humanities was more my thing and followed this up with studies in art history, but also media and communication studies and psychology. Although this seems like a sprawling mix there was a common thread throughout: my general interest in the circulation and perception of images within different societal and historical contexts. When I came across the notion of visual culture some fifteen years ago there was suddenly a name for my broad interest in images, and since then I have taken on a great diversity of visual artefacts and practices within the discipline of art history.

The writing of this book was made possible through a generous sabbatical grant from the Swedish Foundation for Humanities and Social Sciences in 2015 and 2016. The importance of this funding for the present book, but also for my development as a researcher and individual, cannot be underestimated. As part of this grant I had the opportunity to be a visiting scholar at two universities in London. First I was invited to the Centre for the History and Theory of Photography at the Department for History of Art at Birkbeck University. The seminars and speaking partners at the centre have proved seminal to this project. I particularly want to express my gratitude to Patrizia Di Bello who generously shared her great knowledge on the history of photography and on the craftsmanship of research throughout the completion of this project. In addition she has been a supportive mentor and a great friend. Second I would also like to thank Professor Joanna Zylinska who welcomed me at the Department of Media and Communication at Goldsmith University and who kindly invited me to take part in the seminars and provided vital comments on the present project.

I have discussed and presented parts of this project on many occasions and for these opportunities I am grateful to friends and colleagues, Nina Lager Vestberg at NTNU and Marta Edling at Södertörn College, and my colleagues in art history at Stockholm University: Mia Åkestam, Peter Gillgren,

Magdalena Holdar, Jessica Sjöholm Skrubbe and Sonya Petersson. Thanks to all of you.

While in London I met a number of inspiring researchers who contributed to the present project. I particularly want to thank Eugénie Shinkle at Westminster University, Stina Barchan at University College London and Emilia Terraciano at Oxford University. Our meetings and discussions greatly enriched my work and life in London.

I conducted most of the research at the British Library and Victoria and Albert Museum in London, and in the National Library of Sweden in Stockholm. For the support I received in these and other archives and collections, I am grateful. I would also like to express my thanks to all holders and producers of images: artists, photographers, museums, libraries and publishers, who have enabled me to reproduce their collections and work. I particularly want to thank Nick Knight, Terry Jones, Mark Lebon, E. J. McCabe, Dan Wolgers, Carl Johan De Geer, Cinzia Ruggeri, *i-D* and *Artforum* for generously agreeing to waive copyright fees.

Being myself on the geographical borderlands of the international academic discourse, the need for professional proof-reading is crucial. That's why I am so immensely grateful for the excellent editorial assistance of Doreen Kruger and Sue Womersley who have helped me to bring out what I mean in a foreign language.

Finally, for their countless discussions over the entire journey, for their reading of drafts and for their wit and creativity I thank my fellow art historians and dear friends Andrea Kollnitz and Patrik Steorn.

You are the best!

Introduction: travelling images

Images move. They travel, migrate, transform, disappear and reappear in time and space through reproductions, copies, appropriations and re-use. Images migrate as material objects but also as immaterialities – that is, as visual conventions, patterns or contents. This book considers these movements and their implications for the reception and definitions of art and the construction of art historical narratives.

A key argument developed here is the benefit of simultaneously considering expressions of visual arts and of vernacular mass culture. Accordingly, the intention is to present an ever-present split vision as regards visual expressions and practices in different contexts. Such a strategy not only expands the objects of study; it alters the understanding of established history writing based on media or genre-specific narratives, expressed through notions such as 'art history', 'photo history', 'media history' and 'fashion history'. The expressions and arguments for the nature and existence of such categories are key objects of study in this book. Hence, the aim is to critically question such categories and propose a new totality that is neither media specific nor genre specific. While blurred boundaries have been a key topic within the art field since the postmodern turn and the late twentieth century, this book seeks to point out the frail and illusory character of the art field throughout modernity, commonly understood as an era of media specificity.

This book consists of four case studies covering the period 1860–2010 and includes as disparate objects as photocollages, window displays, fashion imagery and contemporary art projects. Through these four close-ups it seeks to reveal the mechanisms, nature and character of these migration processes, and the agents behind them, as well as the sites where they have taken place. The overall aim of this book is thus to understand the mechanisms of interfacing events in the borderlands of the art world.

Chapter 1 ('Cut and paste') considers the mechanisms of breaks and continuities in the history of photocollage with regard to gender, genre and locations of display. Collage is commonly celebrated as a twentieth-century art form invented by Dada artists in the 1910s. Yet there was already a vibrant

culture of making photocollages in Victorian Britain. From an art historical perspective this can be interpreted as an expression of typical modernist amnesia. The default stance of the early twentieth century's avant-garde was to be radically, ground-breakingly new and different from any historical precursors. However, there is, when turning to the printed press, also a trajectory of continuity and withholding of traditions in the history of photocollage. Since the second half of the nineteenth century collage makers had used cut outs from the illustrated press. At the same time, the illustrated press were using photographs as the basis for their drawn caricatures, and there was thus a constant, mutual exchange between print culture and the practice of making photocollage. This case study has two parts. The first includes a critical investigation of the writings on the history of photocollage between the 1970s and 2010s, focusing on the arguments and rationales of forgetting and retrieving those nineteenth-century forerunners. It includes examples of amnesia and recognition and revaluation. The second is a close study of a number of images that appear in Victorian albums produced between 1870 and 1900 and their contemporary counterparts in the visual culture of illustrated journals and books.

Chapter 2 ('Modernism in the streets') considers the introduction of modernist aesthetics in Sweden in the early 1930s in the image communities of marketing and visual art. The main focus is the Stockholm Exhibition held in 1930, in which marketing and advertising played an integral part in the presentation of modern architecture, design and visual art. The exhibition area hosted the first large presentation of modernist visual art in Sweden, the *Art Concret* exhibition. The exhibition was also a decisive event for the introduction of modernist window displays. From the late 1920s and onwards window displays were clearly influenced by avant-garde modernist art such as cubism, futurism and constructivism. This is evident in the designs themselves but it was also spelled out in professional journals and handbooks. In the commercial context, pure marketing rationales and arguments were linked to the modernist aesthetic and the ambition to cross-fertilize art and marketing. The modernist design in window displays was not unique to Sweden around 1930. However, this is an instructive case as the reception of modernist images differed widely between the two image communities. Within marketing aesthetics the Stockholm Exhibition marks the breakthrough for modernism. Simultaneously, the art field was very resistant to modernist aesthetics and the *Art Concret* exhibition proved to be a complete fiasco.

Chapter 3 ('Magazined art') investigates the printed magazine as a site where the worlds of art and fashion merged in the 1980s. Since the early 1990s fashion photographs have migrated effortlessly between the art field and the commercial field, between being considered as personal works and as assignments limited by the ideas and wants of designers, brands and

fashion publications. As pointed out by several scholars, a crucial part of this development was the new aesthetics that emerged in the 1990s which challenged traditional notions of fashion as glamorous depictions of garments, a style labelled 'trash realism', 'radical fashion' or 'post fashion'. However, as the chapter shows, an equally important material basis for this development was the emergence of new fora in the 1980s. Later on, in the 1990s and early 2000s several magazines that straddled art, style culture and high fashion appeared, such as *Purple Prose, Tank, 032c* and *Sleek*. This chapter traces the beginnings of these transgressions through a close examination of the two magazines *i-D* and *Artforum*, which from different positions and with different strategies served as an active interface between art and fashion in the 1980s.

Chapter 4 ('Imposter art') explores how mass media, in the form of the daily press, professional journals and television, represented and interpreted contemporary art that was deemed as illegal acts. In consequence, it considers how media discourses intervened and acted in such artistic and legal processes. At the centre of this study are artworks made by three Swedish artists between 1967 and 2009 which were simultaneously considered as both artistic statements and real illegal deeds. These artworks and the ensuing media debates are illuminating examples of how the notion of art is continuously negotiated and interpreted very differently by various agents in diverse contexts. This study, therefore, expands its focus beyond the typical agents of the art world such as curators, critics and art historians to include statements and writing by representatives of politics, media, entertainment, law and the general public. Being controversial acts, these artworks were open to multiple interpretations and fed smoothly into the logic of the media system. Accordingly, the artists and their artworks were described as breaking news in the standard vocabulary of the press. In addition, they all elicited extensive media discussions on the definition of art.

Living images

The title of this book paraphrases Mieke Bal's seminal book *Travelling Concepts*.[1] Although Bal deals with the elasticity of concepts as they are differently used (i.e. travel), in different academic disciplines and intellectual practices, her book has been a vital source of inspiration for this project. First, her use of a simultaneously spatial and human metaphor for analysing cultural phenomena, that is, concepts, has inspired me to approach visual images in a similar way. Second, the inherent dynamism and defying of disciplinary boundaries in her approach has been indispensable. Furthermore, her arguments for combining close readings of objects themselves with the critical perspectives of cultural studies have also informed the design of this project.

The central concept of image is in this book used to designate visual conventions, patterns or contents as well as tangible visual images. As pointed out by W. J. T. Mitchell in his seminal essay 'What is an Image?', the concept of images is much broader and includes phenomena of different modalities, both visual and non-visual, which are written into different institutional discourses. Thus 'the family of images' includes not only graphic images but also optical, perceptual, mental and verbal images, which tie into the disciplines of physics, psychology and literature, as well as art history and visual studies.[2] Although this book considers graphic images using Mitchell's terminology – whether handmade, printed or created through the arrangement of three-dimensional objects – his broad understanding and inclusive approach has informed this study in the sense that it considers images both as tangible objects and as 'intangible' designs. Indeed the fact that images can 'remain' mentally or virtually has an important bearing on how the movement of images is considered. This book primarily considers visual images, independent of their medium but also takes into account the technical, material aspects of individual tangible images. Consequently, it feeds into recent developments within image studies, which, according to Keith Moxey, is a research practice that recognizes that 'the physical properties of images are as important as their social function'.[3]

This book is also informed by Hans Belting's notions of image, picture and medium. According to Belting, 'pictures are images embodied in media'. Thus every picture consists of a medium whether it is a painting, a photograph or on a monitor, or whether it is handmade and unique or mechanically mass-produced. In Belting's triangular model the picture is understood as the material artefact, the image as the visual content or pattern and the medium as the image support, the technology or artisanship that transmits and gives visibility to the image. Thus the medium is 'that which conveys or hosts an image, making it visible, turning it into a picture'.[4] Consequently, tying into Belting, the term 'images' refers to visual patterns and contents irrespective of their material appearance and whether they are 'originals', 'copies' or 'reproductions'. However, such a dismantling is only possible conceptually. In effect, the meaning of an image changes not only with the medium but also with the context of display and the composition and expectations of its audiences. Thus the same picture may have very different meanings when it travels from one context to another. However, the main advantage of using Belting's model is that is encourages a simultaneous attention to content and materiality or image and medium. As a consequence of the separation of picture, medium and image, Belting points out that images (that is, patterns), contents and designs may be 'nomads' and that they might 'migrate across boundaries that separate one culture from another, taking up residence in the media of one historical place and time and then

moving on to the next'.[5] In line with this idea the present book sets out to describe and analyse the patterns or mechanisms in such movements in particular historical cases.

The processual take on images, which characterizes this book, is also influenced by Belting who argues that images 'do not *exist* by themselves, but they *happen;* they *take* place'.[6] In a similar vein Kamila Kuc and Joanna Zylinska have recently used the notion of 'photomediations' to emphasize the 'intertwined spatial and temporal nature of photography, pointing as it does to a more processual understanding of media'. Moreover, as remarked in a recent stocktaking of visual culture studies, 'there is no such thing as an image in the singular, but rather always its movements, or process of imaging'.[7]

Furthermore the focus on movements, transformations and transgressions of images is inspired by a number of scholars who have an anthropological approach to images and have pointed out the similarities between cultural artefacts and living beings. In *The Social Life of Things* (1986), Igor Kopytoff argues that cultural artefacts have a 'social biography'. Hence the 'lives' of images can be described as a continuous process of production, distribution, use, discarding and re-use.[8] While this perspective has been used to study individual pictures, for example individual material photographic prints, I deliberately use the more extensive term 'images' in order to include visual patterns or designs.[9] Thus a key idea in this book is that the processes of 'social biography' hold for individual, material pictures but also for images, that is, different designs or contents, irrespective of their materialization or their medium, to use Belting's terminology. The following chapters seek to investigate the social biography of a selected number of images and pictures, but also on a more profound level the social biography of the notion of art.

In a somewhat similar way Sunil Manghani has used the notion 'image ecology', originally coined by Susan Sontag. The concept of ecology refers to the interrelationship of livings organisms and their environment. Thus the term ecology serves as 'a metaphor for a desire to understand the inter-relationships of things (the nature of change, adaption and community), the classificatory, comparative and systems-based approach of ecology [which] can be made pertinent to image studies, as it too seeks to locate how and why images operate in certain "environments" or systems of meaning'. Such image systems, in turn, 'interconnect with political, economic technical, cultural, social, and legal discourses and systems'.[10] These could be the environments of production, distribution and reception according to Manghani but I would add, tying in to the conceptual apparatus of visual anthropology, also to the environment of discarding and re-use.

Manghani identifies five separate 'ecological' key processes, which are distribution, abundance, energy, adaption and succession.[11] Distribution

implies how an image is distributed, that is where and by whom, while the notion of abundance refers to the number of copies and/or reproductions in circulation and the nature of this distribution as being limited or expanded. In short, distribution and abundance concern the conditions of dissemination. Energy in turn stands for the sources. In nature the sun is the main source while sources of cultural products are material and immaterial assets such as tools, money and ideas. Adaption, on the other hand, implies how images change to fit into their respective image systems. When an image is changed and manipulated to acquire new and appropriate features this is an example of adaption. Finally, there is the notion of succession, which is when an image takes prominence over another. Historically, several different concepts have been used within the art world to connote the processes of adaption and succession, such as the notions of pastiche, replica, paraphrase and appropriation. However, such processes also take place between image systems. For example, Jeff Koons's artwork *String of Puppies* (1988) is probably better known internationally than its model, the photograph taken by professional photographer Art Rogers three years earlier, which appeared on postcards in the United States. The reverse might be said about the artist Richard Prince's large format colour photographs from the 1980s which are based on internationally distributed advertising photographs for Marlboro cigarettes. Accordingly, the process of succession can be bi-directional. The successor may be more widely distributed and better known than the original or vice versa.

Adding to Manghani I would argue that different patterns of movement could be discerned in the processes of distribution, abundance, adaption and succession. First, there are different forms of distribution and abundance. Images can be disseminated synchronically, in a sun-ray feather-like form (figure 0.1, I). These images have a great impact in the geographical and temporal place where they appear. Emblematic examples of this type of dissemination are advertisements, fashion imagery and celebrity portraits. They appear in large numbers and are known to large audiences, but are not necessarily known by, or saved, for posterity. Second, distribution can foremost appear diachronically (II). In these cases the spread of certain images is limited synchronically, but does instead include an expanded linear distribution. As such they have limited distribution during a particular period, but will have a 'long life' as they are distributed from one era to another in a long chain of appearances and reappearances. Artworks and their ensuing pastiches and appropriations by other artists are examples of this process, such as Leonardo's *The Last Supper* (1495–98), which has been the subject of numerous pastiches since the sixteenth century.

Likewise, the processes of adaption and succession can be foremost diachronic or synchronic. This could be either a linear movement where

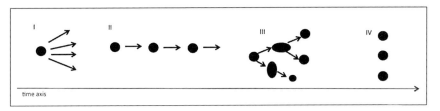

Diachronic or synchronic movements in the processes of distribution, abundance, **0.1**
adaption and succession.

each image is a revision of the image preceding it in a chain of adaption or
succession, and in which every image is slightly different from its predecessors
(III). The above-mentioned work by Richard Prince, which consisted of
photographs of already published advertising photographs, is a typical case
in point. The processes of adaption and succession can also be described as
a parallel movement where different versions of images are circulating
simultaneously. As a result, visually identical images appear and reappear
simultaneously within a geographically and temporally defined sphere (IV).
A typical example of the latter is Man Ray's photographs of fashion man-
nequins at the Art Déco exhibition in Paris 1925. They appeared simultaneously
on the cover of the journal *La Revolution Surrealist* and as fashion imagery
to promote the couture they featured.[12]

The four case studies in this book demonstrate how the ecological processes
of distribution, abundance, energy, adaption and succession have taken shape
in, and between, different image communities between the 1860s and the
early twenty-first century. The main focus in the following four case studies
is on the processes of adaption and succession even if they also implicitly
consider distribution and abundance.

Borderlands of the art world

The notion of the 'art world' is also central to this study. This notion emphasizes
in turn that the distinctions between art and non-art are constructed by
diverse agents and institutions. Typically, the art world consists of the people
engaged in the production, commission, sale, presentation and preservation,
chronicling and assessment of visual art, such as artists, art schools, museums,
galleries and critics.[13] It can be described as a 'network of people whose
cooperative activity, organized via their joint knowledge of conventional means
of doing things, produces the kind of artworks that the art world is noted
for'.[14] There are two important implications in using the notion of the art
world. First, it acknowledges the constructed, and thereby fluid, negotiable,

changeable nature of what is defined as art. Second, it implies a focus on agents.

I deliberately use the term 'borderlands' to defy the idea that there is a definite demarcation or border between what is 'inside' and 'outside' of the art world. The examples discussed in this book clearly attest to the fact that the art world is not a set territory but a conceptual space. The notion of the borderlands, not as a defined line but an expanded area, is a way to emphasize this. Borderlands simultaneously divide and connect. They also point to the conceptual centre of the area they encapsulate. Consequently, the borderlands should not be considered as end points, but rather as loci of particular significance. Geographical borderlands are often heavily policed. As the following case studies illustrate, the conceptual borderlands of the art world are also sometimes heavily policed, where gatekeepers strongly defend what is art and what is not art. At other times, however, they may be quite unmonitored. The cases studied in this book all disclose how such borderlands function as a semi-permeable membrane. They have never been definitive or set, unlike political, legal and geographical borders – at least in theory – but rather have remained fluid and negotiable and consequently osmotic in that some images and individuals have been able to cross these borderlands unnoticed, while others have not.

It is also important to note that I do not seek to determine whether the material objects as well as the individuals that are the focus of these case studies are art or not art, artists or not artists. My intention is not to define but rather to explore and analyse different mechanisms of such labelling and negotiating processes. In order to do so this book sets out to investigate the agents, in terms of individuals and institutions, acting in these processes, and their rhetorics and rationales. Moreover, it investigates the visual and textual contexts where these processes have taken place. Images always exist in a set of contexts, in the plural. By context I refer to the immediate material, physical context, such as the page of a printed magazine or the room where a painting is hung. However, the notion of context also implies an expanded one, which includes the different uses and functions of images; and different audiences and their expectations.

I deliberately avoid the concept of genre, preferring 'image community' in this book. The concept of image community, coined by Manghani, denotes a genre and/or a modality of images based on the 'formal, aesthetic properties, particular content and uses an image might share with other images, or indeed with which it is attempting to work against or appropriate'. Such image communities steer how images are understood, used and valued.[15] The cases I consider here are instances where images have travelled from one image community to another. Accordingly, these images not only work against the communities in which they originally existed but, indeed, leave

these communities as a consequence of transformed or altered uses and understandings. A vital difference between the concept of genre on the one hand and image community on the other is that the former is based on set, formal features or contents that are supposed to reside inherently in the image, while the latter emphasizes the decisive significance of the environment or social milieu of the image. Thus the concept of image community creates a more dynamic model. To hark back to the metaphor of living beings, an image could consequently enter and exit a community and most importantly could simultaneously be part of several communities.

While the main focus is on the mechanisms of the migrations and transgressions, the material artefacts and contexts of production and distribution studied vary. Consequently, this book considers a multitude of artefacts, as regards image communities, both defined by the medium that is the technology or artisanship that transmits and gives visibility to the image and defined by certain aesthetics, uses and display contexts. The mediums include photographs, drawings, prints, oil paintings, printed texts, sculptures, installations and displays. The image communities studied, categorized by the instrumental uses and functions, are simultaneously art, fashion, advertising, news and science. Challenging categories based on genre or material has been a core theme in avant-garde art practices since the early twentieth century and notions of clearly defined image genres have been even further questioned since the postmodern turn in the late twentieth century, both within art practices and scholarly writings on art. However, this same period has witnessed the desire to impose rigid boundaries and a strong impetus to uphold and divide categories within museum practices, the art market and history writing.[16] The cases analysed in this book exemplify combinations of typical and atypical display contexts for the art world. They disclose the personal album, the illustrated magazine, the daily press, the fair and the street in addition to the standard venues in the art world: the gallery, museum and the art journals.

A variety of methods have been employed in order to address the diversity of sources. I have included quantitative surveys of media contents, images and texts, as well as detailed analyses of single artefacts. Following on are analyses of visual and verbal discourses as well as close studies of technical, semiotic and aesthetic aspects of individual objects, such as specific photographs, printed images, magazine pages and displays. Despite its not being a fully fledged field analysis, I have consequently taken into account *what* has been said, that is utterances, arguments, rationales, but also *who* said what and from what *position*. An important method for obtaining such diversity of data has been the analogue method of browsing through magazines, illustrated press and literature. This is a time-consuming but entirely necessary procedure because the only matter commonly indexed and

searchable through databases is editorial text content in printed material, while advertisements and images are less visible and graphic design or layout of texts and images are never accessible in this manner.[17] Another simple, yet seminal method when working with less-documented, less-archived and -preserved historical artefacts and processes is the interview. The following results are partly based on my own, and previously conducted, interviews which have not only proved decisive in obtaining information on certain agents and events but also provided me with visual and textual material that it would not have been possible to find in public archives, libraries or museum collections.

Cultural osmosis

Tying into the vocabulary of the natural sciences of Manghani, I would propose the concept of *osmosis* as a way to analyse movements in the borderlands of the art world. The process of osmosis implies that there are semi-permeable membranes, which let through some molecules but not others. Osmosis is a vital process in biological systems. Typically, such membranes are impermeable to larger molecules while simultaneously permeable to smaller ones. It is clear that the borderlands of the art world are characterized by osmosis. This 'cultural osmosis', as it were, lets through some agents and images but not others. Following this, one might ask if and how this permeability differs in various periods and contexts; in other words, whether there are any patterns in these mechanisms or, put differently, what have been the critical conditions for migrations across the borderlands of the art world.

First, it appears that there has been greater leeway for images, agents and contexts with less cultural capital, to use the vocabulary of Pierre Bourdieu, to cross the borderlands of the art world. As the case studies show, it appears that agents who are young and not fully established in their image community are more likely to challenge the dichotomies between different fields of cultural production than those who are already well established. This was typically the case for the art directors and photographers who worked with British *i-D* in the 1980s. It also holds for the American journal *Artforum*, whose editor-in-chief, Ingrid Sischy, was only twenty-seven when she took on the assignment in the early 1980s. This also holds for the artists whose works were judged to be illegal acts in the late twentieth century in Sweden. Something similar can also be said about the context in which transgressions between image communities took place. Those things distributed and displayed via established art institutions like galleries and museums were subjected to much greater scrutiny than if they had been displayed in venues outside the art world.

Objects of different image communities can be said to have different osmotic capabilities. Artworks are large molecules, their movement and whereabouts are recognized, evaluated, and discussed widely. Images of fashion, marketing, for entertainment and for personal use are, on the other hand, small molecules which move more easily over the borderlands.

In addition, there are differences regarding the direction in which things may pass over the borderlands and their ability to do so. It appears easier to expel a work of art from the art field, than it is for, say, a fashion image to enter the same. Likewise it seems to be easier for marketers to say that they are inspired by modernist, abstract paintings than for artists to express their affinities to the commercial visual culture. This attests to the fact that there are strong gatekeepers within the art world while less significant image communities, communities with lower cultural capital and sometimes also economic capital, may to a larger extent permit experimentation and migrations as regards aesthetics and function. Put differently, some image communities are less controlled; migrations in one direction across the borderlands of the art world are supervised carefully while movements in the other direction are freer, not unlike the geographical borders between more and less affluent nations.

It is obvious that the borderlands of the art field have always been under negotiation, changing, expanding and diminishing. What is interesting with the cases presented here, however, is that they demonstrate that osmosis between image communities has been heightened during some periods. In other words, the borderlands have at times been vast and the distance between art and other genres considerable, while in other periods there has been a fine distinction between visual art and mass culture. The immediate question, then, is why there seems to have been such 'open windows' in some periods but not in others.

Without going into the how and why, Karl Steinworth concluded in a short article in *Photographis* in 1980, that fashion photography had been highly esteemed in the 1920s and subsequently lost its reputation.[18] Apparently, it regained its reputation in the decade following Steinworth's article. I would argue that an important rationale for such pending movements could be the introduction and development of new tools and techniques for producing and disseminating images. As pointed out by media scholars Lisa Gitelman, Jay Bolter and Richard Grusin among others, the use and function of a medium or technique is not always fixed but rather open-ended in the introductory phases of new media techniques.[19] Medium in this case includes not only a new type of mass medium like the printed magazine, or a new image technique like photocollage, but also mediums such as the shop window or conceptual project as a mode for artistic expression. Although this has

not been the object of this study a possible explanation, informed by recent media studies, for the appraisal of fashion photography in the 1920s, as put forward by Steinworth, might be the establishment of the photographic illustrated press in the 1920s.

It is also worth noting that it was only certain images, in the form of patterns, motifs, designs or contents that travelled. With regard to the adaption of modernist painting and sculpture into the realm of marketing and display windows, some artistic styles or movements were preferred. While cubism, constructivism, futurism and representational surrealism were recognized within commercial visual culture, other art styles were not. For example, surrealist art dealing with the grotesque, the transient and death was never absorbed by commercial agents in the 1930s.[20] However, such image aesthetics would be taken up by fashion photography much later, in the 1990s and onwards, and were referred to as radical fashion or post fashion.

While I find the notion of ecology, with its implied biological references, truly useful in describing and analysing images, some important points must be made. Natural processes, like osmosis, are completely governed by the laws of physics. This is of course not the case with cultural processes. Yet there appear to be some recurrent patterns in what can be termed 'cultural osmosis' and it is exactly such patterns that this book sets out to reveal.

Another key difference between natural and cultural processes is the existence of *intention* in the latter. This not only separates them from natural processes that lack agency in this sense but makes cultural expressions and processes both easier and harder to pinpoint in terms of cause and effect. They are easier to evince, as intention could be gleaned from the utterances and writings of the human agents, but also harder as there is not always a causal relationship between intention and outcome or result.

Commuting perspectives

The variability in the objects of study in this book calls for a corresponding mobility in disciplinary perspectives. Thus the theories and working concepts are taken from a range of scholarly disciplines. Consequently, this study not only considers a great variety of empirical sources, like so much earlier scholarly work on visual culture, but seeks to challenge the theoretical framework from which visual artefacts are conceptualized and studied. The intention is thus to provide a study of visual culture, characterized by criticality, vis-à-vis theory and method. As recently pointed out by Gustav Frank, the key mission of visual studies 'cannot be the object, that is image and vision, but how it is theorized, in which theoretical framework it is conceptualized and studied, and by which methods it is analysed and interpreted'.[21] This book is an answer

to this call in the sense that it combines methods, concepts and theories from art history and visual studies with media studies.

With provisos and in the absence of a better term, this book uses the notions of visual culture, which have been heavily criticized and today abandoned by many scholars.[22] It rather ties into the recent developments of image studies, derived from W. J. T. Mitchell's writings and the German tradition of *Bildtheorie* and history of *Bildmedien*, which seem to be the most viable and productive in the field at present.[23] As pointed out recently by art historian James Elkins, 'images in visual studies continue to be simply illustrations of the theories they accompany' and 'visual studies needs to make more adequate *use* of its images'.[24] This book therefore fills a gap in the existing body of research within visual studies, using a diversity of images as prime sources. It offers a close study of images in two ways. First, it presents and analyses individual, material images, or 'pictures', to use Belting's terminology, which could be either a page of a magazine, a window display or a handmade or printed picture. Second, the interpretations of these pictures are based on an assessment of a large body of visual material which includes not only images but also their spaces of display or their visual context. It is thus also a study comprising a number of larger visual contexts. The main benefit of such an approach is that it is possible to reveal phenomena and trace and delineate patterns, trajectories and relations where little or no written sources are available. In short, this book maps visual statements, where textual statements are scarce. By studying such 'visual discourses', the present book displays the possibilities with the rationale for, and strengths of, image studies. Hence, the results and conclusions presented here are primarily based on visual material and show how 'the image is not a derivative or an illustration, but an active bearer of the thinking process', to cite Horst Bredekamp.[25]

This study is informed by media studies in general, and theories of mediatization and media archaeology in particular. As pointed out by media theorist Andreas Hepp, 'media culture is *constitutive of reality*', which means that perceptions of reality, but also meanings of notions and concepts, are influenced by media.[26] Accordingly, this book investigates such processes in relation to the notion of art and thus provides new perspectives on the relations between art and mass media.

With inspiration from media history I use the concepts of 'media system' and 'image systems' to acknowledge that different visual expressions act as components in a historically situated system of distribution and circulation and, in consequence, also with intermedial relations. My emphasis on processes and systems, on continuities and ruptures and alternative histories is inspired by recent developments within media studies, such as media archaeology and cultural historical media studies.[27] Such systems of distribution and circulation could be political, economical, technical, social or legal

and the aim of this study is to analyse the relations between different kinds of image systems such as those of the art and fashion world, print media and the visual world of marketing.

The inclusion of theories of media archaeology and mediatization is made with some key considerations in mind. First, I seek to combine what Wolfgang Ernst has argued are two incompatible methods: the technological considerations from media archaeology with attentiveness to visual details and aesthetics common to art historical analysis.[28] Consequently the case studies include close analysis of form, aesthetic and layout of particular pictures common to art historical studies with a simultaneous consideration of the technological aspects and of the mediating apparatuses, common to media studies. As such, this study bridges the alleged gulf between the hermeneutic traditions of *Bildwissenschaft* and art history and the focus on medium or techniques of media studies, in general, and of media archaeology in particular. It thus analyses images freed 'from the confines within which various academic disciplines have imprisoned' them.[29] It also attests to Belting's remark that 'the coexistence of art and nonart images even in historical times invites a dialogue between the respective disciplines' of art history and media studies.[30]

Second, this study comprises what Jürgen Wilke has defined as the dissemination of art by secondary media, that is mediation and dissemination of art via mass media.[31] However, I do not only consider mass media, such as the press and television, to be an intermediary link or channel for different cultural contents. As argued throughout this book, mass media have not only played the part of mediator, remediating art in the form of adverts, art reviews and satires. Rather they have been an active part or a platform and even an aesthetic medium for art, as is particularly evident in Chapters 3 and 4. The case studies, therefore, demonstrate that mass media have played a decisive role in the construction of art in a more concrete and far-reaching way than is commonly noted. In relation to the discipline of media history the present book also stands out in its focus on images.

Finally, in contrast to much work within media studies, this study applies a historical perspective to the processes of mediatization, by including nineteenth-century material. Typically, writing on the mediatization in society considers the contemporary early twenty-first century, sometimes the period of high modernity, but seldom earlier historical periods.[32] It is indeed true that the processes of mediatization are progressive. Yet I argue that media has not only left its mark on everyday life in high modernity and contemporary times but also on earlier historical periods. If by media convergence we mean 'flow of content across multiple media platforms' this had been going on well before the contemporary age of digital dissemination.[33] Media have always been converging. An important starting point for this study is thus

to acknowledge images as embedded, networked and mediated. While this is a default stance in scholarly work on the imagery of journalism and media this is not always highlighted in studies on visual art.[34] However, visual art is, and has historically always been, mediated by and entangled in media systems, be it the illustrated handbooks of art history, lithographic and photographic reproductions of artworks, or the gallery or museum itself.

Entangled histories of art and media

The four cases included in this book testify to the dependences and interrelations between the visual arts and the development of media techniques, formats and systems. As these case studies show, an awareness of this two-way exchange opens up new understandings on the mechanisms and underlying factors for changes within the art world and, in consequence, on historical narratives of art.

The case studies mark key events and processes in media history, when new media formats, techniques and forms of address emerged. The first is closely connected to the spread of the illustrated press and the invention of the carte-de-visite format photograph, which paved the way for an exponential rise in the circulation of images from the 1860s onwards. The second is connected to the development of the window display as a medium for marketing, while the third coincides with the introduction of desktop publishing, which decisively changed the prerequisites for producing print media (cheaper, faster, simpler). The third case study can also be connected to the structural changes in printed news media in the 1970s when many press photographers were laid off, and the same photographers' move into advertising and fashion photography in the following decade. The fourth and final case study spans a period of forty years demonstrating how forms of address in traditional print media and television changed, parallel to the advent of Web 2.0, as the audience was increasingly enabled to express their opinions.

These case studies are also 're-visits' to seminal events in the history of art as regards modernity: the invention of the photomontage, the breakthrough of functionalism, the introduction of fashion photography (and fashion) into the art world and the emergence of relational art.[35]

Thus taken together, the cases cover a period that coincides with the emergence and demise of modernism *and* modern mass media, one which includes the development of new media techniques and media formats and new aesthetics, and new circumstances for the production and reception of art. This book thus seeks to describe the relations between such transformative periods within media history along with the developments within the art world, and argues that events and understandings of art's histories have

always been entangled with different media systems, developments of new media techniques, formats and forms of address.

The cases show that mass media have not only played the part of mediator, remediating art in the form of reviews, adverts, satires and so on, but have played a more profound role for artistic practices. The use of, and focus on, media systems rather than individual mass media has been one way of uncovering these interrelations. With regard to the history of photocollage, it is evident that an acknowledgement of the media system – that is, how the personal album and the popular but short-lived loose carte-de-visite cards depicting satires of contemporary events and personalities were displayed and circulated – is crucial in understanding why they were not acknowledged as visual art and as predecessors of the avant-garde art of the twentieth century. Something similar can be said about the transformation of fashion photography in the 1990s. A sole focus on aesthetics of the fashion images, which has been the default approach in earlier scholarly work of this trans-formative period, demonstrates a neglect of the medium through which these images have been disseminated. As this study display the medium is vital. Only by scrutinizing the media system of fashion imagery is it possible to uncover the transformative factors behind this change of aesthetics.

It can be shown that mass media have not only functioned as a repre-sentational, transmitting channel; art has been invested with new interpreta-tions when entangled in mass media. In the case of the illegal artworks it is clear that they possessed not only artistic or aesthetic value but also news value. When the discourse on these artworks appeared in the mass media, in the printed press and television, they were described with the same vocabulary as scandal news. This can be explained along two lines. First, it shows that mainstream media are more willing to give extensive space to contemporary art when it is illegal. Second, and more relevant to the three examples in Chapter 4, the migration into news media amplifies the inter-pretations of these acts and artefacts as something other than art. To use the vocabulary of the printed press and television, they are rather scams, pranks and dishonourable acts. Consequently, they could be discussed in mainstream media, on the news and entertainment pages, rather than on the cultural pages simply because they were not considered to be art.

Finally, this book offers historical perspectives on the increasing mediatiza-tion of the art field. At present, 'media' or 'media techniques' are integral elements in definitions and discussions on contemporary art. Labels like 'new media art', 'internet art' or 'digital art' testify to this.[36] In relation to this the present book provides a historical background to today's art 'lingo' by exemplifying how the fields of mass media and art have always been intertwined since the emergence of mass media in the mid-nineteenth century. Such a historical perspective may relativize the understanding of current

new media art. To paraphrase media historians Geoffrey B. Pingree and Lisa Gitelman, all art was once 'new media art'.[37]

Patterns of travelling images

Although the chapters are arranged chronologically this book does not make the argument that there are any chronological changes as regards the mechanisms in transgressions.

However, there are both similarities and differences as regards the processes of adaption and succession in the four case studies included here. Common to all is that the images have migrated between the art world and vernacular image culture or between the visual arts and mass culture. In the case of the photocollage and fashion photography there has been a movement from popular to visual art, whereas the transformation has gone in the opposite direction in the case of window display and illegal artworks. In the two latter, images originally produced as artworks eventually migrated into popular image culture where they were given a new function. Tying into Manghani's concepts of succession and adaption the first case study on photocollage is a typical example of succession in that both early twentieth-century artists using photocollage and many later art history writers failed to acknowledge their predecessors in nineteenth-century popular visual culture. The following two cases, on the uses of avant-garde modernism in window displays and experimental fashion photography in printed magazines are, on the other hand, typical examples of adaption where images have changed to fit into their respective image systems. In the fourth and final case of artworks that have been deemed to be illegal representations or acts, the images or artworks themselves have not adapted or changed. However, the notion is applicable in this case in the sense that the *interpretation* or *reception* of these representations and acts was itself subject to adaption. While initially produced as artworks they were subsequently interpreted as illegal deeds. These interpretations were literal, neither acknowledging the artistic rationale or intention, nor their conceptual or transferred meaning. In these cases, movements between the art world and the world of law and news were pending in the sense that they all eventually migrated back to the art world and were subsequently, in a longer historical perspective, primarily considered as artworks.

The cases studied offer examples of both synchronic and diachronic processes of adaption and succession. The first case on the uses of photocollage in nineteenth-century popular image culture, and in visual art in the following century, is a clear example of a diachronic, linear movement of succession. Although the main focus in the case study on photocollage is limited to the period 1860–1920 there is a diachronic distribution more broadly speaking

as photocollages were constantly produced in advertisements and the press from the nineteenth century and into and throughout the twentieth century. In the following two cases the processes of adaption can rather be described as synchronic, a parallel movement, as different versions and interpretations of the same images were circulating simultaneously in different contexts, eliciting very different interpretations. The final case study, imposter art, includes examples that can in fact be described as both synchronic and diachronic succession and adaption. When these artworks were first presented there were three simultaneous and very different interpretations of them, that is, a synchronic adaption. In a longer historical perspective however they have all once again been considered as artworks and thereby exemplify diachronic succession.

In all four case studies, crossing the borderlands of the art world seems to imply amnesia on both sides. Thus when an artwork migrates into the realm of business, law or news journalism its original intention and source of production is downplayed or even completely neglected. The same appears to be the case when popular or mass culture images migrate into the art world, as the cases on photocollage and fashion photography in this book clearly testify to. Thus, it seems that the borderland between the art world and mass culture is, metaphorically speaking, a dark place. Tying into the vocabulary of natural phenomena this transformative process can be likened to the magical transformation from caterpillar to butterfly, which takes place in the opaque space of the chrysalis, out of sight.

The notion of the art world explains to a large degree the different energies available to the agents studied. It is, for example, interesting to note that both the photographers and art directors of *i-D* in the 1980s and the artists whose works were reconsidered as illegal deeds were all young; they were still students or had just recently graduated from art schools.

Another recurrent theme concerns the ties to commercial business and economic values. The fourth and final case of art migrating into the news pages as reports of criminal acts is particularly instructive in this regard. Although the art world is a global big business the monetary aspects of different activities and objects are not always spelled out. However, when these monetary aspects are put on the table they typically revolve around the (often high) value of particular artworks. In the cases studied here, when artworks were dragged into public debate in the news media as potentially illegal acts, the economic aspect became a recurrent topic. Interestingly enough, though, these artworks were primarily discussed in terms not of *value*, but of *cost*, for individuals and for society at large.

The migrations over the borderlands of the art world can also be described in terms of a tension and movement between aesthetics and practice. When images have been received as artworks their instrumental and applied

functions have been downplayed. However, when the same images have appeared outside the art world, their aesthetic has been valued in relation to their instrumental function. Their *raison d'être*, always highlighted, is thus the function of their particular aesthetic. This, in turn, indicates that the Kantian notions of aesthetic perception as disinterested and the idea of art for art's sake were still in operation throughout the twentieth century despite there being many arguments against such views. The omission of an explanatory text in *i-D* as a means to enhance the fashion photographs is just one example of this movement from informative function to aesthetic experience. However, there is not only a tension between aesthetic and function but also a tension between the abstract and the concrete. Accordingly, artworks created with the intention of posing questions about the potential and role of art in society were perceived as concrete, literal (illegal) acts when they migrated into the realm of journalism and law. Thus the abstract ideas on politics and ideology invested in the artworks were not perceived or acknowledged in their new image community.

Visual discourses

This book includes detailed case studies based on the assumption that such research design allows 'complexities to emerge'.[38] Such deep cuts in time and space are both a way of limiting and qualifying the theoretically infinite material of image studies. Moreover, such finely grained studies are particularly instructive in cases where there are few sources at macro-level which is the default condition when dealing with ephemeral, vernacular, visual material produced outside the art world, as here.[39] While the agents and objects in the art world are generally well documented for future research, in museums, archives and libraries, the lack of sources is a constant hardship when researching events, individuals and objects from the vernacular visual culture in historical periods. Thus, because of their different historical, societal and economical circumstances the four cases share ephemerality. Little material has been preserved, and there is a lack of documentation of authorship and circumstances of production and consumption.

In that sense the material studied in this book is paradoxical because while many of these images have been widely distributed and consumed by large parts of society they have been less well documented than artworks, which have circulated in much narrower circles in society. In their respective periods they were well known and largely distributed but were not saved with the foresight and in the ordered manner that characterizes artists and private and public collectors of art. Quite often the names of the image producers were not even documented at the time of production, and their biographies have not been recorded for posterity. This is in stark contrast to the resources

available when researching agents within the art world, such as established artists, museums and galleries. It it obvious that maintaining and expressing an artistic persona, expressing intentions, aims and recording biographical notes is a vital part of being an artist in the modern age. Art is, in other words, a personal venture, a personal investment which includes a duty and call to express oneself. Thus an important part of acting as an artist is to document oneself, agree to give interviews, gather one's own archive, for future retrospective exhibitions, journalists' interviews and research.

That such distinct differences exist is something that is not always evident unless you make a combined study of visual art and popular, vernacular image culture. However, this is mainly a problem for the historical scholar who seeks to document and analyse such images in retrospect. The arguments and rationales which this book sets out to map out and analyse appear to have been less spelled out by the agents outside the traditional art field and therefore harder to find and map. Taken together, the expressions of popular, vernacular mass culture have been an obvious part of the contemporary public space during their respective periods but are not always part of the historical public space of the archive and collective memory.

For both material, pragmatic reasons and more immaterial ones, much popular imagery is ephemeral. Such imagery is *literally* ephemeral, perhaps produced using cheap, flimsy material. Moreover, their low economic value has reduced the incentive to collect and save the artefacts themselves, or document the agents and processes involved with their production and circulation. The existence of a provenance (i.e. records of owners, transactions and placements), is default knowledge for valuable and treasured items like artworks. For scholarly work this is a challenge, as an academic discipline requires archives, both in the literal and the abstract Foucauldian sense. It is also clear that once artistic practices migrate into the borderlands of the art world, interest in saving and documenting decreases.

The legal process following Dan Wolgers acting on the exhibition in Stockholm in 1992, analysed in Chapter 4, is a telling case in point. Today, the only existing copy of the legal investigation and verdict is in the artist's possession as it was culled from the Stockholm public archive during routine thinning. This indicates that the lack of documents not only impacts on historical periods but also holds for quite recent ones. This is certainly the case for the whole image community of window display. These have only been documented where they have found their way into professional journals or handbooks, but the large majority have not been documented at all. Even the great agents in Sweden, such as the large department stores and the originator of the first window decorating school in the country, are remarkably little documented. Moreover the agents themselves did not always clearly express their activities in the borderlands of the art world. The producers

of the magazine *i-D*, for example, did not spell out either in the magazine itself or in later interviews that their ambition was to challenge the genre of fashion photography. Similarly, the window decorators of the 1930s primarily argued for rational and effective marketing. That this was consistent with a modernist aesthetics was scarcely spoken of by the marketers, and not at all by contemporary artists and art critics.

It is also clear that several of the cases studied are the product of a collaborative venture, as with many artefacts of image mass culture. This has also contributed to the tendency not to record the outcome for these joint efforts. As there is no single originator, no single copyright holder, the drive to archive and document, to manage or preserve them for posterity is diminished. As a result, scholarly work on such material becomes more complex. Although the focus in Chapter 3 is on fashion photography, every page in the magazines *i-D* and *Artforum* is the shared result of the work of editors, writers, graphic designers, stylists, models and photographers. If nothing else, it has proved to be a complicated matter to obtain the right permission to reproduce these spreads in the present book.

As pointed out in earlier research, the relationship between art and fashion has never been clear cut, but has rather been characterized by a complex interrelationship mainly due to the latter's 'intermediate position between the artistic field and the economic field'.[40] I would argue that this holds for *all* artistic products, not only fashion but also graphic design, marketing design and the visual arts, and the positions and movements in these borderlands are significant in how a particular artefact or agent is perceived.

As the case studies in this book show, the mode of circulation and the context of viewing are vital to the understanding and definition of something as art, or not art. This means that while the images (that is pictorial motifs, patterns, designs) remained the same, their place and their mode of circulation changed and with this, particular audiences and obviously also their attitudes or expectations about what they perceived. In some instances the audiences were the same, but their attitudes might be radically different depending on the display context. The abstract modernism in window displays is the clearest example among the case studies in this book. The upper middle-class customers of the exclusive department stores in Stockholm comprised an important section of the audience at the Stockholm Exhibition. Thus it was the same audience, the same individuals, who rejected the modernist aesthetic when it appeared as visual art, and simultaneously embraced it when it appeared in the department store windows.

In some cases, the broad perspectives of this book – spanning the visual arts and the vernacular or applied uses of image culture – uncover particular paradoxes. The reception and use of the abstract visual patterns in early twentieth-century visual art was apprehended in very different ways, becoming

the means to different ends. For the American business managers they illustrated the conditions of modern, efficient production while the same studies of movements represented the urban, modern way of life for artists like Giacomo Balla and Fernand Léger. Thus businessmen focused on the production part while artists were attuned to the consumption contexts of these industrial products. For the former, the abstracted patterns were associated with the progression of modern industrial production while for the latter, they represented the consumption context of modern society.

All the cases in this book are in one way or another closely tied to the public domain, via the vernacular, everyday culture of the printed press and/or the urban street. Indeed, the public sphere has a vital importance for the art field as pointed out by Leonard Diepeveen in his study of caricature and satires on modern art, where he argues that 'Modernism isn't just a story of major centres, of a few magazines, and of major newspapers of record. The public sphere was much more diverse than that, and it played a more significant and diverse role in the construction of modernism than has usually been granted.'[41]

It is evident that the borderlands of the art world have had clear boundary markers at various periods, while at others they have been an open landscape for exploration, experimentation and migration. At times this borderland has been vast while at other times it has been limited or non-existent. It is my belief that further investigations into the patterns of movement of its immigrants and emigrants will tell vital stories of the centre which this borderland encapsulates. Hence, this book is to be read as a contribution to the body of work that seeks to broaden the understanding of modernism by focusing on the osmotic borderlands of the art world.

Notes

1 M. Bal, *Travelling Concepts in the Humanities. A Rough Guide* (Toronto: University of Toronto Press, 2002).
2 W. J. T. Mitchell, 'What is an Image?', *New Literary History*, 15:3 (1984), 503–537.
3 K. Moxey, 'Visual Studies and the Iconic Turn', *Journal of Visual Culture*, 7:2 (2008), 132.
4 H. Belting, *An Anthropology of Images: Picture, Medium, Body* (Princeton, N.J. and Oxford: Princeton University Press, 2011), pp. 11 and 18. Belting considers the human body as a medium for mental images. In the following I have however limited the analysis to consider only artefacts as mediums.
5 Belting, *An Anthropology of Images*, p. 21.
6 H. Belting, 'Image, Medium, Body. A New Approach to Iconography', *Critical Inquiry*, 31 (2005), 302–303.
7 K. Kuc and J. Zylinska (eds), *Photomediations. A Reader* (London: Open Humanities Press, 2016), p. 12; Sunil Manghani, 'Visual studies, or This is not a diagram', in

J. Elkins, G. Frank and S. Manghani (eds), *Farewell to Visual Studies* (University Park, Pa.: The Pennsylvania State University Press, 2015), p. 23.

8 I. Kopytoff, 'The cultural biography of things. Commodification as process', in A. Appadurai (ed.), *The Social Life of Things. Commodities in Cultural Perspective* (Cambridge: Cambridge University Press, 1986), pp. 64–94.

9 Examples of that focus on material pictures can be found in E. Edwards and J. Hart (eds), *Photographs, Objects, Histories. On the Materiality of Images* (London: Routledge, 2004).

10 S. Manghani, *Image Studies* (London: Routledge, 2013), pp. 31 and 35; S. Sontag, *On Photography* (London: Penguin Books, 1979), p. 180.

11 Manghani, *Image Studies*, pp. 34–36.

12 *La Revolution Surrealist*e, 4 (15 July 1925).

13 A. Danto, 'The Artworld', *Journal of Philosophy*, 61:19 (1964), 571–584; G. Dickie, *Art and the Aesthetic. An Institutional Analysis* (Ithaca: Cornell University Press, 1974).

14 H. S. Becker, *Art Worlds* (Berkeley: University of California Press, 1982), p. x.

15 Manghani, *Image Studies*, p. 35.

16 See for example the organization of museums and collections with departments for different materials or mediums and constructions of a historical narrative based on material or technique, such as the ambitions to construct a history of photography. In others the genrc has been dominating such as the history of art.

17 See for example the digital search engines for *Artforum* (https://artforum.com) and *Punch* (http://www.gutenberg.org).

18 See K. Steinworth, 'The Arrested Glance', *Photographis*, 15 (1980), 8–9.

19 J. D. Bolter and R. Grusin, *Remediation. Understanding New Media* (Cambridge, Mass.: The MIT Press, 1999); L. Gitelman and G. B. Pingree (eds), *New Media 1740–1915* (Cambridge, Mass.: The MIT Press, 2003).

20 J. Lears, 'Uneasy Courtship. Modern Art and Modern Advertising', *American Quarterly*, 39:1 (1987), 146.

21 G. Frank, 'Affect, agency, and aporia. An indiscipline with endemic ambivalence and lack of pictures', in Elkins, Frank and Manghani, *Farewell to Visual Studies*, p. 11.

22 Among the most famous is the debate on visual essentialism in *Journal of Visual Culture*, 2:1 (2003), 5–32 and 2:2 (2003), 229–268. See also W. J. T. Mitchell, 'Showing Seeing. A Critique of Visual Culture', *Journal of Visual Culture*, 1:2 (2002), 165–181; W.J. T. Mitchell, 'There Are No Visual Media', *Journal of Visual Culture*, 4:2 (2005), 257–266.

23 Mitchell, 'What is an Image?', 503–537; W. J. T. Mitchell, *Iconology. Image, Text, Ideology* (Chicago: University of Chicago Press, 1986; W. J. T. Mitchell, *Picture Theory. Essays on Verbal and Visual Representation* (Chicago: University of Chicago Press, 1994), 1994; S. Manghani, A. Piper and J. Simons, *Images. A Reader* (London: Sage, 2006); Manghani, *Image Studies*; K. Moxey, *Visual Time. The Image in History* (Durham, N.C.: Duke University Press, 2013); 'Histories. Bildwissenschaft', in Elkins Frank and Manghani, *Farewell to Visual Studies*, pp. 81–98.

24 J. Elkins, 'First introduction. Starting points', in Elkins, Frank and Manghani, *Farewell to Visual Studies*, p. 6.

25 H. Bredekamp, *Darwins Korallen. Frühe Evolutionsmodelle und die Tradition der Naturgeschichte* (Berlin: K. Wagenbach, 2005), p. 24 as referred to in 'Histories. Bildwissenschaft', p. 89 and Moxey, 'Visual Studies and the Iconic Turn', 139.

26 A. Hepp, *Cultures of Mediatization* (Cambridge: Polity Press, 2013 [2011]), p. 22.

27 Gitelman and Pingree, *New Media*; J. Harvard and P. Lundell (eds), *1800-talets mediesystem* (Stockholm: Kungliga biblioteket, 2010); E. Huhtamo and J. Parikka (eds), *Media Archaeology. Approaches, Applications and Implications* (Berkeley: University of California Press, 2011); Manghani, *Image Studies*, pp. 26–27.

28 W. Ernst, 'Let There Be Irony. Cultural History and Media Archeology in Parallel Lines', *Art History*, 28:5 (November 2005), 582–603.

29 Belting, *An Anthropology of Images*, p. 36.

30 H. Belting, *Art History after Modernism* (Chicago: University of Chicago Press, 2003), p. 163.

31 J. Wilke, 'Art. Multiplied mediatization', in K. Lundby (ed.), *Mediatization of Communication* (Berlin: De Gruyter Mouton, 2014), p. 465.

32 See for example Hepp, *Cultures of Mediatization*; S. Hjarvard, *The Mediatization of Culture and Society* (London: Routledge, 2013), pp. 6–7; Lundby, *Mediatization of Communication*.

33 H. Jenkins, *Convergence Culture. Where Old and New Media Collide* (New York: New York University Press, 2006). See also Hepp, *Cultures of Mediatization*, p. 26.

34 For examples of such studies, despite they are not presented as 'media' studies, see D. Karlholm, *Art of Illusion. The Representation of Art History in Nineteenth-century Germany and Beyond* (Bern: Peter Lang, 2004); T. W. Gaehtgens and L. Marchesano, *Display and Art History. The Düsseldorf Gallery and Its Catalogue* (Los Angeles: Getty Research Institute, 2011).

35 N. Bourriaud, *Relational Aesthetics* (Dijon: Presses du réel, 2002).

36 See for example Thames & Hudson World of Art-series, such as R. Green, *Internet Art* (London: Thames & Hudson, 2004); M. Ruch, *New Media in Late Twentieth-century Art* (London: Thames & Hudson, 2005); C. Paul, *Digital Art* (London: Thames & Hudson, 2008) and recent exhibitions such as *Electronic Superhighway. From Experiments in Art and Technology to Art After the Internet*. Catalogue edited by O. Kholeif, S. McCormack and E. Butler (London: Whitechapel Gallery, 2016).

37 Gitelman and Pingree, *New Media*, p. xi.

38 L. Gitelman, *Always Already New. Media, History and the Data of Culture* (Cambridge, Mass.: The MIT Press, 2006), p. 11.

39 A. Ekström, *Representation och materialitet. Introduktioner till kulturhistorien* (Nora: Nya Doxa, 2009), p. 116.

40 See further below, pp. 96–97.

41 L. Diepeveen, *Mock Modernism. An Anthology of Parodies, Travesties, Frauds, 1910–1935* (Toronto: University of Toronto Press, 2014), p. 23.

Cut and paste **1**

The introduction of Photoshop and other digital software for editing photographic images in the early 1990s heralded a surge in the production of photomontages, photocollages and other image manipulations in all genres. Although the tools were new, the themes or subject matter already had a long visual history and these gained new popularity in the wake of the so-called digital revolution in photography. When I wrote my thesis on this tranformational period, using Swedish image materials, I found some recurring themes, particularly in the daily press. Montages and collages were commonly used to portray politicians or abstract, metaphorical concepts in politics and business. A recurrent motif was a combination of photographs of politicians' heads mounted on playing cards.[1] Some fifteen years later when I came across Victorian photocollages with the same motifs a question took shape in my mind. How could these motifs have travelled from the handmade Victorian albums in 1870s London to the pages of a Swedish newspaper in the 1990s (plate 1 and 2)?[2]

The aim of this chapter is to trace and emphasize the links between the nineteenth- and twentieth century practices of making photocollage, between the handmade and the mass produced, and between art and the press. By emphasizing the visual trajectories between the centuries *and* between different image communities this chapter seeks to revise the understanding of the history of photocollage.

Consequently this chapter inscribes and considers these early photocollages in another context, namely that of print culture and media history. As we turn our gaze to print media like daily journals and the illustrated press and literature there emerges a remarkable pattern of continuity, upholding traditions from the late nineteenth century into the the twentieth century and beyond as regards the practice of photocollage. Most art histories put the 'invention' of photomontage at c. 1910, used within the art field in constructivism, Dada and surrealism. This chapter maintains that there are several links between different image communities and between image techniques in the nineteenth century. It then argues that the printed press may be regarded as a link that connects the production of photocollage and

photomontage in the nineteenth century with avant-garde art practices, as well as with the popular visual culture, of the early twentieth century.

This recontextualization enriches the understanding not only of these images' origin, but also of their legacy. Accordingly, the combination of perspectives from art history, photo history and media history lays bare other trajectories and relationships, and new interpretations of visual culture of the late nineteenth century in which the first photocollages were produced.

The invention of photomontage and photocollage

According to the Raoul Hausmann, he and other Berlin Dada artists 'were the first to use the material of photography to combine heterogenous, often contradictory structures, figurative and spatial, into a new whole that was in effect a mirror image wrenched from the chaos of war and revolution, as new to the eye as it was to the mind'.[3] This, then, is a typical example of succession as defined by Manghani, of the failure to acknowledge predecessors. It is easy, in retrospect, to correct this, as the production of photomontage and photocollage had been around since the invention of photography, particularly during the sixty years preceding the Dada movement when paper became the dominant material for photographic images. Although photomontage and photocollage have been celebrated as a twentieth-century art forms invented by Dada artists in the 1910s there are today a number of scholars who have revised this story.[4] Even the Dadaists themselves acknowledged their predecessors and sources of inspiration, to some extent. For example, Raoul Hausmann and Hannah Höch pointed out that popular postcards and the contemporary practice of making vernacular military memorials were among their sources of inspiration and, thus, they were not ignorant of historical predecessors.[5]

What from an art historical perspective appears to be a story of revolution and amnesia combined may instead be described as continous process where an image tradition is sustained. The history of photocollage and photomontage can be described as a trajectory of continuity and the upholding of a tradition, with regard to print culture, that is, illustrations in the press and literature as well as mass-produced photographs.

This chapter considers the mechanisms of breaks and continuities, inclusions and exclusions, in the history of photocollage and photomontage. It deals with travelling images, illustrating how the technique of cutting up and reassembling of photographic elements has existed simultaneously (and appeared and disappeared), in different image communities. It also acknowledges travelling images in the form of images, motifs or visual content that have appeared and reappeared in photocollage and montages in different contexts of production and display, within the art worlds, but also in mass-produced carte-de-visite photographs, private albums and the illustrated

press in different periods. Thus I argue that neither the technique of photo-montage nor its alleged criticality were new in the 1910s when taken up by Dada and later by surrealist artists. Finally, this chapter deals with travelling images in a very literal sense, as material pictures that have been literally cut out from one context to be inserted in another: that is, a cut and paste art.

Two concepts have been used for the type of images discussed here, photocollage and photomontage. The term photomontage is commonly used to refer to composite pictures made up of several photographic elements, while photocollage includes photographs combined with non-photographic imagery such as line drawings, watercolours or printed picture elements.[6] However, the concepts have not been used consistently, as pointed out by art historian Dawn Ades. In some cases the term has not even been based on the technical process but rather on the operation of transforming the meaning of the original photographs whether they are combined with other photographs, or with painted or drawn elements.[7] In the following chapter I use the term photocollage throughout except when making direct references to earlier writings. This is not only to simplify the text but also to avoid a constant double reference. In this way I also try to evade a focus on the production technique of the elements they are made up of, which may be difficult to determine in some cases. Thus the common denominator of the images discussed here is the 'photographic element', which is cut out and inserted into a new context, consisting of other photographs or drawings, watercolours or printed texts or images.

A number of scholars have pointed out that there are two principal types of photocollage. The first, which has been labelled 'naturalism', strives to conceal its composite nature, while the second, labelled 'formalism', empha-sizes and displays its composite nature, the juxtaposition of disparate ele-ments.[8] While the artistic uses of photocollage within Dada and surrealism have mostly been formalist collages, both types of photocollages appeared within and outside the art field in the nineteenth and twentieth centuries.

This chapter is divided into two parts. First, it includes a critical survey of the writings on the history of photocollage between the 1970s and 2010s, focusing on the arguments and rationales for separation and forgetting, or acknowledging and linking, the photocollage practices of the nineteenth and the twentieth centuries. It thus includes examples of both amnesia and recognition. Second, it considers the agents and platforms for photocollage making in the nineteenth century as well as some particular images, that is, recurrent visual patterns, content and motifs. These images travelled synchronically as well as diacronically and, by looking at particular examples, the context of production of the nineteenth century as well as their relations to the production of art and popular visual culture in the following century are evident.

Photocollage avant la lettre

A vital element for making photocollages was access to printed images. By the seventeenth century it had become highly fashionable to collect printed material in the form of clippings that were later assembled in scrapbooks or on tableaux. The clippings came from journals, almanacs, fashion magazines, newspapers and advertising and also included die-cut images made especially for collaging.[9] In the late nineteenth century the use of scraps truly flourished owing to the abundant supply of affordable raw material for clippings. The output from the printed press – illustrated magazines, for example – had increased dramatically in the mid-nineteenth century as a direct result of the enormous drop in manufacturing cost in the transition to paper made of wood pulp.[10]

In the second half of the nineteenth century photographs were also included. This was a direct effect of the introduction of the albumen print in 1847. From then on the dominant material base for photography was paper, vastly increasing the accessibility and affordability of photographic material. The standardized format of the carte-de-visite, which was patented in 1854 and had its heyday during the following three decades, was also a factor in the rising popularity of photocollage. Carte-de-visite portrait photographs were not only circulated among family members and friends; they were also produced in large editions targeting a mass audience. The majority of these mass-produced cards depicted celebrities of the day, such as royals, sovereigns, politicians, artists and other cultural personalities. Reproductions of artworks and architectural monuments and views were also mass produced at the time.[11] Some of these contained collages of several photographs, or photographs combined with drawn or painted elements.

Photo historical surveys reveal that the most-documented sort of photocollage in the nineteenth century is the so-called mosaic card (carte mosaïque), which was produced in several European countries from the mid-nineteenth century onwards. The technique was patented by the French photographer André Adolphe Eugène Disdéri in 1863 and the cards were compositions of photographs of heads of the members of royal families, politicians or other members of high society.[12] The main purpose of these collages was to include a larger number of portraits on the same card – such portrait-mosaics might typically consist of between twenty and hundred portraits. In his patent application Disdéri argued that with this technique one could achieve a thousand portraits for the cost of a single one.[13]

Although the technique was patented in the 1860s the visual content or image, that is, the mosaic of heads, dates back to the Renaissance and can be found in caricatures and studies by Leonardo, Agostino Carraci and – much

later – William Hogarth.[14] However, such caricatures were enfolded into the field of photography quite literally from the start as one image in the first photo illustrated book, W. H. Fox Talbot's *The Pencil of Nature* (1844) included a photographic reproduction of a lithographic print by the eighteenth-century artist Louis-Léopold Boilly, famous for his caricatures.[15] Thus the image itself was not new in the 1860s, only the practice of using photographs to produce it.

Besides the professional production of mosaic cards it was a popular pastime among women of high society to cut out and paste photographs and combine them with pencil drawings or watercolours. The best known examples were made mostly in England, France and the USA between the 1860s and 1880s. These photocollages were individually handmade and commonly mounted in albums. Today they are scattered among archives and museum collections, either in their original bound volumes, or as loose leaves which have been sold and displayed as single works of art.[16]

A third type of photocollage that existed in the second half of the nineteenth century, which has hitherto not been given much attention by later writers on photography, was the mass-produced photocollage in carte-de-visite format. However, these were not composed as a mass of faces in mosaic form but instead combined different photographs, occasionally accompanied by drawn elements, to produce a fictional scene of the celebrities of the day. These might depict morally dubious images of famous men and women while others displayed fictional scenes where politicians and state leaders were caricatured.[17]

Forgetting and discovering

From an art historical perspective the amnesia of the Dadaist artists is indeed characteristic. The early twentieth century's avant-garde positioned itself as radically, groundbreakingly new, and different from any historical precursors. However, this amnesia has also coloured the art historical reference work on photocollage, which has typically drawn a definitive line between the photocollages of the nineteenth century and those of the twentieth. *The Grove Encyclopedia of Materials and Techniques in Art* published in 2008 concludes for example that 'Despite occasional usage by earlier artists and wide informal use in popular art, collage is closely associated with 20th-century art.'[18] This also holds for the most recent survey of the history of photography, Michel Frizot's edited volume *A New History of Photography*. This book provides extensive coverage of both nineteenth-century photocollage techniques and Dadaist photomontage. Yet they are presented separately in the book and the paragraph on the latter points out that photomontage was an 'invention' that was 'born' in the first decades of the twentieth century.[19]

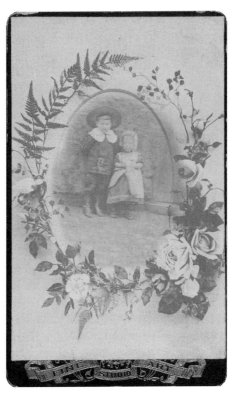

1.1 Carte-de-visite photograph with painted frame of flowers.

This view also holds for the standard work on photomontage by British art historian Dawn Ades, *Photomontage*, first published in 1976 and in a revised and extended edition in 1986.[20] *Photomontage* sets out to 'examine … the historical origins of photomontage and suggest … some predominant themes, their intersections and parallel development'.[21] Already in the first paragraph of the introduction Ades acknowledges that the 'manipulation of the photograph is as old as photography itself', and mention Fox Talbot's experiments in the 1830s. Comic postcards, albums and military mementos are also mentioned. These are, however, very briefly covered. In the second edition of the book nineteenth-century seamless montages, prompted by technical deficiencies in the photographic technique and practised within art photography, are given coverage, more, indeed, than the above-mentioned 'amusements' of the same century. However, Ades concludes that the 'term "photomontage" was not invented until just after the First World War' by the Berlin Dadaists and that the 'word gained currency … in the context of

an art (or anti-art) movement' and did not enter common use until the International Dada Fair of May 1920.[22]

The history of photomontage by Ades, with its focus on the avant-garde artistic practices from the 1910s onwards, is premised on two assumptions. First, her emphasis is on the intentions and inherent criticality of the artistic practices and on individual artworks by artists like Hannah Höch, Raoul Hausmann and John Heartfield. These differ strongly from the nineteenth century's seemingly lightweight and mass-produced postcards and visual amusements on the one hand, and the seamless montages intended to display technical perfection, on the other. Second, Ades' history writing is strongly focused on designation. Although she explains that the 'practice of photomontage has precedence over the name' her history of photomontage concentrates on the agents who coined the term and the period when it gained currency.[23] Thus, the history of photomontage, according to Ades, starts with the coining of the term and with critical art practices by Dada artists.

While Ades focuses primarily on art practices she does acknowledge other image communities in the twentieth century. In the second edition of her book she remarks that it 'is in the field of advertising, perhaps, that photomontage has become most familiar today – in the creation of the strange and marvelous, in the sense of magic and images in the rendering enigmatic of isolated commonplace images'.[24] Moreover, she also refers to *Courrier Dada*, which already in 1958 acknowledged the sources of photomontage to be 'American publicity' and 'the militant and political photomontage … created on the soil of the Soviet union'.[25] However such publicity images are completely invisible in Ades' book. In the enlarged second edition a whole chapter is dedicated to surrealism. Here Ades deals mainly with surrealist art by Schwitters, Ernst, Bréton, Valentin, Mariën and Duchamp from the 1920s onwards, acknowledging the popular postcard and illustrated magazines, but concludes that the postcards 'profilerated after the turn of the century'.[26] While it is true that postcards, as a way of circulating photographic images, did indeed profilerate around the turn of the century, they also existed in the nineteenth century.

However, the kinds of motifs found in the early twentieth-century postcards were very similar to those in the mass-produced carte-de-visites of some twenty to thirty years earlier. Thus both types of photocollage were mass-produced images but were circulated differently. The latter were sold and collected like other types of carte-de-visite photographs and held in albums for example, while the former circulated by mail. Thus earlier practices of photomontage are mentioned but a break between the visual culture of the nineteenth-century and that of the twentieth century is once again drawn by Ades.

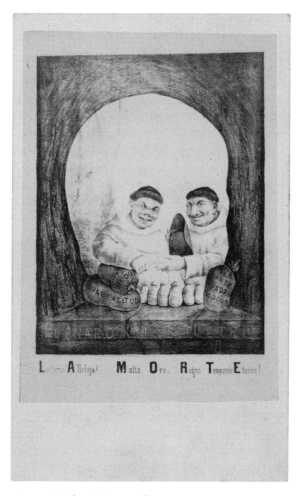

Nineteenth-century carte-de-visite surrealism.

Another seminal contribution to the history of photomontage appeared as two articles in *Artforum* in 1978 by Robert A. Sobieszek, curator at George Eastman House in Rochester, New York. These articles point to two major types of montage: those which aim to construct a seamless whole, the naturalist strain; and those which emphasize the broken surface, the formalist strain.[27] Sobieszek's main argument is that 'Earlier examples of photomontage have been usually brushed aside on grounds of eccentricity' and thus the main aim of his texts is to acknowledge the practices of photomontage during the nineteenth century. Indeed 'photomontage formed an extensive part of the photographic vocabulary for nearly three-quarters of a century before Dada', Sobieszek reminds us.[28] According to Sobieszek, the main reason for the

continuing amnesia has been a general assumption that photography 'remained quite pure' and was not manipulated before the artistic avant-garde uses of the medium.

Sobieszek's first article deals with composite art photography like the famous prints by Oscar Gustave Rejlander, which give the impression of 'the naturalism of a single shot'. His second article considers the other type of nineteenth-century photomontage, which makes 'no attempt to disguise spatial disharmonies or incongruities of scale'.[29] According to Sobieszek much of the photomontage created between the 1850s and the late 1910s was intended to portray a naturalistic image, but there existed also images that were 'in no way realistic' and were made simply 'for the sake of assemblage and/or amalgamation'.[30] This is mainly exemplified by mosaic cards, both Disdéri's from 1863 and similar earlier examples, which incorporated heads of famous contemporaries.

Sobieszek does not consider the popular carte-de-visites which displayed faked tableaux of celebrities of the day. Moreover, his rationale for tying together the nineteenth- and the twentieth-century photomontages is based primarily on technical considerations. Sobieszek concludes that 'certain similarities of approach are apparent, even if, of course, the subject matter is decidedly different'.[31] His main focus when linking the practices of the two centuries is on material and technique, not on subject matter, aim or content. Moreover, he focuses primarily on the 'serious' reasons for making montages; that is, photocollages developed because of the technical deficiences in the camera (i.e. small depth or width, or photographic emulsion's varying sensitivity to hues) or to meet business rationales, as cost-efficient amassments of portraits. Thus the surrealistic and humorous aspects of nineteenth-century photocollages, in caricatures for example, are not examined by Sobieszek.

He does, however, mention the photocollages in personal nineteenth-century albums such as the Sackville-West album at George Eastman House and the Blount album from the Gernsheim collection at the University of Texas, Austin. Yet he does not expand on the circumstances of their production, their producers or visual content. He only mentions their existence, and reproduces two images in the article, one from the Sackville-West and one from the Bouverie album.[32]

Such album photocollages have, however, been successively recognized by scholars since the 1990s and included in the histories of photography. In the early 1990s such Victorian album collages were acknowledged in the British journal *Creative Camera* and American journal *American Art*. The purpose behind both of these articles was that these images should be considered as art.[33] In the former, art historian Marina Warner grounded this argument by relating them to the contemporary art world, suggesting that they provide 'an interesting model for contemporary photographic explorations, offering the potential of combining documentary and

intervention approaches, of meshing objectivity and subjectivity'.[34] Just like Sobieszek, Warner associated contemporary, postmodern art practices with Victorian photocollages as a way of acknowledging the (more than) 100-year-old images as art. The same theme can be found in the subsequent scholarly work on the nineteenth-century album collage.

During the 2000s a number of publications appeared on photocollage in personal albums made primarily by women in the Victorian period. In 2007 British art historian Patrizia Di Bello published *Women's Albums and Photography in Victorian England*, which was based on her art history thesis, presented three years earlier. This was followed by the exhibition *Playing with Pictures. The Art of Victorian Photocollage* at the Art Institute of Chicago in 2010, which was accompanied by an extensive catalogue including three longer essays and over a hundred pictures.[35] The contributors were Di Bello and the American art historians Marta Weiss, curator at the Victoria and Albert Museum in London, and Elizabeth Siegel at the Art Institute of Chicago and curator of the exhibition. *Playing with Pictures* opens with a text by the editor Elizabeth Siegel, which discusses the motifs and context of production of these album collages. They were produced within aristocratic circles, primarily by women, and their visual vocabulary included objects and activities enjoyed by these upper-class women. Siegel also elaborated on why photocollage has been regarded as only a twentieth-century art form and why the pictures produced by women in the Victorian era have not been considered to be art.

Like Sobieszek, Siegel acknowledged that the album collagists employed the same techniques and methods as the avant-garde artists, including 'the infiltration of mechanically produced materials into art, the fluid mixing of diverse media, the convergence of multiple authors, and the creative act as a process of collecting and assembling rather than origination'. According to Siegel there are, however, at least three major reasons for this neglect by later art historical writers, which include issues around their circulation, technique and producers. First, they were circulated privately; second, they were a product of mass-produced photographs and neither proper photographs nor drawings or painting but a hybrid that did not fit into the high modernist idea of media specificity; and finally they were produced by women with no distinct authorship. Some are anonymously made and are the product of several artists. It is interesting to note that this omission from the history writing is entirely due to the images themselves and to their creators, according to Siegel. Yet a crucial reason, I believe, is rather how later uses of photocollage was described and defined in the period between the early and the late twentieth century.

As indicated by its title, a further aim of the exhibition was to acknowledge and re-evaluate these pictures as modern and as art. Although the wording in

the title gives it a dual meaning, referring both to visual art and to craft, the re-evaulation of these as artworks were emphasized by the exhibition itself.

A more diversified discussion of several different types of nineteeth-century photocollage appeared in a book by Henisch and Henisch, *The Photographic Experience 1839–1914. Images and Attitudes*, published in 1994. It acknowledged the mosaic cartes, the popular mass-produced caricatures and the handmade album collages. However, owing to its limited scope it considers neither the period nor the genre of avant-garde art like Dada, and hence does not highlight the trajectories in the history of photocollage or the connection between the two centuries.[36] Another book on nineteenth-century photography, published in 1965 by the French photo historian and collector Michel François Braive, mentions photomontage and its relation to surrealism but does not elaborate. Unlike Sobieszek, Braive points to Rejlander's images such as the *Bachelor's Dream* (1860) as primarily romantic, mysterious and anti-realist, and as forerunners to surrealism, instead of relating them to the idealistic history painting of the same century.[37]

A number of scholars have tied together the visual culture of collage in the nineteenth and the twentieth centuries. Although not exclusively concentrating on photography, literature scholar David Banash argued in an article in 2004 that 'collage has deep roots in the rise of mass media and commercial culture that both precede and make possible the avant-garde innovations of modernists and postmodernists'.[38] Thus he links the visual culture of the two centuries. However, like Ades, Banash emphasizes advertising when he concludes that it 'was in the techniques of advertising, with their reliance on the ready-made and radically abstract forms, that the material and basic elements of collage first emerged'. Banash focuses on the decades preceding the invention of collage where he argues that advertising was characterized by abstraction and fragmentation.[39]

Something similar was shown by German historian Anke Te Heesen in her book on newspaper clippings. Her research not only spans a long period, from the seventeenth to the twentieth century, but also covers different contexts, so that newspaper clipping is discussed in relation to scholarly, popular, artistic and archival practices. In effect this extensive study connects the practices of the twentieth-century avant-garde artists with the practice of cutting and pasting paper clippings in the preceding centuries.[40] However, Te Heesen does not, like Sobieszek and Siegel, expand on the content but rather focuses on the technique or medium itself.

Two tendencies can be discerned in the texts discussed above. First there are writings that link the practices of making photocollage in the nineteenth and twentieth centuries, but these efforts are primarily made outside the context of visual art. Accordingly, both the seamless montages of Rejlander and expressions of popular culture in the nineteenth century are related to

practices within advertising in the following century. Thus, while some writers have argued, in particular, for the artistic quality of the Victorian album collages they have not emphasized their legacy within the art field. Other writers, however, have hinted at the relationship between the avant-garde art practices of surrealism and the collage culture of the preceding half century. But they do not go into much depth regarding the similarities and their implications for interpreting both nineteenth-century collages and their successors within the art field.

In the following section I draw out these links by looking carefully at the context of production and some of the motifs that appear in the Victorian albums. A major reason for the neglect of these photocollages *avant la lettre* until the late twentieth century may be that they have not been considered in the broader visual culture in which they existed. Indeed, they were not only personal, individual expressions but also part of a larger media landscape and visual culture of the late nineteenth century.

Punch as interface

As pointed out by Elizabeth Siegel several of the album collages were inspired by, or direct copies of, images produced in contemporary literature and the illustrated press. In *Playing with Pictures*, Siegel presents examples of such transmissions of images from the British satirical weekly magazine *Punch* (1841–1992) and contemporary fairy tales by the Grimm Brothers, Hans Christian Andersen and Lewis Carroll.[41] Contemporary print culture in general, in the printed press and illustrated books, and *Punch* in particular, functioned as important sources of inspiration for the first wave of photocollages.

Indeed, *Punch* and its agents illustrate the constant exchange between the practices of making illustrated magazines, illustrations, photography, caricature and portraiture in the late nineteenth century. *Punch* included and tied together several image communities and image techniques, and can be said to have served as an intermediary between art and the press on the one hand and between photography and satire on the other. It may therefore be described as an interface, a platform enabling works to trangress between image communities, linking the Victorian album collages with a broader image community and, by extension, the art world.

The images in *Punch* echo the two types of images found on carte-de-visites and in albums. First, there were 'naturalist' images, which portrayed men, women and children in everyday situations in the private or public sphere such as the street, the shop or in the living room. The pun in these cases would be found in the accompanying text, which upturned the 'normality' of these seemingly banal images. Second, there were the 'formalist', surreal, fantastic images which included dislocation in size, hybrid creatures, and animated objects. These images were in themselves a pun, both textual and

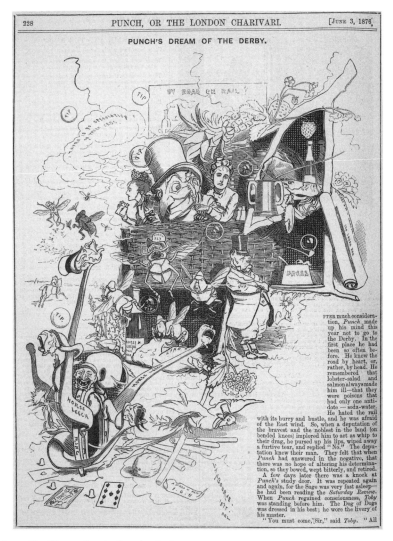

Collage-like illustration in *Punch*, 1876. **1.3**

visual. It was primarily, but not exclusively, the latter that served as inspiration and constituted the material for the handmade photocollages in the period.

Punch created an environment characterized by open relations between the art field and the press. It was common practice for Victorian artists to earn a living by making illustrations for the press and several artists contributed to *Punch* on a regular basis. Among them were James Whistler, John Millais, George du Maurier, Frederic Leighton and Myles Birket Foster. In fact there was 'hardly any artist of note who did not at some time, or

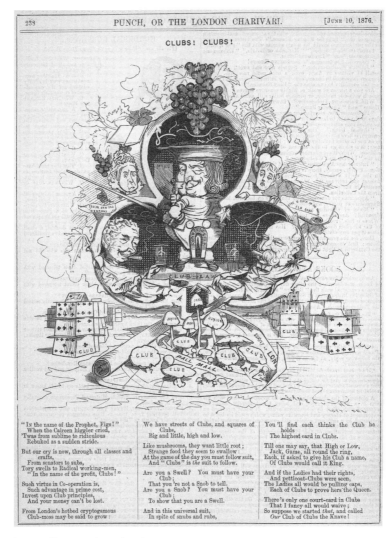

1.4 *Punch* surrealism, cards and caricatures, 1876.

even for a considerable period, become involved in … illustration', noted art historian Jeremy Maas.[42] Accordingly, an individual might act in several communities of image production simultaneously and *Punch* could be said to be a hub in a network of individuals and practices. Thus there were agents who worked in tandem as painters, illustrators, photographers and caricaturists. The good relations between the graphic artists of *Punch* and the British Royal Academy also testify to this. The graphic artists often knew the painters

well and events at the Academy were meticulously covered in Punch as has been pointed out by Juliet McMaster.[43]

Furthermore, there were several instances of cross-media references between different image techniques. Some of *Punch*'s cartoons were based on contemporary painting while others were made from photographic originals.[44] The graphic artist and cartoonist Edward Linley Sambourne, *Punch*'s first illustrator, amassed a large collection of carte-de-visite and other photographs during the 1870s. The fact that photographs were produced in grey tones and not in full colour seems to have been an advantage as it made this translation to another medium easier. Sambourne believed that working from photographs 'provided an important dimension of authenticity to his graphic work'.[45] In addition, many of the caricatures and humorous tableaux in *Punch* were reproduced as diverting stereoscopic photographs of the same motifs with live models.[46] This demonstrates the circular migration from the medium of photography to printed xylographic pictures and back to photography again. Another illustration of this openness as regards media is the inscription on carte-de-visite photographs by photographer William Henry Tuck in London. As stated on the back of two examples from around 1875 'A life sized oil or water colour painting, a crayon drawing or an enlarged photograph can at any time be produced from this carte'.[47] Thus the customer could choose freely what medium the image should be delivered in.

The production of *Alice's Adventures in Wonderland* (1865), whose illustrations inspired several Victorian album collage makers, is another case in point. Sir John Tenniel, the illustrator, was a political cartoonist for *Punch* from 1851 until 1901. Tom Taylor, the editor of *Punch*, introduced Tenniel to Lewis Carroll, who was practising photography.[48] He had studied with Oscar Gustave Rejlander, famous for his 'symbolic pictures', composed of elaborate collages of several photographs. Carroll took photographic portraits of Tennyson, Millais, Rossetti and many young girls such as Alice Lidell. He also wrote some commentaries on the art of photography.[49]

A similar figure is Cuthbert Bede (Edward Bradley). He was simultaneously acting as an author, illustrator, satirist and photographer and was the originator of the book *Photographic Pleasures*.[50] He also produced illustrations for many papers and magazines, including *Punch* and *Bentley's*, *All the Year Round*, *Illustrated London Magazine*, *The Field*, *St. James's* and *The Gentleman's* magazines, *Leisure Hour*, *Quiver*, *Notes and Queries*, *The Boy's Own Paper*, and the *Illustrated London News*.[51] The many caricatures and satires on photography and photographers in *Punch* testify, if nothing else, to the impact of such agents.

As pointed out by photo historian Carolyn Peter many photographers entered the business of photography via caricature, the common denominator

being a great interest in facial expressions (physiognomy) and celebrities of the day. The photographer Gaspard-Félix Tournachons (1810–1910), better known as Nadar, is one such. Both he and his brother Adrien Tournachons (1825–1860) practised photography and caricature in tandem; the same holds for his compatriot Etienne Carjat (1828–1906).[52]

Taken together, it is evident that the photographs, graphic prints, illustrated magazines, literature and paintings produced were intertwined in the period through the multi-disciplinary and multimedial acts of their agents. Accordingly, there were clear, direct links between the art, illustrations, caricatures, photographs and photocollage produced in the late nineteenth century, and an acknowledgement of this context of production is vital to the understanding of the photocollages of the period.

Recurrences

Another way of mapping the cross-disciplinary and cross-medial links in the production of collage images in the period is by looking at how certain images – that is, visual content, motifs or patterns – occurred and reoccurred in different image media and outlets. In the following, I trace a number of such images, which appeared and reappeared in the late nineteenth century, and show how these, in turn, can be related to image production in a variety of contexts in the twentieth century. I show that Victorian album collages were indeed part of a widespread and established visual culture. Moreover, trajectories can be seen between the nineteenth-century photocollages and the avant-garde art practices and popular or commercial imagery, including photocollage, of the following century.

Before turning to specific examples it is important to note that in most cases the pictorial motifs of the photocollages are generic and it is impossible to trace their provenance. However, the question of which picture came first, or what is the original, is not relevant, as the main aim of this analysis is rather to highlight the *circulation* of the images, that is, the image ecologies, in the period rather than tracing their origins. In some cases, the trajectory between print culture and practices of photocollage is evident, as in the collages composed of paper clippings. One album, in the collection of Victoria and Albert Museum, reveals a literal relationship between print culture and photography, as the collages consist of paper clippings from magazines, scraps, packaging, paper dolls and other empheral visual material. In some cases it is even possible to determine the exact source as *Punch*, since one collage consists of the image of the Punch dog (here, with the face of the Hon[ble] Percy) that adorned every cover of the magazine from 1849 to the 1880s.[53]

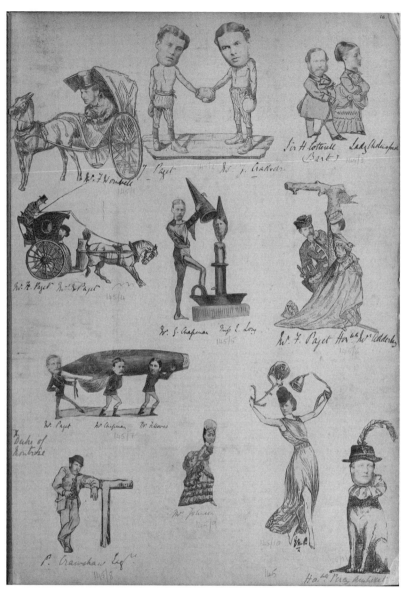

The Punch dog in Edith Mary Paget's album, 1868–80. **1.5**

Crafted meetings

Two kinds of images have been the standard reference points in writings on the seamless nineteenth-century photocollage. One is the metaphoric and entirely fictional image, *Two Ways of Life* (1857), produced by Oscar Gustave Rejlander, the other being the fake news images of Eugène Appert depicting the executions carried out by the Communards in Paris in 1871.[54] However, the act of making seamless photocollages was widespread. Photographic images of landscape in the nineteenth century were often produced by combining two prints to compensate for the different sensitivity to different hues in the photographic emulsion. Such photographs might be produced using one plate with longer exposure, which caught the details of the blue sky, and another with shorter exposure for the brown/red/yellowish ground, which would be too dark if taken from the same plate as the sky.[55]

When photographs of events and places were reproduced through xylography in the press it was also common practice to add features to the illustrations to improve their liveliness and to make them more picturesque. This was especially true for moving objects such as human figures and vehicles, which were routinely added when photographs were transcribed by graphic artists.[56] Moreover, collage was also used to produce large group portraits of politicians and members of royal families. Eugène Appert, for example, produced portraits of the French ministers in the 1870s which are obvious collages of several portraits but apparently served as documentary records of the political leaders of the country. There is also evidence that the same practice occurred in England as similar photographs exist: for example, a group portrait of British prime minister William Ewart Gladstone and his cabinet taken by the London-based photographer William Luks. Another photocollage produced by H. J. Whitlock in Birmingham displays a group of famous musicians and singers. It is clear that the latter is a collage of different photographs because those portrayed are listed on the album page and their dates of birth range across almost forty years, while in the picture they appear to be more or less the same age.[57] Neither of these are dated but are estimated to have been produced in the late 1860s or early 1870s, based on the dates of Gladstone's premiership (1868–74), in the former, and the year of death of the portrayed in the latter.

These mass-produced pictures of possible yet fictional meetings can in turn be related to the Victorian album collages. A recurrent theme was the recreation of parlours where individuals taken from different photographs appeared to socialize in a painted, fictional space.[58] It seems that both the mass-produced collages of politicians, royals and others and the handmade collages collected in albums served the same ends – to portray an assembled

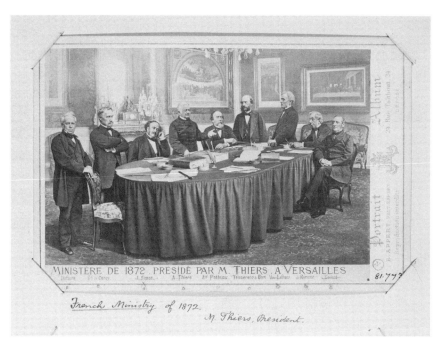

French ministers of 1872. Collage by E. Appert. **1.6**

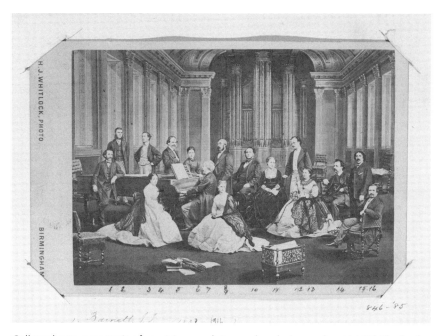

Collaged group portrait of musicians and singers by photographer H.J. Whitlock of **1.7**
Birmingham.

group of people where no such photograph was possible. As pointed out by Patrizia Di Bello such an assembly of photographic depictions in the same painted parlour was not only a way of creating desirable and amusing pictorial meetings, but also an often commented upon function of the assembling of carte-de-visites in albums in the period. Such juxtapositions could, for example, be provoking, challenging visual plays as in the case of Lady Filmer who played out or staged flirtations between herself and Prince Albert through the photocollages of her album.[59]

Hybrid creatures

The combination of man and beast has been a literary and pictorial theme since antiquity, with hybrid characters symbolizing different gods and mythical figures and, in consequence, different traits, characters or abstract concepts. Thus large and physically strong animals such as the lion represented leaders like kings, while birds were associated with speed and lightness, vanity and lack of intellectual power. Such hybrid creatures have also been stock themes in caricature and satire since at least the sixteenth century, when the concept of caricature was first developed.[60]

In the *Punch* caricatures such hybrid creatures were used to symbolize certain traits, characters, positions or individuals. In the context of the caricature in general and in *Punch* in particular, hybrid characters of man and bird were recurrent images.[61] The image of the human bird was used for different purposes, depending on the implied gender. In general the bird symbolizes someone timorous and stupid, but when the human bird was female, this was also linked to vanity and fashion.

Hybrids of man and bird can also be found in the Victorian albums. One image of particular interest is found in the Gough album and exemplifies the similarities and possible links between the handmade collages and the contemporary caricatures in *Punch*. Gough's collage is a watercolour drawing of three ducks floating in a stream, their heads being cut-out photographs of three young women. The duck in the foreground is the album maker herself, or her identical twin; behind her is another sister, and to the right an unidentified woman. The Gough album is alleged to have been produced sometime between 1875 and 1885 (plate 3 and 4).[62]

Although the wit and pictorial skill of Gough's collages have been pointed out, this particular image is referred to as a 'whimsical fantasy' in the catalogue *Playing with Pictures*.[63] To argue against such interpretations, two images, published in *Punch* in the same years may illustrate the potentially subversive and political content of the Gough image. The first and most evident example was published in June 1883. This picture entitled 'The daring duckling' displays five ducks with human heads. A 'grand old hen', a portrait of the British

Prime Minister Gladstone, stands at the shore and looks concernedly over the water. Beside him stand three ducklings with unidentified human faces. Together they look anxiously at another duck swimming out into the water. This last is a depiction of the liberal politician Joseph Chamberlain, who is about to swim into the water labelled 'radicalism'.[64] The picture is a political cartoon referring to a particular event in British history, which displays the divided opinions between the more conservative, and older, prime minister and the – initially in his political career – radical liberal Chamberlain.

Another picture on the same theme was published in *Punch* in 1876. In this image the hen on the shore represents the First Lord of the Admiralty, Ward Hunt, and the ducklings the British fleet.[65] In both political satires the shore represents tradition and safety while the ducks in the water represent vulnerability and risky ventures. It is not possible to prove that Gough had, indeed, seen these particular caricatures, but they *were* in fact published during the same years that she produced her album collages. In the context of these caricatures the meaning of Gough photocollage may then be read not merely as an image of women as limited, thoughtless or vain 'ducks', but as an image of women daring and free to explore the social and political landcape around them in a figurative sense. Note that there is no restricting grand old hen on the beach to watch over the whereabouts of the daring ducks in Gough's collage.

Dislocation of size

Dawn Ades points out the 'abrupt disruptions of scale that were a common feature of Dada photomontages'.[66] The same holds for the photocollages of the nineteenth century, indeed, they are a part of the standard repertoire within fairy tales and caricatures in general. In caricatures these typically include humans with a giant head on top of a medium-sized body and miniature limbs. From the 1860s these also took the form of mixed media images, containing photographic and drawn elements, and many illustrations from contemporary published fairy tales served as models for album photocollages. There exist, for example, several photocollages depicting Thumbelisa flying on the back of a bird or sitting in the corolla of a water lily, and of the smoking caterpillar sitting on a mushroom cap from the story *Alice in Wonderland*.[67]

Dislocation of size was also used in social, political satires in which the caricatured often had large heads with small trunk and limbs. The large head not only provided more space for the individual, recognizable features of the face and headdress but also made the person look smaller and possibly childlike owing to the ratio between the size of the head and the rest of the body.

An interesting case in point which also highlights the intricate relations between caricature, drawing and photography is the carte-de-visite caricature of John Brown. The carte rests today in an album in the collection at the Victoria and Albert Museum, surrounded by ordinary photographic portraits of aristocratic and bourgeois men. The carte is a classic caricature drawing of a man with a disproportionately large head and small body and limbs. He is identified as John Brown by the handwritten text on the album page. To the left of Brown is a building so small in appearance that it cannot be discerned visually. However, the text 'Balmoral' is written above it with a pointing line, which further testifies to the identity of the caricature as Brown, who was personal servant to Queen Victoria at Balmoral castle in Scotland. This, however, is not only a caricature of Brown. In the background on his right a very small, sketchy silhouette of a person on horseback can be discerned. For contemporaries the identity of that person would have been clear. This drawn caricature is a reproduction of a famous and widely circulated photograph of Queen Victoria and John Brown taken by the Scottish photographer George Washington Wilson in 1863. Indeed, the silhouette of Queen Victoria looks very like that in the famous photographic portrait of her.[68] Brown wears a kilt and the same kind of round headdress with a pom-pom on the top as in the photograph. Thus for contemporary viewers this was not only a caricature of John Brown but also of Queen Victoria. Accordingly, this exemplifies how an image has travelled from a photograph into a drawn caricature in the photographic format of the carte-de-visite. It clearly shows how photographs served as material for drawn caricatures, and also demonstrates how the interpretation, and consequently its provocative or daring potential, might be dependent on familiarity with other contemporary pictures.

Visual trajectories from one century to another

While Sobieszek in his *Artforum* articles established a link between nineteenth- and twentieth-century photomontage he did so from a technical perspective, that is, through examining the craft of cutting and pasting photographic material. However, I argue that similarities exist not only on a formal basis. Indeed, certain designs, content and practices can be found both before and after the turn of the century, that is, in the album collages and carte-de-visite caricatures of the nineteeth century and in the visual art and popular visual culture of the twentieth century. In connection with the exhibition *Fantastic Art Dada Surrealism* at MOMA in 1936 a comprehensive list of features typical for Dada and the Surrealists was drawn up. Twenty-one different characteristics were listed and in fact many of them also apply to the photocollages produced in the nineteenth century.[69] The list included for example 'collaborative

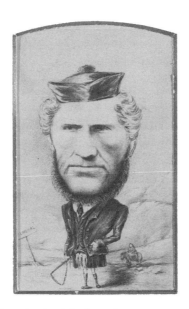

John Brown caricature in carte-de-visite format. **1.8**

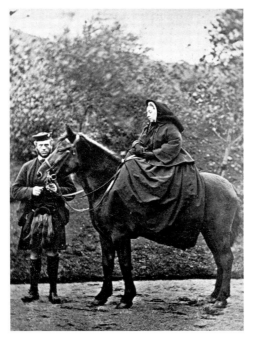

Photograph of John Brown and Queen Victoria by George Washington Wilson, 1863. **1.9**

compositions', which may be found in many Victorian album collages as pointed out by Siegel.[70] Also included are 'animation of the inanimate', 'metamorphoses', 'isolation of anatomical fragments', 'confrontation of incongruities' and 'miracles and anomalies', all of which can be found in album photocollages, as well as in the satiric illustrations of *Punch* from the 1860s to the 1880s.[71]

Thus in contrast to earlier writings, which pointed out the relations between surrealism, Dada and nineteenth-century photocollages in general terms, this section seeks to establish the links between the centuries and image communities in terms of specific designs, content and practices. The focus is thus not only on aesthetics or techniques but on content and to what ends.

In some image communities both the aesthetic and function have remained the same from one century to another. This holds, for example, for photocollages which have been used for political satire and for celebrity portraits. Several of the mass-produced carte-de-visite photocollages included politicians and other celebrities of the time exposed in humiliating, embarrassing or otherwise compromising situations, a paramount example being the notorious photograph of the French empress, Eugénie de Montij, which circulated unofficially in Paris in connection with the 1867 Exhibition. This image combined a photograph of the head of the empress with another of the body of an unknown naked model.[72] Images like these were obviously made by a cut and paste technique and the daring content of the finished picture was supposed to look like a seamless whole. While such images were not common in the avant-garde artistic practices of photomontage they did become staples in the tabloid press throughout the twentieth century. The main attraction of using photographs in such collages lay in being able to reproduce the facial features of the key characters, thus creating a realistic effect.

In many cases the visual allure of these photocollages was that they enabled two or more people to 'meet' who were not likely do so in reality or under such circumstances. A typical example is the 1860s caricature of the statesmen of Austria and Prussia entitled 'Marriage of Convenience'. In this carte-de-visite collage the Austrian Foreign Minister Johann Bernhard von Rechberg appears as the bride and Prussia's prime minister Otto von Bismarck the groom. The couple reluctantly take their vows and this image refers to the uneasy agreement between the two countries with regard to their joint actions against Denmark in the Second Schleswig War in 1864.

Another example is the caricature carte-de-visite 'The Great Surrender' produced by the photographer E. Anthony in New York in 1862. Although it looks like a humorous caricature of five men with oversized heads the picture refers to a serious diplomatic incident which occurred between Great

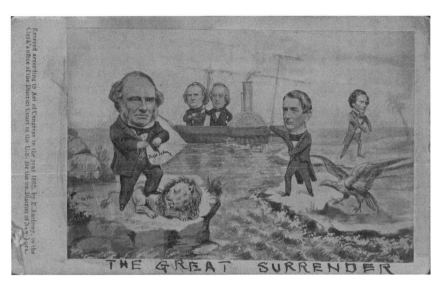

'The Great Surrender'. Carte-de-visite photocollage by E. Anthony, 1862. **1.10**

Britain and the United States in 1861. The main characters of this political drama are identified on the back of the card: 'The portraits of Earl Russell, Mason, Slidell and Sec'y Seward are Photographed'. Mason and Slidell, in the background, were envoys of the American Confederacy who were arrested while travelling on the British mail packet. This created a diplomatic crisis between the USA and Britain which almost paved the way for war. The Americans did eventually apologize and avoided an open conflict.

The collage depicts the bitterness felt by Americans about their nation's compliance toward the British. However, it also depicts their partial victory in the drama, as the British Foreign Secretary Lord John Russell, to left in the picture, angrily has to tear up the 'Right of Search' document. As a consequence of this incident this British right at sea was abolished. This satire also uses animals to further emphasize the involved nations, a well-known trope from *Punch* and other sources: a lion lies at the feet of the British foreign secretary, while an eagle stands behind the American Secretary of State.[73]

A final example where a certain aesthetic of photocollage has travelled between the centuries is the mosaic portrait, originally patented by the photographer Disdéri in 1863. While the design – the group photograph of heads, or head and shoulders portraits – has remained very much the same, the context or function changed as it travelled into the twentieth century. Nineteenth-century mosaic cards were primarily used to portray members of the royal families, politicians, attendees at various high-profile meetings,

or a certain group or category of people. Such collages of personalities can still be found in photo illustrated magazines and daily papers today, yet the most common appearance is on posters for cinema and theatre productions. Furthermore, is is interesting that the different sizes of the portrayed have the exact same function – the relative size depends on the character's importance or rank in the context, exactly like in the nineteenth-century mosaic cards.

An agitational tool

Unlike the Berlin Dadaists who claimed to have invented photomontage and disavowed the technique's relation to advertising, contemporary artists of the Soviet Union explored such relations. Thus while the avant-garde artists in the west continued to produce unique handmade art objects, although their components were mass produced, the artists associated with the Soviet journal *LEF* explored not only the aesthetics of advertising and other mass-produced visual material but also its forms of distribution and address. Accordingly, as pointed out by Benjamin H. D. Buchloh, the Soviet artists considered photomontage as primarily an agitational tool, whether for advertising or in radical, political art.[74] Although Buchloh does not expand on this in his seminal text 'From Faktura to Factography', such a perspective evades the notion of definite genres, and the dichotomous model of visual art and mass-produced imagery as two separate units. Moreover it slips away from an art historical writing focused on pioneers and inventors. Consequently, and most importantly, considering photomontage as an agitational tool independently of the material used and context of display made it possible to consider the photomontages of the nineteenth century and the twentieth century as intertwined practices.

The demarcation and division by centuries and different practices of photocollage is a recurrent feature in the published work on Dada and surrealism, as shown. What is particularly interesting is that this also holds for the writing on the elaborated, handmade photo album collages. While their aesthetic qualities and their similarities to surrealism have repeatedly been acknowledged, the writing so far has also clearly shown that they are something quite different. That they should be considered and valued as art has not been questioned; and in 1992 art historian Marina Warner pointed out in *Creative Camera* that such albums provide 'an interesting model for contemporary photographic explorations'. Art historian Patrizia Di Bello, in turn, concluded in 2007 that these images possess 'a visual and haptic vitality, a complexity of form and signification, a sensual suggestiveness, an engagement with the modern, and subversive potential as rich as those to be found in recognized works of modern art'.[75]

The same view is found in the catalogue *Playing with Pictures* in 2010 whose title already signals the relation to art. Yet the curator and editor Siegel concludes: 'Many photocollages are mysteriously odd; the medium allowed for experimentation, bawdy humour, and a Victorian version of Surrealism.'[76] The same holds for the most extensive study of the Kate Edith Gough album by Brittany M. Hudak. Although Hudak acknowledges the subversiveness in photocollages as regards gender identity and class she remarks that Gough's album 'was never meant for public display, but rather for entertainment in the parlours', and the bottom line was that they were 'a story of her own identity' and thus primarily a way of presenting her witty personality.[77] Although writers such as Siegel and Hudak show that these collages *avant la lettre* have similarities with Dada and surrealism, they are at the same time careful to point out that there are fundamental differences between the two.

These differences are not to do with technique or artistic quality but appear to be about content or, more precisely, their criticality. Indeed, several writers have dismissed their critical or intellectual quality. In the catalogue to the exhibition *Playing with Pictures* the pictures are continually described as 'whimsical fantasies', 'topsy-turvy', and 'whimsy'.[78] *Victorian Studies'* review of the exhibition similarly concluded that 'The Allure of the albums … their spontaneity, their fun and creativity, and their lack of pretention to weightier meaning defy efforts to contain them with theorizing.' Moreover *Art in America*'s reviewer wrote that 'many of the sheets in "Victorian Photocollage" look astonishingly like … the movements of modern art, Dada and surrealism [which thereby]… are so convincingly presaged by a bunch of idle, rich 19th century women with no express grand ambitions to radicality'.[79]

However, I believe that the album collages as well as the caricature carte-de-visite photocollages have critical potential in a number of ways. In consequence, I argue that it is not only on formal grounds and technique that there exist links between the practices of photocollage in the nineteenth and twentieth century. What they share is the agitational element.

An important link between the album collages and the political caricature of the same period are the carte-de-visite caricatures. However, very little is known about how these caricatures were produced, circulated and consumed. One reason might be that they had a very short life-span, as pointed out by Henisch and Henisch.[80] Browsing through the key photo historical reference works you find but one instance – in Henisch and Henisch; theirs is the only work that reproduces and discusses the nineteenth-century political caricature with regard to photocollage.[81] As these caricatures were produced in the standard size of the carte-de-visite and and made to fit into the available frames and albums they probably circulated in the manner of mass-produced celebrity cartes and were sold in stationery shops and at

photographers' ateliers. The best-known examples were either produced by photographers, like E. Anthony in New York, or by printers, like W. H. Mason in Brighton. Many are not attributed to a particular producer. These caricatures depicted and commented on actual political events and were simultanously an amusement. Thus they provided a fast and appealing way of getting an update on recent political events, much like today's Twitter and other social media. Although it is yet to be proven, one could imagine that such cartes were particularly attractive to those who did not read newspapers, or to those who were not literate.

The creativity, artistry and wit of the album collages have been acknowledged abundantly in earlier reseach and their emancipating content has for example been explored by Di Bello and Hudak. By looking at some particular pictures I wish to explore the critical potential of their contents not only with regard to gender issues but also in relation to contemporary media and political and social play.

Having said this, it is important to remark that I do not aspire to lay bare the intention of the makers or the meaning of each individual picture. Although some details are known about them and their producers, the body of knowledge is comparatively small. The pictures have no titles and in many cases the names and identities of the individuals depicted are unknown. In order to be able to grasp the original intention or meaning of these images one needs to be familiar not only with contemporary culture, topics and events but also with the social relations of the album makers. Like later amateur albums these compilations were intended to be used within a relatively small social circle, and the explanatory written information that is the default mode in much print culture is therefore often lacking.[82] In the following I therefore link the album collages to contemporary print culture as a way of extracting the potential criticality of the former.

My first example in the Gough album depicts Edith Gough and her husband, Hugh Gough, lieutenant in the Royal Navy, by a banner which bears the text 'England expects that every man will do his duty'. This famous sentence, uttered by Admiral Nelson before the Battle of Trafalgar in 1805, was widely quoted and referred to in several different contexts, including in the writings of Charles Dickens and Lewis Carroll.[83] The expression 'steer the ship' has been used metaphorically and applied to large ventures such as political and military leadership. The metaphor has also been used visually, for example in political caricatures in *Punch*. One such caricature, of the British prime minister George Hamilton-Gordon, appeared in the *Punch Almanack* of 1854. The prime minister is depicted as a captain steering the ship's wheel – inscribed with the word 'Government', in harsh weather.[84] The implied readings of this caricature are manifold. It could imply that the captain has problems managing the state or that he simply steers the

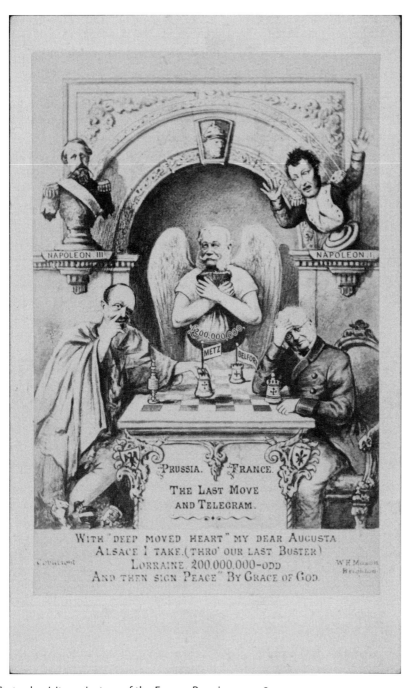

Carte-de-visite caricature of the Franco-Prussian war, 1870–71.

1.11

goverment after his will, or that he is a captain steering the country in a brisk international, political environment. Independent of how such a caricature is interpreted the person at the wheel influences the steering. In the light of such images, Gough's picture, in which she and her husband appear on either side of the wheel, has a double meaning. First, they act as important leaders, and second, they share the prime position. This implies that women could be equal leaders with men at a time when women did not even have the right to vote let alone any positions in Parliament.

Another recurrent theme in the album collages, which was also a staple in contemporary political caricature, concerns plays, games and performance. There are puppets, marionettes, jokers, playing cards, performers and props from the theatre and circus which emphasize politics and social life as a performance and play. A telling example for these album collages is a caricature of British politicians and Parliament which appeared in *Punch* in 1865. In the picture entitled 'Our play box' Mr Punch, the alter ego of the magazine, has lifted the roof of the houses of Parliament in which the politicians lie higgledy-piggledy like soft dolls. This image not only portrays the politicians as dolls and the houses of Parliament as a box of toys, but also views the satirical magazine as a child playing with the former. It depicts 'Mr. Punch's delight at finding his dear old puppets where he left them in July', as the text below the image explains. [85]

The playing cards with inserted faces are also part of this theme. These were abundant both in the album collages and in caricatures in print culture in the nineteenth century. In print culture the faces of famous politicians and royals were inserted into playing cards while in the album collages it was the faces of family members, friends and acquaintances.[86] The use of playing cards was gratifying in several respects. First, for their reference to games, a popular pastime in Victorian high society and second for their reference to rank and network, as the face cards used were kings, queens or knaves which belonged to different suits. Morover, there was also the play on words between the face cards and photographic cards (the carte-de-visites), the latter also having a similar format to cards in a deck.

A final theme which also may be interpreted in terms of criticality is seen in the many references to, and depictions of, different media formats in the album collages. There were printed media like letters, posters, advertising but also a number of other popular mediums for photographs in the period, such as albums, fans, jewellery and porcelain. To include them in an album created a kind of circular reference, from one medium to another. These media references have not been mentioned by writers like Sobieszek and Warner in their discussions of the relationship of postmodern (i.e. late twentieth century) photographic practices to nineteenth-century collages. Yet I believe that these photocollages of the nineteenth century with their

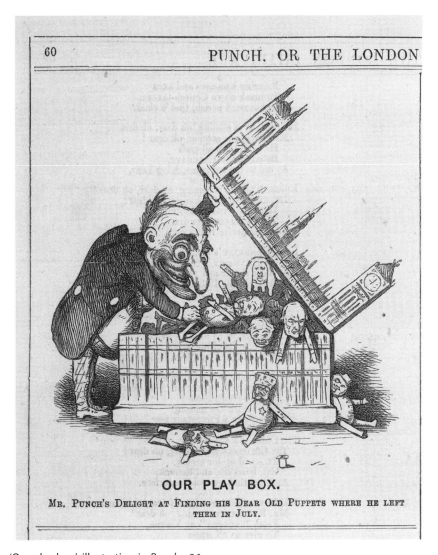

'Our play box', illustration in *Punch*, 1865. **1.12**

self-awareness – as a type of medium among many – are of relevance to the postmodern art practice of the late twentieth century.

To understand and interpret album collages as more than an expression intended for personal, domestic use one must also consider the different meanings 'private' and 'public' had in the late nineteenth century. What to a contemporary eye may appear as highly personal and private, as a photo album to be viewed in the parlour, may have been regarded differently by

nineteenth-century standards. The division between the private and public spheres was not so clear cut and the parlour was the public area of the home.[87] The personal compiled photo album would have been on display in the parlour, i.e. the social, public part of life in the home. Moreover, many of these female album makers would have taken part in contemporary political life as either daughters or wives of politically active men.[88] This strengthens the argument outlined above, that these photocollages are more that mere whimsical fantasies. Indeed, though they were made as diversions, pastimes, they also possessed critical properties which they shared with contemporary mass-distributed images such as the carte-de-visite caricatures and the caricatures in the printed press.

The media system of photocollage

According to Dawn Ades, 'Photomontage belonged to the technical world, the world of mass communication and photo-mechanical reproduction.' As this point was made in reference to Walter Benjamin's arguments about the relations between Dada art and the development of film, photocollage is viewed as primarily a twentieth-century phenomenon.[89] While I agree with the conclusion – that the practice of cutting and pasting photographic prints is directly connected to certain media techniques and media systems, I do not agree on the periodization. I argue, rather, that these practices in the last decades of the nineteenth century belonged to the world of mass communication and photo-mechanical reproduction, in the form of the printed press and the carte-de-visite photograph respectively.

This chapter has shown that the photocollages of the 1860s and onward were not isolated instances or experiments made by a few individuals but were part of a widespread practice in the mass media landscape of the period. It has also been pointed out how certain media techniques or media formats tied into new aesthetic practices and techniques within the visual culture. Thus the emergence of photocollage in the mid-nineteenth century was directly linked to the production of cheap, wood-based paper that prompted an increase in the number of illustrated magazines which, in turn, enabled the mass circulation of printed images. Furthermore the emergence of the photocollage is also directly linked to the invention of the photo-based mass medium, the carte-de-visite. Accordingly, I argue that the carte-de-visite technique can be regarded as a mass medium, a means of communication designed to reach large audiences. This was a consequence of its relative cheapness due to its mode of production and small format, which enabled a global production and exchange not only of the photographs themselves, but also of all accompaniments such as

mounting boards, albums and frames. Indeed, the carte-de-visite fulfilled the function of several later mass mediums. Through this medium portraits of the celebrities and policymakers of the day were spread, a function later fullfilled by the daily papers and magazines. Via carte-de-visites political commentary and satires were circulated in public, and were taken up by the daily press and comic magazines in later periods. Finally, the carte-de-visites were used to commemorate travel and send greetings. Cards of the main attractions were, for example, sold in travel destinations and portrait cards were exchanged between friends and family members as a token of social ties. Both the illustrated magazine and the carte-de-visite photographs were mass-media formats and when their paths crossed the new image practice of making photocollage emerged.

This broader media approach and comparison to print culture may also provide an explanation why there are some recurring images or pictorial motifs in the existing handmade photocollage in England, France, the USA and Sweden in the nineteenth century. Although the individual albums themselves were unique, the practice of making photocollage was widespread, through the mass-production and mass-circulation of carte-de-visite collages and illustrations in the printed press. The links between the dozen or so albums that are known today are thus the mass-produced and mediated images that circulated in the same period.

The self-referentiality and destabilization of the photographic medium inherent in photocollage might also be the reason why the album collages were 'found' from the 1970s and onward by curators, dealers and academic writers. Indeed, there was a broad and increasing interest in historical photographic prints in the 1970s. Yet vital in relation to the album collages was that they tied into the postmodern questioning of, and interest in, the nature of representation, in which the photographic image played a key role. This could be gleaned from Sobieszek's *Artforum* articles in 1978 where he established, though not explicitly, a link with the (then) current postmodern applications of photography, concluding that in these photocollages 'the photograph is no longer treated as a surrogate reality, but as a pictorial reference to reality'; 'The photomontage … is fundamentally a picture of pictures rather than a picture of something before the camera, and as such it begs a type of modernist thinking about images that occurs quite early.'[90] Only a year later this theme was fleshed out by Douglas Crimp in his seminal article on the Picture generation artists where he stated that 'underneath each picture there is always another picture'.[91] Thus what characterized the new wave of photo-based artists in the late 1970s, such as Sherrie Levine and Barbara Kruger, can directly be related to the practices of photocollage some hundred years earlier.

Disciplinary divides

As pointed out by Elizabeth Siegel the main reason for the neglect of album photocollages was their arbitrariness as regards genre and medium. They were hybrids in a double sense, combining different image techniques and image communities. However, I argue that the reasons for the amnesia with regard to these nineteenth century photocollages are not only inherent in the images themselves. Just as important a reason are the clear differences between how art history, photo history and press history have been understood and written historically. All have, until the late twentieth century, neglected the nineteenth-century photocollage, but for different reasons.

Among professional photographers, particularly in the twentieth century, these composite photographs were considered as cheating, in terms of technical skill. Yet already in the nineteenth century photomontage was not without controversy. The British Photographic Society, for example, banned composite photographs in their annual exhibitions.[92]

Moreover photocollages may have been neglected by photo historians because of their lack of 'purity'; they were perceived as mixes of images from photography and other techniques. Even if they were not completely excluded, they were downplayed because of their hybrid character, which did not fit into the twentieth-century modernist notion of photography as a medium with specific characteristics.[93] For the same reason they were revived in the wake of the questioning of modernism in the late twentieth century. Indeed, many efforts to construct 'a photohistory' during the twentieth century have been tinged by modernist ideals. Consequently, they have very much been media specific, creating a narrative in which photographic artefacts and practices are described as a separate practice. The underlying ambition in these ventures has been to elevate photography to art, to make it look like art history.[94] As a result, there was little place for the impure and non 'serious' photocollages of the nineteenth century, as regards both composite technique and content.

For art history writings up to the late twentieth century, the photocollages did not fit into the formula of unique art object, either in their mode of production – with several artists collaborating – or in the use of the work of 'others'. The photocollages were evidently also excluded because they were not art but popular visual culture. Thus it was not the photocollages themselves, nor the technique used or their motifs that made these nineteenth century works unimportant or irrelevant for the artist in the early twentieth century; rather this was the effect of a certain rhetoric that actively emphasized the new, the radical and the break with tradition, one which has tinged art-historical writings since modernity and until the end of the twentieth century.

Within media studies and media history, popular imagery has for several reasons been neglected historically. First, images in general have been less researched than texts within the discipline. Second, serious topics like news, the economy and politics have historically been given precedence over lightweight media material like humour and other feature material. Finally, there has until recently been a strong focus on large media institutions like publishing houses and broadcast companies.[95] For all of these reasons the emphemeral carte-de-visite caricatures and the 'private' album collages of the nineteenth century have not been subject to interest within media historical studies. Owing to these disciplinary divides there have also been institutional reasons why these images have fallen between stools. Indeed, they have been institititutional 'misfits' or 'orphans', something which can be explained along two lines.

First, it typically take two to three generations before photographic albums are donated to museums or archives, and this also seems to hold for these albums. The majority of the fifteen albums included in the exhibition *Playing with Pictures* came to museum collections in the second half of the twentieth century. The Gough album was, for example, donated to the Victoria and Albert Museum by her niece in 1963. In the 1970s the Bouverie Album came to George Eastman House and three of Lady Filmer's albums were sold through Christie's or Sotheby's, whereby some ended up in museum collections. The Milles album was most probably acquired by the Gernsheim collection during the 1940s or 1950s and it was rediscovered in the collection at the University of Texas in the 1970s.[96] The known album collages are today kept in art museums and museums dedicated to design or photography while some are still in private collections. In some collections they are still difficult to locate, as collages or montages – whichever classification one wishes to use. Searching the collection at the Victoria and Albert Museum for photocollage or photomontage, for example, gives few hits on nineteenth-century material. The Gough album appears, but no other album in the collection and none of the carte-de-visite photocollages, some of which have been presented in this chapter. Indeed, it appears that the best-documented and best-kept albums can be found in royal collections, which have not been governed by collection policies for a certain image technique, image community, or period as is the case with so many museums and archives.

When one considers the photocollages in albums and carte-de-visites in a broader, contemporary context of visual production it is clear that they were not isolated, individual examples but rather different instances of a widespread visual culture of cutting and pasting, of appropriation and reproduction. Besides the fact that many of these album collages are the product of meticulous work and a considerable artistic talent they differ in

one respect from the mass-produced carte-de-visites and printed illustrations they are related to. These combinations of photographic material, paper clippings, pencil drawings and watercolours were a way of personalizing current events, models or images through inserting photographs of the album maker themselves, their friends and family. Thus, the photocollage of the Victorian album can be said to be a way of both personalizing and animating the visual contents of mass-produced images in printed magazines and carte-de-visite cards. As such these photocollages are not only photocollage *avant la lettre* but also social media *avant la lettre*.

Notes

1 A. Dahlgren, *Fotografiska drömmar och digitala illusioner. Bruket av bearbetade fotografier i svensk dagspress, reklam, propaganda och konst under 1990-talet* (Stehag: Brutus Östlings förlag Symposion, 2005).
2 *Aftonbladet* (22 September 1998), p. 11.
3 R. Hausmann, 'Photomontage', in David Evans (ed.), *Appropriation* (Cambridge, Mass.: The MIT Press, 2009), p. 29 [originally published in the journal *a bis z*, May 1931].
4 See below, in pp. 32–35.
5 D. Ades, *Photomontage* (New York: Pantheon Books, 1986 [1976]), pp. 19–20.
6 R. A. Sobieszek, 'Composite Imagery and the Origins of Photomontage. Part I. The Naturalistic Strain', *Artforum* (September 1978), p.59. (Photomontage is the fabrication of a composite but single image made up of a number of distinct photographic parts.); J. Turner (ed.), *The Dictionary of Art*, 34 vols (London: Macmillan Publishers, 1996), vol. 7, pp. 557–558 and volume 24, pp. 685–686; G. W. R. Ward, *The Grove Encyclopedia of Materials and Techniques in Art* (Oxford: Oxford University Press, 2008), pp. 111–112, 498–500; J. Hannavy (ed.), *Encyclopedia of Nineteenth Century Photography*, 2 vols (London: Routledge, 2008), vol. 2, pp. 1,123–1,124.
7 Ades, *Photomontage*, pp. 15–17.
8 Sobieszek, 'Part I. The Naturalistic Strain', pp. 58–65; R. A. Sobieszek, 'Composite Imagery and the Origins of Photomontage. Part II. The Formalist Strain', *Artforum* (October 1978), pp. 40–45. See also Turner, *The Dictionary of Art*, vol. 24, p. 685.
9 A. Te Heesen, *The Newspaper Clipping. A Modern Paper Object* (Manchester: Manchester University Press, 2014), pp. 22–28.
10 Te Heesen, *The Newpaper Clipping*, p. 7.
11 E. A. McCauley, *Industrial Madness. Commercial Photography in Paris 1848–1871* (New Haven and London: Yale University Press, 1994), p. 97.
12 J. Sagne, 'Composite cartes', in Michel Frizot (ed.), *A New History of Photography* (Cologne: Könemann, 1998), p. 112.
13 Disdéri writes: '2 ou 3 personnages jusqu'à mille pour le même prix qu'on paie aujourd'hui la carte d'un seul personnage'. See Sobieszek, 'Part II. The Formalist Strain', p. 44. See also E. A. McCauley, *A. A. E. Disdéri and the Carte-de-visite Portrait Photograph* (New Haven and London: Yale University Press, 1985), p. 94.

14 For examples see C. C. McPhee and N. M. Orenstein, *Infinite Jest. Caricature and Satire from Leonardo to Levine* (New Haven: Yale University Press/Metropolitan Museum of Art, 2011), pp. 24, 29, 31–38.

15 Sobieszek, 'Part II. The Formalist Strain', p. 40; W. H. F. Talbot, *The Pencil of Nature* (London: 1844–46), plate XI.

16 P. Di Bello, *Women's Albums and Photography in Victorian England. Ladies, Mothers, Flirts* (Aldershot: Ashgate, 2007); E. Siegel (ed.), *Playing with Pictures. The Art of Victorian Photocollage* (Chicago: The Art Institute of Chicago, 2010).

17 For examples see H. K. Henisch and B. A. Henisch, *The Photographic Experience 1839–1914. Images and Attitudes* (University Park, Pa.: The Pennsylvania State University Press, 1994), pp. 290–292 and 355–359 and the collections of the Library of Congress, Washington D.C., the National Portrait Gallery, London, and the Victoria and Albert Museum, London.

18 Ward, *The Grove Encyclopedia*, p. 111; Turner, *The Dictionary of Art*, vol. 7, p. 557.

19 M. Frizot (ed.), *A New History of Photography* (Köln: Könemann, 1998) comprises of 776 pages in A4 format. It covers Disdéri's Mosaic Cartes (p. 112), photomontages of the Paris Commune (p. 146), Combination printing by Rejlander and Robinson (pp. 188–191), and Dada and their followers (pp. 431–455).

20 Some of the points referred to in the following appear in both editions, while some do not. I therefore cite both editions where applicable.

21 Ades, *Photomontage*, 1986, p. 159; Ades, *Photomontage*, 1976, p. 23.

22 Ades, *Photomontage*, 1986, pp. 12 and 23; Ades, *Photomontage*, 1976, p. 7.

23 Ades, *Photomontage*, 1986, p. 23.

24 Ades, *Photomontage*, 1986, pp. 141 and 159; Ades, *Photomontage*, 1976, pp. 21–23.

25 Ades, *Photomontage*, 1986, pp. 63–64 and Ades, *Photomontage*, 1976, p. 15 which refers to R. Hausmann, *Courrier Dada* (Paris: Le TerrainVague, 1958), p. 42.

26 Ades, *Photomontage*, 1986, p. 107.

27 Sobieszek, 'Part I. The Naturalistic Strain', pp. 58–65; Sobieszek, 'Part II. The Formalist Strain', pp. 40–45.

28 Sobieszek, 'Part II. The Formalist Strain', p. 40.

29 Turner, *The Dictionary of Art*, volume 24, p. 685.

30 Sobieszek, 'Part II. The Formalist Strain', p. 40.

31 Sobieszek, 'Part II. The Formalist Strain', p. 44.

32 Sobieszek, 'Part I. The Naturalistic Strain', p. 65.

33 M. Warner, 'Parlour Made', *Creative Camera*, 315 (April/May 1992), 29–32; L. Roscoe Hartigan, 'The House That Collage Built', *American Art*, 7:3 (Summer 1993), 88–91.

34 Warner, 'Parlour Made', 32. Warner also points out the similarities between the collages of Kate E. Gough and the collage novels of surrealist Max Ernst (p. 30).

35 Di Bello, *Women's Albums and Photography in Victorian England*. Based on her PhD in Art History at the University of London, 2004; E. Siegel, 'Society cutups', in E. Siegel (ed.), *Playing with Pictures. The Art of Victorian Photocollage* (Chicago: The Art Institute of Chicago, 2010), p. 13.

36 Henisch and Henisch, *The Photographic Experience 1839–1914*, pp. 48–49, 155–159, 289–293 and 354–363.

37 M. F. Braive, *L'Age de la photographie. De Niépce à nos jours* (Bruxelles: Éditions de la Connaissance, 1965) [*The Era of the Photograph. A Social History*, 1966], pp. 178, 253, 258–259, 307. Braive also refers to surrealist photocollages from the beginning of the twentieth century ('long before Surrealism was born as a movement in 1924, the makers of photomontages for picture postcards were indulging in the wildest Surrealist fantasies'), p. 302.

38 D. S. Banash, 'From Advertising to the Avant-Garde. Rethinking the Invention of Collage', *Postmodern Culture*, 14:2 (January 2004), unpaginated.

39 Banash, 'From Advertising to the Avant-Garde', unpaginated.

40 Te Heesen, *The Newspaper Clipping*.

41 E. Siegel, 'Society cutups', in Siegel, *Playing with Pictures*, pp. 27–31.

42 A. Prager, 'The Artists Amuse Themselves. Victorian Painters and *Punch*', *Notes in the History of Art*, 1:3 (1982), 25–27; J. Maas, *The Victorian Art World in Photographs* (London: Barrie & Jenkins, 1984), p. 133.

43 J. McMaster, '"That Mighty Art of Black-and-White". Linley Sambourne, *Punch* and the Royal Academy', *British Art Journal*, 9:2 (2008), 62–64.

44 For example 'An anxious moment' by Briton Riviere, 1878, was cartooned the same year by *Punch*, where the geese were the members of the Royal Academy; William Salter's *The Waterloo Banquet* and Sambourne's cartoon, *Royal Academy Banquet at Burlington House*, 7 May 1881 and drawn caricatures of James Clarke Hook based on his photograhic portraits appeared in *Punch* 1882, 1883, 1884 and 1886. McMaster, 'That Mighty Art of Black-and-White', 68–72.

45 McMaster, 'That Mighty Art of Black-and-White', 75–76.

46 D. Pellerin and B. May, *The Poor Man's Picture Gallery. Stereoscopy Versus Paintings in the Victorian Era* (London: London Stereoscopic Company, 2014), pp. 156–178.

47 Examples of these carte-de-visites can be found in the collection of the Victoria and Albert museum in London (X290D) and in the collection of the author.

48 Prager, 'The Artists Amuse Themselves', 28; L. Carroll, *Alice's Adventures in Wonderland*. With forty-two illustrations by John Tenniel (London: Macmillan & Co., 1866 [1865]).

49 L. Carroll, 'Photography extraordinary', in Vicki Goldberg (ed.), *Photography in Print. Writings from 1816 to the Present* (Albuquerque: University of New Mexico Press, 1981), pp. 115–118.

50 C. Bede, *Photographic Pleasures. Popularly Portrayed with Pen and Pencil* (London: Thomas McLean, 1855).

51 Hannavy, *Encyclopedia of Nineteenth-Century Photography*, vol. 1, pp. 133–134.

52 Hannavy, *Encyclopedia of Nineteenth-Century Photography*, vol. 1, pp. 272–273 (Etienne Carjat); vol. 2, pp. 971–974 (Nadar) and pp. 1,400–1,402 (Adrien Tournachon). McCauley, *Industrial Madness*, pp. 115–148.

53 M. H. Spielmann, *The History of Punch* (London: Cassel and Company, 1895), p. 48.

54 Hannavy, *Encyclopedia of Nineteenth-Century Photography*, vol. 1, p. 55.

55 Ades, *Photomontage*, 1986, p. 9; Ades, *Photomontage*, 1976, p. 89; Sobieszek, 'Part I. The Naturalistic Strain', p. 61.

56 R. Hassner, *Bilder för miljoner. Bildtryck och massframställda bilder från de första blockböckerna, oljetrycken och fotografierna till den moderna pressens nyhetsbilder*

och fotoreportage (Stockholm: Sveriges radio, 1977), p. 165; Henisch and Henisch, *The Photographic Experience 1839–1914*, pp. 85–88.

57 For examples see Victoria and Albert Museum, X16 Vol. 3 (Ministère de 1872, 1874, 1875); X14 Vol. 1 (Gladstone Cabinet, av William Luks); X14 Vol. 1 (H. J. Whitlock, Photo Birmingham). The latter photograph depicts J. F Barnett (1837–1916), W. G. Cusins (musician and composer, 1833–93), D. Bennett (1816–75), Teresa Titiens (singer, 1834–77), Sir Julius Benedict (1804–85), Madame Patey (1844–94), Simpson (organist), M. Sainton (d. 1885), Christina Nilsson (singer, 1843–1921), Sir M. Costa (1810–84), Madame Lemmens Sherrington (1834–1906), W. H. Cummings (singer and organist, 1831–1915), Charlotte H. Sainton Dolby (singer, 1821–85), Charles Santley (1834–1922), J. Sims Reeves (1822–1900) and W. H. Weiss (1820–67).

58 For examples see Siegel, *Playing with Pictures*, pp. 64–73 and 78–79; Roscoe Hartigan, 'The House That Collage Built', 88–91; di Bello, *Women's Albums and Photography in Victorian England*, pp. 107–137.

59 Di Bello, *Women's Albums and Photography in Victorian England*, pp. 131–134.

60 McPhee and Orenstein, *Infinite Jest*, pp. 57–59 and 70–75.

61 See for example *Punch* (25 June 1870), p. 257; *Punch* (23 April 1870), p. 167; *Punch* (7 January 1865), p. 13; *Punch* (4 February 1860), p. 49; *Punch* (19 June 1880), p. 280; *Punch* (20 November 1880), p. 230; *Punch* (19 June 1880), p. 279; *Punch* (21 February 1880), p. 79; *Punch* (19 March 1870), p. 107; *Punch* (11 January 1862), p. 15; Punch (16 June 1860), p. 243; *Punch Almanack* 1868, unpaginated. See also E. Shefer, *Birds, Cages and Women in Victorian and Pre-Raphaelite Art* (New York: Peter Lang, 1990).

62 B. M. Hudak, 'Assembling Identity. The Photo-Collage album of Kate E. Gough (1856–1948', Master's thesis, University of Cincinnati, 2004, pp. 7 and 48.

63 M. Hofeldt, 'The Gough Album', in Siegel, *Playing with Pictures*, p. 186.

64 *Punch* (30 June 1883), p. 307; Spielmann, *The History of Punch*, p. 207.

65 *Punch* (8 July 1876), p. 7.

66 Ades, *Photomontage*, 1986, p. 136.

67 Siegel, 'Society cutups', pp. 30–31; H. C. Andersen, *Fairy Tales* (London: Sampson Low, Marston, Low and Searle, 1872).

68 Copies of the photographs are today held in the National Gallery of Scotland among others. https://art.nationalgalleries.org/art-and-artists/63179

69 A. H. Barr (ed.), *Fantastic Art Dada Surrealism* (New York: Museum of Modern Art, 1936), pp. 65–66. The list was originally published as part of 'A Brief Guide to the Exhibition of Fantastic Art, Dada, Surrealism', January 1937.

70 Siegel, 'Society cutups', p. 13.

71 See for example 'Animation of the inanimate', in *Punch* (25 August 1860), p. 74; *Punch* (25 March 1865), p. 115; *Punch Almanack* 1851, pp. 1–6; *Punch Almanack* 1877, unpaginated.

72 Henisch and Henisch, *The Photographic Experience 1839–1914*, p. 356; J. Laver, *Manners and Morals in the Age of Optimism* (New York: Harper & Row, 1966), p. 61. Neither of these, however, reproduce the alleged image and my efforts to find it in other publications, archives or museum collections have been without luck.

73 Henisch and Henisch, *The Photographic Experience 1839–1914*, pp. 357–359.

74 B. H. D. Buchloh, 'From Faktura to factography', in R. Bolton (ed.), *The Contest of Meaning. Critical Histories of Photography* (Cambridge, Mass.: The MIT Press, 1993), p. 61.

75 Warner, 'Parlour Made', 32; Di Bello, *Women's Albums and Photography in Victorian England*, p. 156.

76 Siegel, 'Society cutups', p. 28.

77 Hudak, 'Assembling Identity', pp. 7 and 52–53. This is a master's thesis in art history. However, it is the most thorough study of the Gough album to my knowledge.

78 See for example Siegel, 'Society cutups', , pp. 23, 26, 32; Hofeldt, 'The Bouverie Album', in Siegel, *Playing with Pictures*, p. 189, and 'The Gough Album', p. 186.

79 J. Green-Lewis, 'Playing with Pictures. The Art of Victorian Photocollage', *Victorian Studies*, 53:2 (Winter 2011), 384; P. Plagens, 'Cut Me Up, Paste Me Down', *Art in America*, 98:4 (April 2010), 42.

80 Henisch and Henisch, *The Photographic Experience 1839–1914* ('they made contemporary viewers smile or shake their head, but left no lasting impression'), p. 358.

81 See for example B. Newhall, *The History of Photography* (New York: Museum of Modern Art, 2006 [1937, 1982]); Frizot, *A New History of Photography*; M. Warner Marian, *Photography. A Cultural History* (London: Laurence King, 2002); L. Wells (ed.), *Photography. A Critical Introduction*, 5th edition (London: Routledge, 2015 [1996]); Hannavy, *Encyclopedia of Nineteenth-Century Photography*, vol. 2, pp. 1,123–1,124; H. Gernsheim and A. Gernsheim, *The History of Photography. From the Earliest Use of the Camera Obscura in the Eleventh Century up to 1914* (London: Oxford University Press, 1955).

82 M. Langford, *Suspended Conversations. The Afterlife of Memory in Photographic Albums* (Montreal & Kingston: McGill-Queen's University Press, 2001), pp. 7–8.

83 Siegel, *Playing with Pictures*, p. 185. See for example Charles Dickens, *The Life and Adventures of Martin Chuzzlewit* (London: Chapman & Hall, 1844); Lewis Carroll, *The Hunting of the Snark* (London: Macmillan Publishers, 1876).

84 *Punch Almanack* 1854, unpaginated.

85 *Punch* (11 February 1865), 'Our play box'. A similar motif could be found in *Punch* (5 August 1876), p. 47.

86 For example, from seven different albums see Siegel, *Playing with Pictures*, pp. 74–77; See also Carroll, *Alice's Adventures in Wonderland*, p. 113; A. McQueen, *Empress Eugénie and the Arts. Politics and Visual Culture in the Nineteenth Century* (Farnham: Ashgate, 2011), p. 286 (Princess Eugénie of France); André Gill, Marie Sass, 1867 (http://catalogue.bnf.fr/ark:/12148/cb39627084m).

87 J. Habermas, *The Structural Transformation of the Public Sphere. An Inquiry into a Category of Bourgeois Society* (Cambridge: Polity Press, 1989), p. 50. Original title *Strukturwandel der Öffentlichkeit. Untersuchungen zu einer Kategorie der bürgerlichen Gesellschaft* (Neuwied, Berlin: Luchterhand, 1962).

88 Siegel, *Playing with Pictures*, pp. 175–199.

89 Ades, *Photomontage*, 1986, s. 13 and Ades, *Photomontage*, 1976, p. 8; W. Benjamin, 'Art in the age of mechanical reproduction', in H. Arendt (ed.), *Illuminations* (New York: Schocken Books, 1969), pp. 16–17.

90 Sobieszek, 'Part I. The Naturalistic Strain', p. 63.

91 D. Crimp, 'Pictures', *October*, 8 (Spring 1979), 87.

92 A. Scharf, *Art and Photography* (Harmondsworth: Penguin, 1975 [1968]), p. 109.

93 A seminal example of this modernist notion of what photography is can be seen in J. Szarkowski, *The Photographer's Eye* (New York: Museum of Modern Art, 1966).

94 See for example photo historical reference works such as Frizot, *A New History of Photography*; Warner Marian, *Photography*; Wells, *Photography*. This also holds for classics like Gernsheim and Gernsheim, *The History of Photography* and Newhall, *The History of Photography*.

95 S. Jülich, P. Lundell and P. Snickars (eds), *Mediernas kulturhistoria* (Stockholm: Mediehistoriskt arkiv, 2009); A. Ekström, S. Jülich and P. Snickars (eds), *1897. Mediehistorier kring Stockholmsutställningen* (Stockholm: Mediehistoriskt arkiv, 2005).

96 Siegel, *Playing with Pictures*, pp. 175–199.

2 Modernism in the streets

In 1930 Frederick Kiesler's book *Contemporary Art Applied to the Store and its Display* was published in the USA. The author had originally trained as an architect in Austria before moving to the United States in 1928 where he started to work as a window decorator for Saks department store. Throughout his subsequent career he simultaneously created architectural projects, exhibitions, theatre sets, furniture, and store windows and wrote on art and design.[1] According to Kiesler the department store 'was the true introducer of modernism to the public at large'.[2] The same year that Kiesler's book was published a paradigmatic exhibition on architecture, art and design was held in Stockholm which introduced functionalistic architecture and modernist art and design. Indeed, the Stockholm Exhibition of 1930 may be seen as a brilliant illustration of Kiesler's thesis.

Modernist design in window displays was not unique to Sweden around 1930. However the Swedish case is interesting as the Swedish art field was simultaneously relatively sceptical to modernist art and its introduction and general acceptance came late to the country.[3] The modernist window display was in this particular case the introducer of modernist art to the public at large, as Kiesler had predicted, its acceptance first occurring in everyday visual culture rather than in the traditional outlets of the art field, such as galleries and museums in Sweden. Thus the present close study of commercial visual culture in early 1930s Sweden and the Stockholm Exhibition brings new perspectives to the understanding of the introduction of modernism in Sweden and, by extension, to the construction of an art historical narrative.

In the late 1920s and early 1930s modernist art influenced the theories and practices of commercial window display, as may be discerned in professional journals, handbooks and the shop windows themselves. Apparently, the window display was a site where art and vernacular visual culture merged. The modernistic aesthetic migrated from one arena to another. In the vernacular, commercial context the features, form and colour inspired by contemporary modernistic painting and sculpture were

Window display for Saks, New York, 1928 by Frederick Kiesler. **2.1**

given different explanations and new functions. Moreover, its reception was completely different when taken out of the artistic frame, literally speaking. The shop window became the main vehicle for introducing a modernist aesthetic to Sweden as it literally brought modernism to the man in the street.

The majority of the scholarly studies on window display have adopted a cultural or social historical perspective. Accordingly, relatively few studies have hitherto taken aesthetics as the main subject. Even though the look of the windows is in some cases discussed by these writers, their main focus is on their function as commercial messages that reveal prevailing cultural concepts of shopping, selling and consumption. The shop window as an aesthetic phenomenon, and its relation to art, are not given much attention.[4] In this context art historian Charlotte Klonk is an exception, having written on the formal similarities between displays of art and displays of goods in

early twentieth-century Germany.[5] She points out that the change in display design that occurred simultaneously in the art galleries and in street windows not only concerned a change in appearance but also implied different ideas about perception. Art displays and window displays changed, from appealing to a sensual and emotional sophistication, to offering arguments to the rational mind. Klonk argues that the rational display strategies in art and commerce were short-lived and not used on a large scale in Germany or anywhere else. However, a contemporary British handbook *The Art of Window Display* (1931) explains that modernism in display aesthetics could be found not only in Germany but also in Russia, Austria and France, which might be a reason for revising this.[6] Also, Kiesler's book presents visual examples of modernist displays from London, Basel and New York in addition to the German ones.[7] Sweden also proves to be an exception, as a country where modernism had a strong influence in marketing through display, and where functionalistic ideas permeated the display trade in the 1930s and led to significant changes in marketing strategies in general as well as display practices and aesthetics.

Modern marketing and modernist displays

The late 1920s was a dynamic period in marketing in Sweden, characterized by a greater professionalism attuned to the science and rationality of marketing. Several professional associations were established and the publication of journals and handbooks on window display flourished.[8] The first professonal journal on display appeared in 1920 but between 1932 and 1936 no fewer than five journals were lauched in Sweden; and in 1932 a specialist school for decorators was opened in Stockholm by Oscar Lundqvist, former head of decoration at the department store Nordiska Kompaniet (NK).[9]

At the same time that new aesthetic ideals were being established a new discourse within marketing and display strategies evolved. It was felt that the modern window display should not only be a visually pleasing arrangement but also promote sales: 'it should gain the customer's attention, evoke a desire to buy and finally induce a purchase' as a correspondence course tutorial put it in 1934.[10] The modern marketing strategy was characterized by an instrumental function and a window display should act as a printed advert or a choice of packaging influence customer behaviour.[11]

Many of the leading marketers in Sweden were educated in, and drew inspiration from, the United States, where new ideas about commercial production, business, marketing and consumer behaviour were evolving in the early twentieth century. As modern ideas on marketing spread there was simultaneously a paradigm shift in display aesthetics. The aesthetic impulses came from constructivism via the influential Bauhaus school in

Germany and were also strongly coloured by functionalism. Consequently, Swedish window decorators combined ideas from modern American marketing theory with the ideas and aesthetics of constructivism, functionalism and *Die neue Sachlichkeit*. Truth became a core value in the 1920s and, particularly in the 1930s, marketing and advertising were presented by the business as providing useful information and as a true advantage to society.[12] In this sense, the window display that actually contained real products became the ideal marketing channel. 'The window display can speak to the general public in a much stronger way than the most excellent drawing or photograph, because it shows the commodity itself', wrote Harald Rosenberg, the head of advertising at the department store MEA in Stockholm in 1930.[13] The window display was the most honest advertising medium, placing real objects behind glass. The size, colour and shape of the products would be presented exactly as they were, as no transformations in appearance by retouching, cropping or choice of angle were possible. The fashionable light colours and absence of distracting decoration were, of course, a part of the same ideal, and would add to the rationality of the display.

From an aesthetic perspective the window display was also 'a paragon of modern visual communication', as pointed out by Barnaby Haran. Accordingly, the window display emerged as 'one of a plethora of planes and screens that represented a new understanding of space, including glass department stores, television, virtual museums, and the cinema screen'.[14] During the first decades of the twentieth century interest in, and knowledge about, how this ideal marketing tool functioned increased, which coincided with the evolution of a modern marketing theory based on scientific principles and rules.[15] The window display was not supposed to be 'a work of art, but rather it should create a desire to buy'.[16] Interest in how the window attracted customers grew, as did interest in communicating differently with different target groups. Seen as a means of communication, as a medium, the window display became part of a complete array of marketing actions that could be consciously combined in different ways.

A radical aesthetic shift

To grasp the radical shift in the aesthetics of the window display it is necessary to return to previous decades. Window displays, in other words, windows that differ in size from other windows in the street, became common in Sweden and other European countries in the last decades of the nineteenth century. Before that time, shop windows were designed just like ordinary windows and their main purpose was to bring light into the shop. The introduction of electric light made the window less important as a provider of light and opened up the possibility of filling the window with goods.[17] Window

2.2 Premodernist window display in the shape of a fan.

display as a trade had been professionalized in Germany and the United States around 1900,[18] but arrived in Sweden and other countries in Europe somewhat later, in the 1920s and 1930s.[19] A seminal driving force behind this development was the establishment of large department stores with elaborate displays. Another reason was the increase in mass-produced branded goods, which made window decoration an important means of gaining competitive advantage for the shop owner.[20]

Until the 1930s shop windows were characterized by abundance. Just as the world fairs, museums and art gallery walls of the late nineteenth century would be filled with objects and pictures from floor to ceiling, the shop owner filled the window from top to bottom. Decoration and realism were the key words. Decoration involved large quantities of goods of different shapes arranged in intricate patterns, decorated with ribbons and draped with fabrics. These windows were commonly arranged with a central focal point, for example, in the form of a fan or a pyramid. The basic structure of such arrangements was often organic.[21] The goods were, for example, arranged as a winding flower stem or a tree with a solid trunk and spreading branches. The massing of goods was strikingly effective when it came to

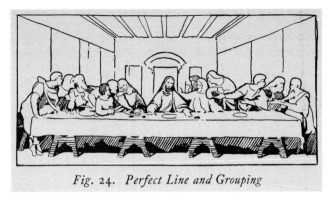

Fig. 24. Perfect Line and Grouping

The perfect line and grouping, from the handbook *The Art of Window Display*, 1931. **2.3**

exposing the range of commodities. Such displays have been termed 'diction-ary' or 'educational' windows.[22] The aim of this window was obviously to show the broad assortment of products on sale, telling the customer: This is what this shop can offer! On a more profound level, these mass arrangements conveyed the 'possibilities of abundance in modern society and … consistency in mass production'.[23]

Realism was another dominant trait of the early shop windows. The tradition of 'open windows' or 'picture windows', where fewer goods were arranged like a tableau, had its origin in new ideas about shopping that were established in the United States and Europe at the end of the nineteenth century. The tableau-like shop window drew upon the visual culture of this period and was closely connected to the evolving culture of the department store. Here customers were encouraged to stroll around; looking entailed no obligation to buy anything, and the idea of 'shopping as a leisure activity', as an amusement and a pastime, emerged.[24]

The aspiration for realism could take different forms. First, goods could be arranged to recreate objects or phenomena, a ship constructed of napkins or a waterfall made of light voile, for example.[25] Some cases were even more ambitious, with goods, props, mannequins and even stuffed animals arranged in front of painted background to form a *tableau vivant*.[26] Such *tableaux vivants* or *tableaux réalistes* are clearly related to nineteenth-century visual culture where such displays were common in museums, the popular wax cabinets, dioramas and panoramas.[27] Windows were visual attractions, and customers would linger to admire them. The basic ideas behind such arrange-ments were highlighted in the professional literature. Ideally, the commodities would be arranged in a narrative that clearly conveyed their function and value, a story that told the passing consumer how, why and by whom the

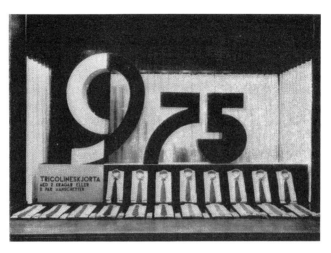

2.4 Modernist window display, MEA department store in Stockholm, 1932.

product was going to be consumed. Indeed, 'the life of the commodity' was to be displayed, as put forward in professional journals and handbooks in the early 1920s.[28]

From having been characterized by decoration and realism, the aesthetic of window display took a completely different path around 1930. Moreover, the overall architectural aesthetics altered as the window display grew from a small-scale show to expansive walls of glass along the streets in the new functionalistic buildings.[29] Truth and function were core values. Accordingly, contemporary professional literature characterized the ideal window with adjectives like 'objective', 'clear', 'reliable' and 'foreseeable'.[30] Mere decorations, albeit beautiful, which rather 'led the eyes from the commodity than to it', were banned. The goods, and the goods alone, should take centre-stage in the display according to the new ideals.[31]

The inspiration came from functionalism. In architecture functionalism meant that form was the effect of function. Forms should be simple and few, and surfaces smooth. Industrial production and the machine-made form were the ideal. In the shop window functionalism influenced the assortment of goods on display and how the selected items were arranged.[32] Colours were pale and limited, the number of elements reduced; the arrangements were linear and the props abstract. Every detail in the window was to have a clear function; there was no room for decorations. As one decorator put it: 'The commodity should be shown clean and simple and speak for itself.' The same writer recommends that one should specialize in one type of commodity and not mix different types of goods in the same window.[33]

While simplicity and repetition are among the basic features of classic rhetorical theory, with the inspiration from modernist art these traits were also given a clear visual, aesthetic expression. For the trade this implied that several identical goods should be on display, typically arranged in straight lines, placed in front of a light and monochrome background. Occasionally, the windows contained some props, but they were stylized and abstracted rather than realistic. This could, for example, include schematic, abstracted human figures made of board. In general, boards with smooth surfaces were the dominant material while organic material like cloth, flowers and life-like wax mannequins, that had been popular in earlier displays, was completely absent.

The marketing value of modernism

The idea that window decoration was an art form was not new in 1930. Several handbooks on window display touched upon this in their titles; they used classical examples of visual art as inspiration for displays, and referred to the decorator as an 'artist'.[34] While these contained references to classical art in general, and sometimes to applied art rather than visual art, the reference for the modernist window display was clearly contemporary modernist painting and sculpture. The modernist aesthetic was considered to be a selling tool, not just a visually pleasing decoration. Thus the use of few, large, simple forms and bright colours was not only seen as aesthetic style or form. In the process of adaption from art to display window this aesthetic was given a certain instrumental, marketing value. Indeed, contemporary marketers emphasized the importance of utility in modernist aesthetics. It would be a sorry state of affairs, the Swedish specialist in window decoration Harald Rosenberg pointed out, if modernity consisted only of a number or 'circles, squares, cubes, parallelepipeds and sectors of circles … without any function what so ever'.[35] Accordingly, the modernist aesthetic alone was not enough. To be of value for marketers it had to be used correctly and have selling power.

While professional papers and handbooks on display at that time were permeated with functionalistic rhetoric, the display designs themselves were clearly also influenced by art styles such as cubism, futurism and constructivism, with their repetition of forms, reduction, abstraction and use of geometrical shapes. This inspiration, evident in the designs themselves, was also spelled out in the professional literature of the early 1930s. Kiesler refers to a number of artists, artistic schools and different material expressions. His book includes examples of modern paintings, sculptures, architecture, interior and furniture design, crafts and stage design for theatres and cinemas by artists like Pablo Picasso, Constantin Brâncuşi, Gabo, Mies van der Rohe, Kazimir Malevitsch, J. J. P. Oud and Fernard Léger. In particular, he

emphasized the elementarism of the De Stijl group and artists like Piet Mondrian and Theo van Doesburg.[36] Of the contemporary art styles, cubism is mentioned as especially valuable in advertising as it 'displays the beauty even in products like steel and tinplate', as an anonymous Swedish writer put it. While shop windows until recently were characterized by 'the overwhelming splendour of distinguished castles,' he continues, 'today's windows mostly remind us of the first cubists' delight in colour'.[37] In the shop window, reduction referred to the absolute number of objects as well as the diversity of commodities. 'No one but a pawnbroker can afford to have his windows look like a Noah's ark', declared Herbert Casson in a British handbook on window display.[38] Instead of displaying one example of each product, the shop owner was encouraged to limit the quantity and diversity of goods. Concentration was an absolute essential in a modern age described as a time of hurry: 'The shorter the form of the selling argument, without losing clarity, the easier it is conveyed to the viewer.'[39] Furthermore, the commodities had to be arranged either in straight lines or geometrical shapes, such as circles, rectangles or triangles. 'The pattern of the goods must appear straight and clear, which can only be obtained by putting the cans and packs in regular columns, semicircles or straight lines.'[40]

While artists produced synthetic cubism by combining painted or found forms to construct images, the window designer used packaging for the same end. Frederick Kiesler described the window decorator as an artist who 'paints the picture for the public. His canvas is space, his pigments merchandise and decoration, his brushes light and shade.'[41] The result would

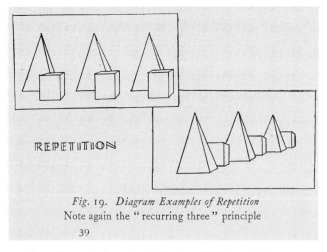

Fig. 19. *Diagram Examples of Repetition*
Note again the " recurring three " principle
39

2.5 Repetition and form, from the handbook *The Art of Window Display*, 1931.

be rectangular cartons, circular tins and square packs arranged in straight lines along with painted forms and text. While the bold lines and strong colours were eye-catching as a modernistic form from a distance, they also worked at short range.[42] In other words, these modernist display designs worked on two levels, from close up as a display of particular goods and from far away as an appealing modernist form. From a distance the arrangements had the same basic structure and outline as artworks by constructivists like Vladimir Tatlin and El Lissitzky. Accordingly, they would catch the city dweller's eye from a great distance and also reward them when they approached the windows to see the details, the products.

According to display managers and marketers, goods arranged in fixed rows making up geometrical figures stayed better in one's memory. They could give the viewer a 'permanent impression' and therefore be more easily remembered than an irregular composition.[43] The idea that visual perception is based on finding and identifying basic figures echoes the fundamentals of gestalt psychology, which was highly esteemed in the first decades of the twentieth century. Among psychologists and art historians it was commonly held that elementary forms and colours could cause emotional effects in the viewer. This would eventually also appeal to marketers, and furthermore visual repetition in the commercial context was considered an important means for reminding the passing consumer of the brand and the product. A product remembered would evidently sell more than one not remembered. The marketers' understanding of modernist aesthetics as sale-enhancing patterns is a clear example of an implied relation between graphic and mental images using the terminology by W. J. T. Mitchell.[44]

Another source of inspiration for the window decorators came from the artworks of futurism and its occupation with urban industrial production, machines, speed, rhythm and movement. The catalogue for the *Machine Art* exhibition at MOMA in 1934 pinpoints the aesthetic ideal: 'The beauty of the machine art depends often upon rhythmical as well as upon geometrical elements – upon repetition as well as upon shape.' The *Machine Art* exhibition contained industrially produced everyday goods and displayed rows of identical screw nuts, cylinders, glassware and cutlery arranged in a Bauhaus-inspired environment.[45] In window displays futurism was translated into a preference for long lines of identical products or packages, an arrangement that took on the appearance of a production line in a factory. This aesthetic, characterized by long straight lines of identical objects, also occurred in advertising and industrial photography of the time and was termed 'Tiller Girl photography'.[46] The Tiller Girls were a British dance troupe whose members were exactly the same height and size, wore identical costumes, and performed with minutely coordinated movements and seemingly mechanical precision.

As rows of identical commodities resemble goods on an assembly line they can also be related to production processes. Accordingly, this aesthetic can be linked to the contemporary economic system and the idea of modern, rational management, as pointed out by Siegfried Kracauer. In an essay originally published in 1927 he discussed this in terms of mass ornament and concludes that: 'The mass ornament is the aesthetic reflex of the rationality to which the prevailing economic system aspires.'[47]

In futurist paintings the repetition of forms was a means of representing movement. Inspired by the chronophotography of Eadweard Muybridge and others, artists like Giacomo Balla explored the successive displacement of forms in an object in flux.

This interest in speed and movement was not only apparent in the look of the displays, but could also be discerned in the new ideas about the relation between the viewer and window. To attract the consumer's attention the message had to be concentrated and well thought out. The movement of the beholder was another new topic discussed in marketing literature in the 1930s, and readers were reminded that the design of the display should be arranged according to the movement patterns in the street.[48] In other words, movement was considered a factor in perception. Repetition of form was eye-catching, which was considered necessary in this modern age when people were moving faster and faster in the city, as one writer states: 'Nowadays something completely different is needed to catch the gaze of the people passing the window compared to just a few decades ago. Everything has a different tempo now. We do not live in a time of tranquil narrative, everything is communicated at film tempo, quickly, to be forgotten and followed by new impressions. When exposing goods one has to follow the pace of the time.'[49] As pointed out by Martin Jay, there exist different visual regimes, different patterns of visualizing, that imply different patterns of viewing. The kind of display design that came in to vogue in the 1930s, with rows of objects, has no central focal point and thus does not presuppose one fixed ideal viewpoint, unlike earlier displays. Using the terminology of Jay's theses modern displays do not follow Cartesian perspectivalism, where visual perception is based on a model with a static, unblinking, singular and fixated eye.[50] Instead, they imply several possible viewpoints and also a moving beholder. Consequently, the imaginary beholder could stop anywhere in front of the shop window. This type of design acknowledges different viewpoints, different gazes and, therefore, different consumer groups. The question of attention was also a matter of distance. The simplicity in overall structure and repetition of forms in the modernist aesthetic meant that the display could be apprehended from both short and long distances. This aesthetic thereby targeted not only the audience walking on the pavement but also viewers who passed by in cars and buses, at speed and at a greater distance.[51]

Exhibitions of art and the vernacular

A significant factor for interchange between modern art and modern marketing was the semi-open boundary between art and commercial or everyday visual culture that characterized several exhibitions in the first decades of the twentieth century. The period stands out in the sense that the art museums were very inclusive, exhibiting objects from outside the art market, and blurring the line between art and mass-produced commodities, and between the art gallery and the commercial store. This is evident, for example, in the exhibitions at the MOMA in New York. From 1934 onwards several exhibitions of everyday goods were mounted at the museum, for example *Machine Art* (1934) and the recurring *Useful Objects* (1938–47) and *Good Design* (1950–55) exhibitions. Here mass-produced goods were exhibited as modern artworks: decontextualized forms spaciously arranged against a neutral, single-colour background. The exhibited objects were accompanied by information on manufacturers and prices and the visitors were encouraged to touch and handle the exhibited objects as in a department store. However, the objects were not on sale at the museum but were made accessible to the audience at department stores collaborating with the museum.[52]

In the context of the merging of art and industrial production, the Deutscher Werkbund, founded in Germany in 1907, played an important role. This association of artists, architects, businessmen, writers and politicians aimed at a refinement of industrial production. The association had several successors in Europe and inspired many international exhibitions on handicraft, design and architecture during the following decades. One of the best-known is the *Exposition Internationale des Arts Décoratifs et Industriels Modernes* in Paris in 1925, where art, furniture, design and fashion were on display. Another influential exhibition was *Weissenhofsiedlung* in Stuttgart, arranged by the Deutscher Werkbund in 1927, which is considered to be the starting point for modern architecture and functionalism.[53]

The Stockholm Exhibition of 1930 was immensely influential and marked a breakthrough in functionalistic design and architecture.[54] Like some other exhibitions, it took a cross-boundary approach mixing the built environment and objects, and included architecture, furniture and handicraft as well as mass-produced household objects. In addition, however, commercial visual culture had a significant place in the exhibition. Graphic and commercial designs, in the form of printed advertisements, book designs, photographs and outdoor signs, were a key feature and the exhibition contained abundant examples of these, and also window displays.[55] The landmark of the exhibition was the so-called 'advertising mast' covered with lighted advertising signs.[56] The Stockholm Exhibition bonded commerce and functionalism and had an immediate effect outside the exhibition area, on the city of Stockholm.

Window displays at the Stockholm Exhibition 1930

The commercial, vernacular approach of the Stockholm Exhibition was highlighted from the start. Already in his inaugural talk in 1928 when the initiator and director of the exhibition, art historian Gregor Paulsson, presented the programme, he emphasized the commodity aspect by announcing that the exhibition should take the form of an ordinary retail space. The objects should not be displayed with 'museal solemnity' he argued but as far as possible like commodities in a shop.[57]

The exhibition area of the Stockholm Exhibition was constructed like a city street lined with exhibition halls described as 'stores of ideal design', which had large window displays facing this main street.[58] Window displays as such had been exhibited before, for example at the *Schaufensterschau* exhibition in Leipzig in 1929, but the exhibition in Stockholm in 1930 would include window display as a part of modern, functionalistic architecture, design and art in general. Accordingly, modern advertising was a completely integrated part, a constituent element of the exhibition.

Several catalogues and guides were produced in connection with the exhibition, but the window displays were a minor feature. In the main catalogue they were mentioned as a sub-category of advertising but the official illustrated brochure of the exhibition contained no images of the 'corso', or main street, and its window displays.[59] The sole publication on the exhibition that featured window displays – several, indeed – was the one on electric lighting. Although primarily focusing on the technical aspects of how the 'shops' and window displays had been lit, it did highlight the visual aspects. Photographic images of the displays for the department store Nordiska Kompaniet, the grocery store Konsum and camera producer Hasselblad appear in this publication as well as displays of books in the windows of the exhibition hall for graphic design.[60] Indeed, lighting played an important role in the modern project. It was a vital part of modern life and urban society as emphasized by contemporary artists, writers, architects and marketers alike.[61] Thus the Stockholm Exhibition included not only the technique of architecture as it were, but also aspects of the street space and commercial space.

Art Concret *exhibition*

One of the restaurants at the Stockholm Exhibition, the Park Restaurant, contained an exhibition of international post-cubist art. Held between 19 August and 30 September 1930, it was organized by the Swedish artist Otto G. Carlsund and included some of the most prominent contemporary artists, such as Hans Arp, Theo van Doesburg, Fernand Léger, László Moholy-Nagy

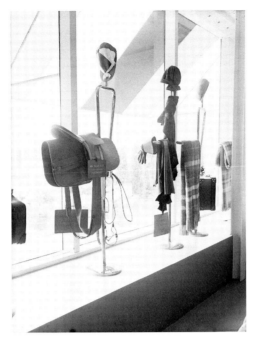

Window display at the Stockholm Exhibition 1930. **2.6**

and Piet Mondrian (plate 5).[62] Mondrian, Léger and Doesburg were among
the artists that Frederick Kiesler referred to in his book on window display.
For Carlsund the *Art Concret* exhibition at the Stockholm Exhibition was an
opportunity to introduce modern painting to a Swedish audience and he
argued that the venture was particularly suitable for the venue as the artwork
presented 'went hand in hand with the modern architecture'.[63] However, the
exhibition was a fiasco.[64] It was scorned by the majority of the critics in the
Swedish press and very few of the exhibited works were sold, which led to
personal bankruptcy for the initiator Carlsund.[65] The press mostly deemed
the artworks to be 'formless colour compositions', 'colour scribble' or 'mania',[66]
whereas the architecture in the exhibition was praised, for example, by the
critic of *Stockholms-Tidningen* who wrote: 'Functionalism is most probably
a revolution as regards architecture. Its counterpart in visual art however is
just an experiment among others' which would eventually 'take place 'in the
cabinet of curiosities of art history'.[67]

There were, however, some positive responses in the press and an interesting
theme is developed in one of them. The critic Karl Asplund at *Svenska
Dagbladet* found the paintings beautiful and praised their well-balanced
compositions and colouring. He also pointed out that the mural painting

HETER Tisdagen den 19 Augusti 1930

och en half minut efter det en scen inspe-
lats kan "provköra" talet från denna scen i
ett rum bredvid.

Jack Hylton, jazzdirigenten, som
var här i somras på China med sin orkester,
har blivit "Officier de l'instruction publique".
Jaja.

Teatrarna i dag.

Operan: Ingen föreställning.
Dramatiska teatern: "Ungkarlspappan".
Oscarsteatern: "Kära släkten".
Vasateatern: "Sympatiska Simon".
Blancheteatern: "Cocktails".
Folkteatern: "Krasch".
China: Revyn.
Utställningsteatern: "Funkisrevyn".
Tantolundens teater: "Söderkåkar".
Söders friluftsteater: "Skeppar Ömans
flammor".
Södermalms teater: "Stackars karlar".

*Biljetter till Rolf, Teatrar, Konserter,
Biografer och dylikt säljas i Dagens Ny-
heters kontor, Stureplan 13, Tel. 23 19,
N. 80 59, Hornsgat. 1, Tel. S. 149 60,
S:t Eriksplan 6 A, Tel. Vasa 147 33,
Hamngatan 7, Tel. 37 95.*

Sista gången.

Funkisvernissage.

Tavla, målad av fullvuxen.

Kl. 2 på tisdagen öppnas dörrarna till
parkrestaurangen för en nyfiken allmänhet,
som skall hugnas med målarkonstens sena-
ste landvinningar eller funkisutställningens
höga idéer omsatta i färgklutter. Det är
"Art-Concret"-gruppen som har sin första
svenska exposition. Vid ett hastigt besök
uppe i restaurangen mötes man av hängan-
de konstnärer och ett enda virrvarr av
konst. Virrvarret torde knappast i olikhet
mot andra banalare utställningar ej formas
om till något enhetligt och systematiskt, ty
att få rätsida på de alster som vilade sina
spartanska ramar mot kaféstolarna är väl
ändå inte möjligt.

Det är en grupp Pariskonstnärer förstärk-
ta med några svenska landsortsmålare och
ett par utlänningar som skola visa sina mo-
dernistiska framfötter. De indela sig själva
i icke mindre än sju olika riktningar, vilka
bära de konstfulländade namnen kubism,
post-kubism, purism, konstruktivism, neo-
plasticism, sur-realism och sur-impressio-
nism. Att skilja det ena från det andra över-
steg mastredaktörens förmåga, och eftersom
den som ingenting förstår inte bör yttra sig,
är det kanske bäst att sätta punkt. Och
konstatera att det finns många slags van-

2.7 'Painting made by an adult'. Painting by Gösta Adrian Nilsson (GAN) reviewed in
Dagens Nyheter, 1930.

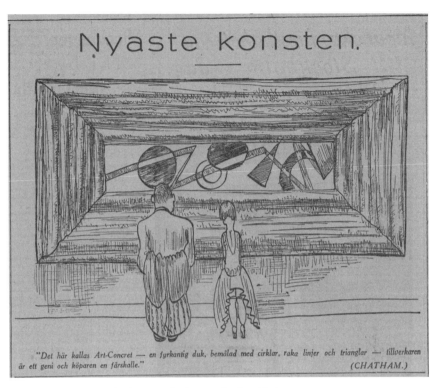

Nyaste konsten.

"*Det här kallas Art-Concret — en fyrkantig duk, bemålad med cirklar, raka linjer och trianglar — tillverkaren är ett geni och köparen en fårskalle.*"

(CHATHAM.)

'The artist is genius, the buyer a fool', *Svenska Dagbladet*, 1930. **2.8**

executed by Otto G. Carlsund in another part of the Park Restaurant had not met with such harsh critique as the easel paintings. According to Asplund this testified to the fact that these new aesthetic styles had primary value as 'architectural decorations'.[68] The Swedish art audience was apparently not ready for the aesthetic that characterized the artworks of the *Art Concret* exhibition; but when applied as architectural decoration or as design it was more acceptable.

It is evident that the abstract, geometrical style, as displayed at the *Art Concret* exhibition, was not accepted as visual art by the majority of contemporary Swedish art critics. However, it appears that within the field of marketing, there were professionals who were much more likely to accept and incorporate this new aesthetics in their practices, demonstrating that there was a clear aesthetic parallel between modernist displays of goods and modernist paintings in the exhibition area. Modern art clearly permeated the window displays at the exhibition but eventually this new aesthetics

also flowed out in the contemporary, commercial visual language of the capital. In May 1930, shortly after the exhibition opened, the department store Meeths advertised ladies' wear with an advert in Art Concret style and invited their customers to view their window display.[69] The same holds for the large and influential department stores MEA and NK in Stockholm which displayed modernist windows from 1930 onwards (figures 2.4 and 2.11).[70]

Other stories

In the histories of art the influx of popular culture into art movements like cubism, Dadaism and futurism is well described, as are the efforts to move art into everyday culture by the Soviet Constructivists. The constructivists argued for purposeful art for the masses, preferably graphic design, book illustration, fashion and exhibition design but also, and less known, designs for advertising posters and packaging for state-owned Soviet enterprises. In fact, for artists like Dadaist Kurt Schwitters and the Constructivist Aleksandr Rodchenko, both running advertising agencies in the 1920s, the commercial assignments were not sidelines but a central part of their avant-garde practice.[71] A fundamental idea was the integration of art and life. As pointed out by Christina Lodder constructivism underwent a transformation in its dispersal to the West by the end of the 1920s. Its revolutionary, communistic, political content was reduced and in effect the 'Russian constructivist experiments were viewed by the Germans solely within an aesthetic context'.[72] However, I argue that the political content of the abstract and geometrical aesthetics of constructivism was not reduced but rather redefined.

When it migrated to the USA it transformed to connote a rationalization of capitalist society in general with a particular focus on scientific methods used in industrial production. Hints of this can be found in the Swedish daily press where the Stockholm Exhibition was deemed to be too much like American advertising. The over-emphasis on commercial features was harshly criticized in the press. The daily paper *Skånska Dagbladet* concluded for example that the exhibition did not present proper architecture: 'it appears to contain too much American advertising and the buildings are just showcases, glass boxes, like in a museum of ceramics'.[73] However, in the Swedish communist paper *Ny Dag* this association was more clearly spelled out. Capitalism implied rationalism of production which was apprehended as a threat to the workers. Accordingly, the Stockholm Exhibition was reported to be propaganda for capitalism.[74]

Frederick Kiesler, who was well informed about Russian cultural production and constructivism, seems to personalize this transgression. However, his interpretation and understanding of it, expressed in his work and activities

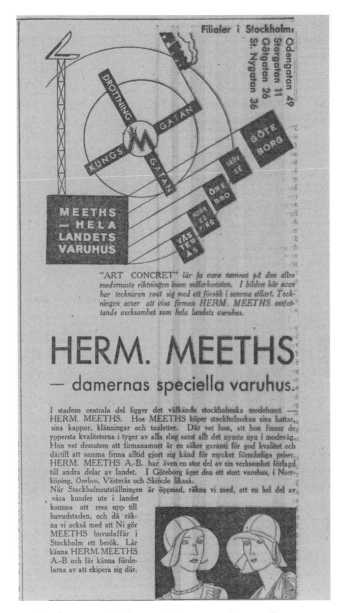

Advertising in Art Concret style, *Dagens Nyheter*, 1930 (cropped). **2.9**

in the USA, mostly concerned its universality and its integration of art and life, and thus not its political aspects.[75]

From revolutionary Marxism to American consumerism

The Stockholm Exhibition was literally a meeting point with regard to American marketing strategy, European architectural trends and contemporary visual art. The influx and acceptance of the aesthetics of avant-garde art movements such as constructivism and futurism into the commercial visual culture in Sweden is paradoxical. Indeed, the USA appears to have been pivotal in this respect.[76] Two of the most influential marketers in Sweden received their education in the USA early in the 1920s. Gerhard Törnqvist (1894–1963), later Professor of Distribution Economics at Stockholm School of Economics, spent an academic year at Columbia University in New York in the early 1920s.[77] Tom Björklund (1898–1968), who obtained his degree from Stockholm School of Economics in 1919, also studied at Columbia University at this time. Thereafter Björklund worked with marketing and sales at the department store Nordiska Kompaniet and played an important role in the business of marketing in Sweden.[78] He translated several American marketing handbooks into Swedish from the 1920s onwards, wrote frequently on marketing and advertising in Swedish publications, and acted as chair of the local, national and the Nordic advertising associations.[79] Together with the marketer Harald Rosenberg, Björklund appeared to be among the most important proponents for modernist window display in Sweden. Harald Rosenberg (1898–1968) also graduated from Stockholm School of Economics in 1919, and then took on different appoinments in marketing at the department store MEA in Stockholm. He sat on the board of the Swedish Association for Crafts (Svenska Slöjdföreningen) and the Swedish Advertising Association and he published in professional journals on advertising, marketing and display.[80]

Björklund and Rosenberg played significant roles in the Stockholm Exhibition. Neither was on the exhibition board or committees yet they both had strong ties to the event – Björklund in his role as marketing director of the NK department store, which was one of the main players in the realization of the exhibition. They exhibited their goods in no fewer than twelve different halls at the exhibition and the director of the department store, Josef Sachs, was a member of the exhibition board.[81] Rosenberg on the other hand acted as adviser in the preparation of the exhibition, in which he established his reputation as a specialist in display.[82] Furthermore, both Rosenberg and Björklund wrote appreciatively about, and actively realized, modernist displays in their respective department stores.

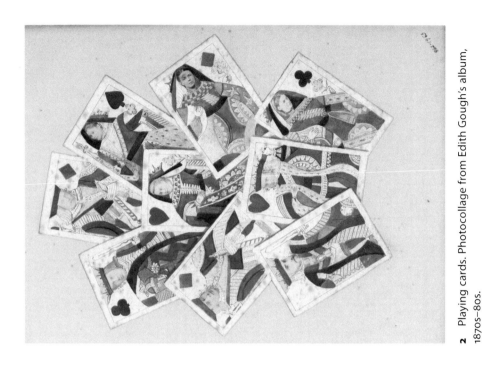

1 Politicians as playing cards in Swedish newpaper *Aftonbladet*, 1998.

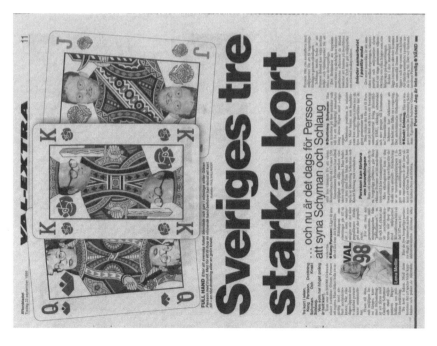

2 Playing cards. Photocollage from Edith Gough's album, 1870s–80s.

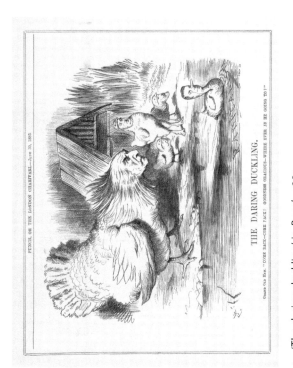

4 'The daring duckling' in *Punch*, 1883.

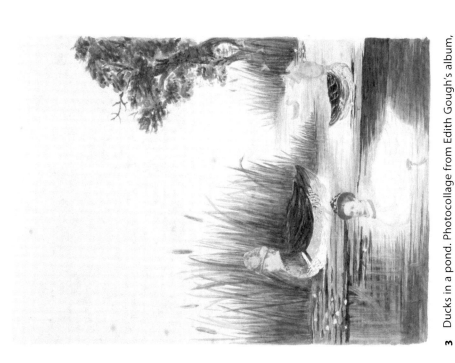

3 Ducks in a pond. Photocollage from Edith Gough's album, 1870s–80s.

5 The *Art Concret* exhibition at the Stockholm Exhibition 1930.

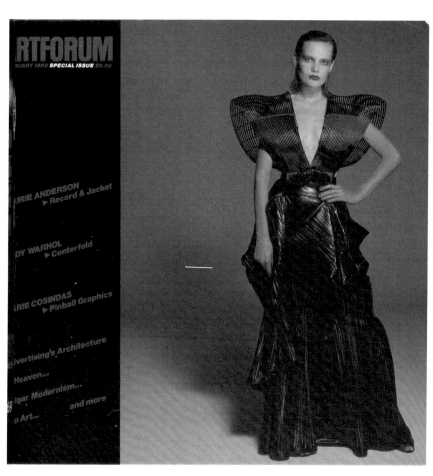

6 Issey Miyake cover of *Artforum*, February 1982.

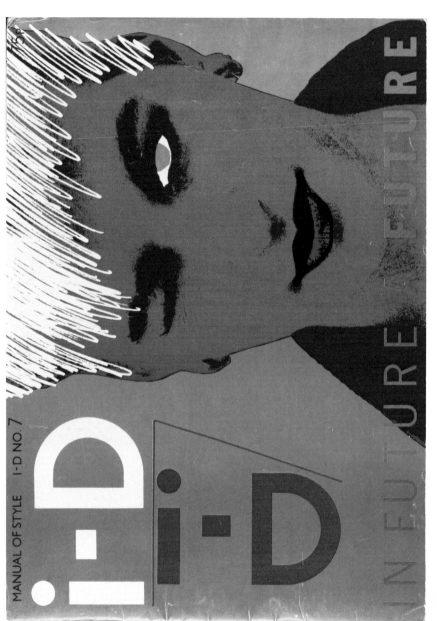

MANUAL OF STYLE I-D NO. 7

i-D

i-D

IN FUTURE A FUTURE

7 *i-D* cover #7, 1982.

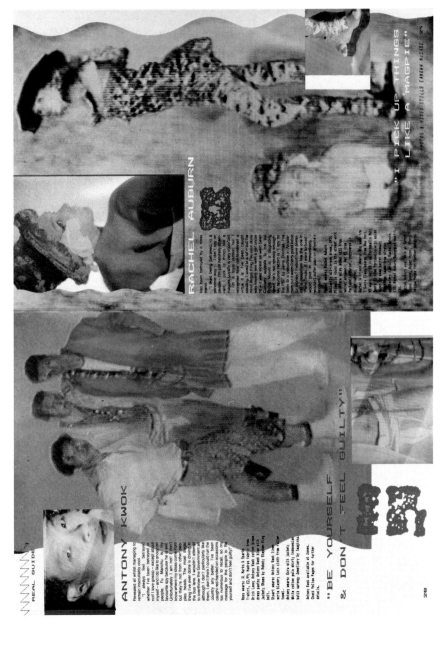

8 Trangressions of text and image in *i-D* layout, 1985.

9 Fashion editorial 'Scoop' in *i-D* #19, 1984.

10 Fashion editorial 'Scoop' in *i-D*, #19, 1984.

11 Pure image pages in 'Superbad' editorial, *i-D* #49, 1987.

12 'Paradise Lost?' editorial by Juergen Teller and Venetia Scott in *i-D #83*, 1990.

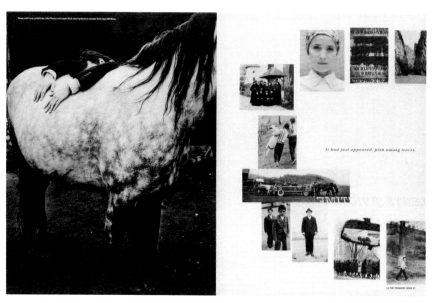

13 'Paradise Lost?' editorial by Juergen Teller and Venetia Scott in *i-D #83*, 1990.

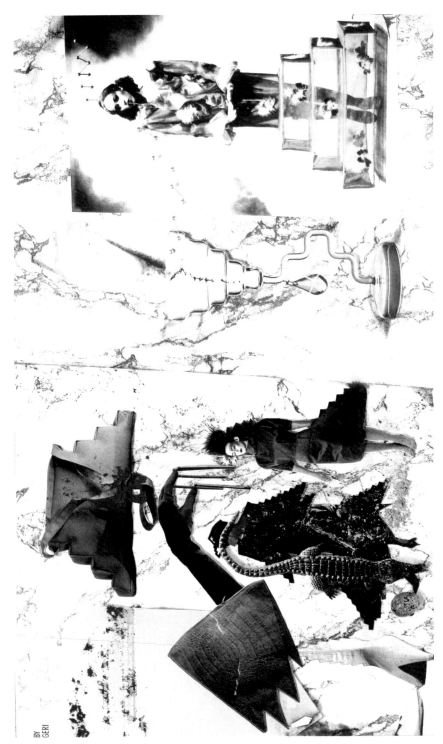

14 An *Artforum* project by Cinzia Ruggeri, 1985.

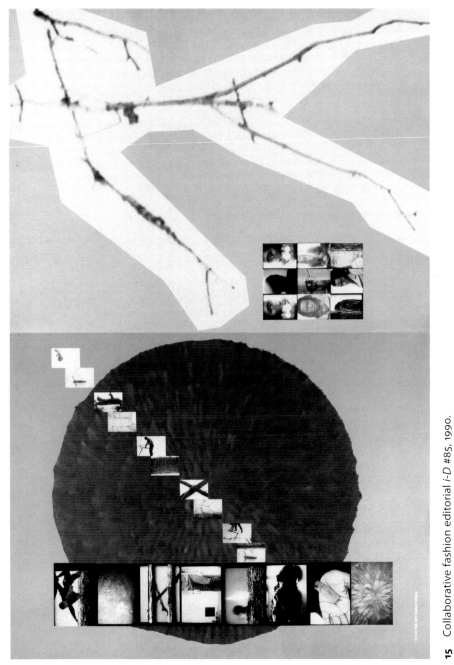

15 Collaborative fashion editorial *i-D* #85, 1990.

Dagens Industri • Fredag 28 maj 1999

1970-talets uppror har blivit museifähigt

SEVÄRT
Ulf Thuland **Di**

Tel 08-736 51 72 ulf.thuland@di.se

Engagemang var tidens lösen. Ondskan hade sitt säte i Washington och det svenska folkhemmet krackelerade. Sverige var blott en liten men hungrig imperialist bland andra. Det var OK att säga "kuk" och att "tända på". Också i konsten.

En hel generation unga konstnärer beväpnade sig på 1970-talet med blyerts och rusch för att att gissla makten, protestera mot Vietnamkriget och bekämpa ekonomiskt och politiskt förtryck var helst det anades.

De besvärades av "stanken från Enskilda Banken" och satte en ära i att "göra varmkorv av heliga kor". Sverige översvämmades av en ny sorts bilder – på affischer och i undergroundtidskrifter.

Moderna museet öppnade i helgen utställningen "Efter majrevolten." Det 'stökiga' 1970-talet". Intendenten Ragnar von Holten har valt ett hundratal verk ur museets egna samlingar.

De medverkandes ställning är numera omtvistad. Somliga bilder har rent av nått ikonstatus, som Peter Tillbergs stora skolmålning "Blir du lönsam lille vän".

Men efter 25 år är det den svartvita konsten som bäst förmedlar tidsandan – och faktiskt förmår lyfta sig över den. Hos de bästa konstnärerna under 1970-talet finns en helig ilska över sakernas tillstånd som är fast förankrad i bildspråket.

Här intar den tidigt bortgångna Lena Svedbergs blyertsteckningar en särställning. Den centrala triptyken "Kennedy Brothers" från 1969 rymmer en svartsyn och ett ursinne som minner om Goya.

Långt från plakatkonsten befinner sig även Petter Pettersson. Hans serigrafier från mentalvården handlar också om makt. Men han väljer att skildra de förtryckta. I sviterna "Avdelning 32" och "Toaletten" porträt-

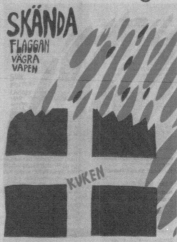

SKÄNDA FLAGGAN: Carl Johan De Geers affisch ingår i Moderna museets utställning "Efter majrevolten. Det 'stökiga' 1970-talet".

teras senildementa och mentalsjuka patienter med ett lågmält allvar och en saklighet som inte utesluter baconska deformationer.

En viktig del av utställningen kretsar kring tidskriften "Puss", den hejdlöst anarkistiska undergroundskapelsen från 1968–1974. Lars Hillersberg var primus motor och ansvarig utgivare. Bland övriga medarbetare märktes Lena Svedberg, Ulf Rahmberg och Carl-Johan De Geer.

"Puss" präglades av glad anarkism och en bildfantasi med rötterna i pop- och seriekonst som känns högst levande än i dag. Som har väl stelnat till kliché eller tom gest, men förvånansvärt mycket har bevarat sin provokativa kraft. När Lars Hillersberg i teckningen "Hommage à Mao"

SVART SYN: Lena Svedbergs teckning av John F Kennedy.

låter ordföranden och demonstranterna byta plats, blir resultatet briljant satir av åsiktsförtryck och politisk likriktning.

I utkanten av Puss-kretsen befann sig Öyvind Fahlström som sporadisk medarbetare och inspiratör. Förankrad i det tidiga 1960-talets estetiska avantgarde och med andra benet i amerikansk popkonst sökte han en annorlunda lösning på den svårlösta konflikten mellan konst och politik. Resultatet kan studeras i den didaktiska litografin "SOMBA Some Of My Basic Assumptions".

Petter Zennström, Roj Friberg, Carsten Regild, Kjartan Slettemark och de övriga konstnärerna från 1970-talet presenterar, var och en på sitt sätt, en personlig lösning på samma dilemma

Utställningen pågår till den 18 juli. □

SATIR: Lars Hillersbergs "Hommage à Mao".

16 'The rebellions of the 1970s have turned "museal"'. *Dagens Industri*, 1999.

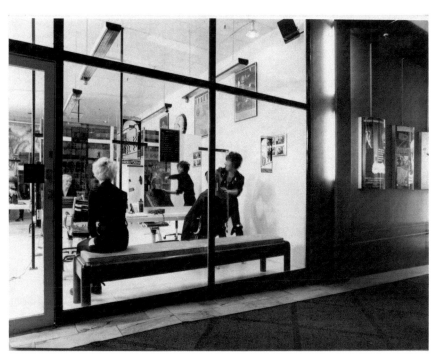

17 Liljevalchs Gallery's benches at the hairdresser's salon in central Stockholm 1992.

VINN dröm- resor till Västindien

VINN fina TV- apparater

VINN kassett- radio med CD

VINN lyxkryss- ningar till Helsing- fors

VINN ett CD- ställ och CD-skivor

SÖNDAGS *tidningen*

DET TOMMA RUMMET *Konstnären Dan Wolgers har ännu en gång skaffat sig uppmärksamhet. Nu har han sålt två av Liljevalchs dyra skinnbänkar och ställer ut ett tomt rum som en del av utställningen "Se människan". – En excentrisk dadaist, säger Philippe Legros på Liljevalchs, men hoppas samtidigt att konsthallen ska få tillbaka bänkarna.*
Foto: TOMMY MARDELL

Konst eller stöld?

Här ställer konstnären Dan Wolgers ut – lumpenhet.
Han lånade Liljevalchs dyra skinnbänkar, värda 20 000 kronor – och sålde dem på Auktionsverket för 2 500 kronor styck.
Nu ställer han ut sitt "konstverk" – ett rum u t a n bänkar.
Och får 5 000 kronor för besväret.
– En excentrisk dadaist, kallar Philippe Legros, indendent på Liljevalchs konsthall, Dan Wolgers.
Han står mitt i "konstverket" – det numera mycket tomma rummet på Liljevalchs konsthall i Stockholm.

Gjorda för att passa rummet

Här stod först två dyra bänkar i läder och mahogny, inköpta för 10 000 kronor styck och specialbeställda av museet för att passa lokalerna.
Här b o r d e de också ha stått i dag, inte utställningen "Se människan" öppnas.
Men bänkarna är borta.
De är sålda – av Dan Wolgers.
Nu ställer han ut "bänkarna som inte finns".

Dan Wolgers konstverk: Att sälja museets bänkar

Eller hur man nu ska säga.
– Jag tappade hakan, säger Folke Lallander, chef för Liljevalchs, som legat vaken varenda natt den senaste veckan och grubblat över hur han ska tolka Wolgers senaste tilltag.

Många sömn- lösa nätter

Konst – eller simpel stöld? Eller både och?
I vanliga fall är ett tomt rum – ett tomt rum. Men om en konstnär tömmer rummet – är det k o n s t då?
– Det får väl bli en rättegång om det, säger Folke Lallander, som dock under sina sömnlösa nätter har försökt förstå "konstverket" och tycker att det är oerhört intressant.
– Dan Wolgers vill visa en mänsklig handling. Det tomma rummet som ändå innehåller något är ju inget nytt i konsten. Han har med hjälp av två bänkar gjort en installation om mänsk-

ligt beteende. Det är mycket väl uttänkt.
– Han har gestaltat tarvlighet och lumpenhet.
Uppmärksammad har han också blivit – igen.
Om Dan Wolgers ska polisanmälas för stöld bestämmer Stockholms stad. "Bänkarna som inte finns" tillhör nämligen Stockholms stad.
Philippe Legros, som ansvarar för utställningen och också utan att veta om det blev "medbrottsling" – han hjälpte Wolgers att bära ut bänkarna från museet – hoppas dock att bänkarna ska komma tillrätta.

Bara namnet finns i rummet

– Jag hoppas att vi kan få dem tillbaka på något sätt, säger han.
Han är dock lycklig över att de 21 andra utställarna i n t e har gjort likadant.
Det skulle bli lite v ä l tomt. 5 000 kronor får Dan Wol-

Konstnären Dan Wolgers sålde de dyrbara bänkarna och tjänar 5 000 på att ställa ut ett tomt rum.

gers för att bära ut och sälja museets soffor – det är de medverkande konstnärernas arvode.
Och Philippe Legros kan inte annat än anse att Wolgers medverkar.
– Ja, han finns ju i rummet, hans namn står där.
Det är det enda som står där – numera.
Att ringa Dan Wolgers berörda telefonnummer – det som står u t a n p å telefonkatalogen, var ingen idé i går kväll.
Där var det lika tomt – som på Liljevalchs.

Kerstin Nilsson

Norge vill gå med i EG

Sent i natt bestämde sig Norge för att söka medlemskap i EG.
Det betyder att hela Norden – ulom lilla Island – kan vara med i den europeiska gemenskapen om ett par år.
Situationen i Norge är i stort sett densamma som i Sverige. En stor majoritet av de politiska partierna

är för ett medlemskap i EG. Men en majoritet av folket säger nej.
Röstsiffrorna i stortinget blev 104 för och 55 röster emot ett medlemskap.
Norge är det sista av de nordiska länderna som bestämmer sig för vilka relationer landet ska ha med EG. Danmark är medlem sedan 19 år till-

baka. Island deklarerade för flera år sedan att de inte vill vara med. Sverige, Finland och Norge står alla i kö för att söka medlemskap.
Redan vid det nordiska statsministermötet i danska Arhus för ett par veckor sedan bestämde sig Carl Bildt, Finlands Esko Aho och Norges Gro Har-

lem Brundtland för att försöka göra parallella förhandlingar med EG.
Orsaken är inte bara att enighet ger styrka. Våra länder liknar varandra och har problem som EG hittills slippits brottas med, exempelvis stora glesbygdsområden och jordbruk i kyliga områden.

Lena Mellin

Se upp rökare!

■ ■ I gårdagens tidning påstods att tobaksskatten höjs vid årsskiftet.
Detta är felaktigt eftersom rekordhöjningen genomförs redan den 1 december.
Aftonbladet beklagar den felaktiga uppgiften.

18 'Art or theft?', *Aftonbladet*, 1992.

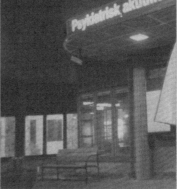

19 'Art student notified for coup at psychiatric clinic'. *Aftonbladet*, 2009.

"Galen" konstelev polisanmäld

STOCKHOLM (TT)
Konsteleven Anna Odells som simulerade psyksjukdom och utbrott på S:t Görans psykakut i Stockholm har fått konsekvenser. Hon är nu polisanmäld för bland annat falskt larm, våld mot tjänsteman och misshandel.

Anna Odell började slåss med ett par poliser för att bli intagen på psykakuten. När hon väl kom till akuten fortsatte spektaklet när hon bland annat skrek åt och spottade på persona-

len. Hennes tanke var att skådespelet skulle bli ett konstverk som en del av hennes examensarbete. Men det har fått kritik både från politiker och sjukhuspersonal. Framför allt är chefen på S:t Görans psykakut, David Eberhard, starkt skeptisk till konstverket.

– Det är ju bara patetiskt. Måla en tavla i stället. Men hon är välkommen hit så ska jag själv spruta henne med Haldol så får vi se hur roligt hon tycker det är.

Är det månne Edward Munchs "Skriet" som inspirerat Anna Odells skrikande konstjippo?

Det blir en fin installation, säger Eberhard till Dagens Medicin.

Resursslöseri

Eberhard menar även att det är slöseri med samhällets resurser, både sjukhusets och polisens. Anna Odell själv säger till Aftonbladet att hennes konstverk inte är klart förrän i maj och att hon inte vill förklara det

närmare innan dess. Men redan innan konstverket har presenterats sågas det av David Eberhard.

– Installationen eller vad det nu skulle föreställa misslyckades. Hon fick bara Stesolid. Om personalen hade trott att hon verkligen var psykotisk hade hon fått neuroleptika, vilket hon inte fick, säger han till Dagens Medicin.

areareare

LINDHOLMS

vard 10-18.30 lörd 10-16 sönd 12-16
tornbyv 3 tornbycity tel 25 22 70
www.lindholms.com tornbycity

20 'Crazy artist notified. Inspired by Munch?', *Corren*, 2009.

21 'He is the bad boy of the art world', Dan Wolgers in *Aftonbladet*, 1992.

Kiesler's window display for Saks was primarily associated with luxury and sophistication, as pointed out by Barnaby Haran. Saks targeted a well-off audience, its black, grey and white window decoration signalling the ultra-modern but also affluence.[83] As Kiesler's New York windows were visible for nine years – that is until 1937 – it is quite likely that Björklund, in frequent contact with American marketing, had come across them. Moreover, Rosenberg's and Björklund's department stores NK and MEA had similarities with Saks. They were the most prestigious and luxurious department stores in the Swedish capital. Their air of affluence and connections to the elite in society might have been a reason why modernist window displays were accepted whereas the same aesthetics when framed and hung on a wall as visual art was not.

The organizer of the *Art Concret* exhibition, Otto G. Carlsund, also had transnational experience and networks. He moved from St Petersburg to Sweden in 1908 at the age of eleven. He returned to St Petersburg in 1917 to work as a translator, then travelled to Dresden in Germany in 1922 to get a artistic education and to Paris in 1924. Here he lived until his return to Sweden permanently after the Stockholm Exhibition in 1930. During the Paris years he maintained contact with the Swedish art field writing regularly as art critic for the Swedish daily press and journals.[84] However, compared to Björklund and Rosenberg his institutional presence was weak in Sweden. This might be one explanation, apart from the different image communities in which they were active, for Björklund and Rosenberg's apparent success in getting the general public's acceptance for modernist aesthetics.

Avant the avant-garde

This close study of agents and events in Sweden around 1930 clearly demonstrates that the avant-garde in the visual arts might not always be the early adaptor or first mover. In the case described in this chapter it not only appears that the vernacular visual culture was a source of inspiration for the avant-garde art movements of constructivism, cubism and futurism but that the breakthrough of these aesthetic movements took place in vernacular visual culture before they were acknowledged on a broad front within the art world in Sweden. As a consequence, this questions the notion of the avant-garde as typically misunderstood, or not appreciated, by the contemporary, greater public. On the contrary this example shows that the modernist aesthetic was appreciated not only by professionals within the marketing and retail business in Sweden but apparently also by the larger public, its customers, in the period.

In the case of the Stockholm Exhibition and the parallel, but very different reception, of these strands of modernism in Sweden it is evident that the

2.10 *Komposition 1* at the *Art Concret* exhibition 1930, painting by Erik Olson.

Skyltning 2. Det suggererande intrycket av liv och rörelse säljer sportartiklar.

2.11 Window display at MEA department store in Stockholm, 1930.

modernist aesthetic was established and accepted within the context of commercial, vernacular culture before it was accepted within the art world in Sweden, here represented by art critics and the art buyers. However, it is also worth pointing out that no national museum felt obliged to buy any of the exhibited artworks at the time and no cultural authorities –representatives of art museums or art education, for example – were willing to support the *Art Concret* exhibition at the time.[85]

Frederick Kiesler, the man behind the modernist window displays at Saks is an emblematic figure. He was a 'misfit modernist' in the sense that his practices and expertise were hard to categorize. However, it appears that this interdisciplinary and multidimensionality was much more accepted or understood in retrospect, after the end of modernism. Indeed, as pointed out by Mark Linder, he can be seen as an 'inadvertent precursor of the neo-avant-garde artists of the 1960s'.[86] He moved freely between genres, materials and display contexts. On the other hand his broad knowledge of the European cultural scene combined with an ability to work between and across disciplines made him a unique character as a translator of modernism to the North American public at large. Which then in turn, via the USA, re-entered Sweden in Europe as this case study has shown.

The importance of framing

The problem with the artworks exhibited at the *Art Concret* exhibition was foremost a question of context, about their literal and figurative framing. As easel paintings they exemplified a blind alley, according to the Swedish critic Asplund. However, he continued, these are examples of 'art, that in order to be spread outside the circles of the purely aesthetically interested professionals has to be applied'. This could imply architectural decoration as mentioned above.[87] As another critic remarked, the art might have its decorative merits and be valuable in relation to 'industrial applied art' or it could for example be used to produce 'an attractive cigarette packaging'.[88] The same line of thought could be found in another quite positive critique of the exhibition published in *Social-Demokraten* on the day after it opened. Indeed, the critic Einar Rosenberg pointed out that what is 'incomprehensible and laughable when put on a gallery wall, is simultaneously accepted when used in a window display at the department store Mea or N'.[89]

A core feature of this scepticism appears to be the relationship between abstract art and the notion of mechanization. To both critics and the artists themselves the idea of the machine was central. In the foreword to the catalogue of the *Art Concret* exhibition, Jean Hélion wrote: 'Their works are exact, precise, clear as machines.'[90] Several critics touched upon this theme in their harsh critique of Art Concret. What was lost in the process were

two things: the free spirit of the artworks and the personal expression of the artist. According to the critics, the art was 'unimaginative', 'mathematical', 'matter of fact', 'intellectual' and 'meaningless'. The latter, especially, was a recurrent designation in the Swedish press.[91] The *Stockholms Dagblad* wrote for example that: 'Functionalism in painting is only an expression of a neurasthenia of machine romantic. Give us houses to live in which ideally fulfil all practical functions, but give us art that is exciting and maintains all within us that for the most ideal house is just indifferent and temporal.'[92] Another critic remarked that it was too much of mathematics and too little of 'the lust of the heart, the excitement of the soul … that brings the personal foundation to the art work'.[93]

According to one critic at *Sydsvenska Dagbladet* the notion of mechanization was also tied to nationality and a national expression of Sweden. The critic feared that the individual and national were at risk and concluded: 'our country is not a country of mass production'.[94] North America was on the other hand the home of mass production at that time; it was the engine of modernity.[95] The USA was not an important hub for the art world yet, but possessed know-how and power as regards industrial production and management, economy and marketing. Some criticism was voiced on the Stockholm Exhibition as a whole in that it contained too much of American advertising and spectacle.[96] Thus there was a polarity between Sweden and Europe on the one hand and North America on the other, and a resistance to the American influence on art, craft and society at large.

The machine associations and aesthetics did, on the contrary, fit with the ideas and ideals put forward in contemporary business and marketing theory. The scientific images, abstracted patterns of movement of the late nineteenth and early twentieth centuries by photographers and scientist like E. J Marey and Frank B. Gilbreth were important tools for the industry and in their search for increased efficiency in production and sales. Accordingly, the studies of human movement had a clear instrumental function. They mapped and measured human movements in order to analyse and advance labour productivity. Interestingly enough there are apparent formal or aesthetic similarities between these images produced for the advancement of techniques and the style of contemporary art of the early twentieth century as pointed out by Seigfried Giedion in 1948.[97] Accordingly, artists and businessmen alike saw the abstracted visual patterns of movements as expressions of modern life. For the managers and businessmen they displayed the circumstances of modern, efficient production while the same studies of movements represented the urban, modern way of life for artists like Giacomo Balla and Fernand Léger. Businessmen focused on production while artists on other hand were attuned to the consumption contexts of these industrial products.

The marketers and businessmen of the early twentieth century perceived a societal, instrumental benefit in modernist, abstract forms or visual patterns. The rationale for appreciation was, in other words, its direct and utilitarian value. Accordingly, abstract art was a part of an overall modern, societal project. In this respect the reception of modernist abstract art by Nazi Germany some ten years later appears to be even more paradoxical. For the Nazis abstract art was deemed to have neither aesthetic nor any practical value. Indeed, this happened at the same time as the same aesthetic was lauded, although not always overtly, by many other European countries and the United States through the practice of window display in the streets.

Another paradox in the reception of the modernist aesthetics is tied to assumptions about the audience. Several writers described the artworks as being art for artists only, in other words not for the greater public, not even the art public, those well versed in the art scene.[98] By contrast the basic idea of modern marketing was that it was targeting a mass audience. This was partly also why the window display was in vogue as it is by definition a very broad marketing medium that targets a large and heterogeneous audience, in contrast to adverts in magazines which may have a more or less limited audience depending on the focus of the publication. Accordingly, the modernist aesthetic was simultaneously apprehended to fit only a very narrow part of the art field audience, and at the same time being just fine for the large, hetereogeneous mass audience of the urban street.

Notes

1 M. Linder, 'Wild Kingdom', in R. E. Somol (ed.), *Autonomy and Ideology. Positioning an Avant-Garde in America* (New York: The Monacelli Press, 1997), pp. 122–153 (quote p. 125); B. Haran, 'Magic windows. Frederick Kiesler's displays for Saks Fifth Avenue, New York in 1928', in J. C. Welchman (ed.), *Sculpture and the Vitrine* (Farnham: Ashgate, 2013), pp. 69–93.

2 F. Kiesler, *Contemporary Art Applied to the Store and its Display* (London, Philadelphia: Sir I. Pitman & Sons, 1930), pp. 66–67.

3 B. Lärkner, '1900–1950', in Lena Johannesson (ed.), *Konst och visuell kultur i Sverige 1810–2000* (Stockholm: Signum, 2007), pp. 137–222.

4 K. Walden, 'Speaking Modern. Language, Culture, and Hegemony in Grocery Window Displays 1887–1920', *Canadian Historical Review*, 70:3 (1989), 301; J. Ward, *Weimar Surfaces* (Berkeley: University of California Press, 2001); S. Lomax, 'The view from the shop. Window display, the shopper and the formulation of theory', in J. Benson and L. Ugolini (eds), *Cultures of Selling. Perspectives on Consumption and Society since 1700* (Burlington: Ashgate, 2006).

5 C. Klonk, 'Patterns of Attention. From Shop Windows to Gallery Rooms in Early Twentieth-Century Berlin', *Art History*, 28:4 (September 2005), 468–496.

6 H. Ashford Down, 'The theory and practice of window dressing', in H. Ashford Down (ed.), *The Art of Window Display* (London: Sir Isaac Pitman & Sons, 1931), p. 7.

7 Kiesler, *Contemporary Art Applied to the Store and its Display*, pp. 127–134.

8 The Swedish Advertising Association (Svenska reklamförbundet) 1919; Institute for Marketing Research (IMU) 1932; The Association for Swedish Advertising Draftsmen (SAFFT) 1936; The Association for Decorators (Handelsdekoratörsförbundet) 1928.

9 Adverts for Oscar Lundqvist's decorators' school, *Butikskultur*, 4 (1932), 7; K. Hermansson, *I persuadörernas verkstad. Marknadsföring i Sverige 1920–1965. En studie av ord och handling hos marknadens aktörer* (Stockholm: Acta Universitatis Stockholmiensis, Stockholm Studies in Economic History 36, 2002), p. 95; L. L. M. Feery's *Konsten att skylta* (Stockholm: Natur och Kultur, 1922). This book, originally published in the UK under the title *Modern Window Display* (London: Cassell's Business Handbooks, 1922), was published in five editions 1922, 1925, 1927, 1934 and 1938 in Swedish to mention one example. See also I. Larsson, *Kortfattad handledning i skyltning* (Kristinehamn: Kristinehamns praktiska skola, 1930); E. Pettersson, *Hur ska jag skylta i mitt fönster. Råd och anvisningar utarbetade för svensk specerihandels tidning* (Stockholm: Hebos förlag, 1934) and H. N. Casson, *Tolv tips för fönsterskyltning* (Stockholm: Lindqvist förlag, 1938). The professional journals on display were: *Reklamen. Skandinavisk tidskrift för reklam och fönsterdekoration* (1920–23); *Skyltfönstret* (1932–36), *Kooperativa Skyltfönstret* (1932–58); *Stockholms skyltfönster. Månatlig tidskrift för affärsinnehavare och dekoratörer* (1933); *Butikskultur* (1932–51); *Reklam & dekoration. Tidskrift för moderna dekoration och fönsterskyltning* (1936–38).

10 *Skyltning*, första brevet, brevkurs i Sveriges Köpmannaförbunds regi, Stockholm: 1934, s. 1. In the following all translations from Swedish to English are made by the author unless otherwise stated.

11 Larsson, *Kortfattad handledning i skyltning*, pp. 15–17.

12 See for example advert for the Gumælius advertising agency in G. Strengell, *Den nya annonsen. En studie av den moderna reklamens väsen* (Stockholm: Bonnier, 1924); 'Den nya sakligheten i skyltfönstret', *Handelsdekoratören. Månatlig Tidskrift för Skyltning* (June 1928), 12–13; A. Billow, 'Fotografiens reklamvärde är dess sanningsvärde', *Svensk Reklam. Svenska Reklamförbundets årsbok*, 3 (1931), 117–148; E. Lenning, 'Reklamen och tidsandan', *Svensk Reklam. Svenska Reklamförbundets årsbok*, 3 (1931), 81–88; T. Björklund, 'Samhälle och reklam', *Futurum*, 4 (1937), 231; T. Björklund, 'Reklamen tjänar samhället', *Svensk Reklam. Svenska Reklamförbundets årsbok*, 6 (1937), 7–10.

13 H. Rosenberg, 'Våra skyltfönster av idag', *Svensk Reklam. Svenska Reklamförbundets årsbok*, 2 (1930), 116–117.

14 Haran, 'Magic windows', p. 82.

15 See T. Björklund, *Reklamen i svensk marknad 1920–1965*, 2 vols (Stockholm: PA Norstedt & Söners förlag, 1967), vol. 1; Hermansson, *I persuadörernas verkstad* and L. Nilsson, *Färger, former, ljus. Svensk reklam och reklampsykologi, 1900–1930* (Uppsala: Acta Universitatis Upsaliensis, 2010), pp. 66–82 and 148–159.

16 Anon., 'Med vilka varor skola vi skylta?', *Butikskultur*, 5 (1937), 8.

17 B. Bergman, *Handelsplats, shopping, stadsliv. En historik om butiksformer, säljritualer och det moderna stadslivets trivialisering* (Stockholm: Symposion, 2003), pp. 41–42; J. Garnert, *Anden i lampan. Etnologiska perspektiv på ljus och mörker* (Stockholm: Carlsson, 1993), pp. 176–177.

18 For the development in the United States see Walden, 'Speaking Modern', 289. In 1898 the National Association of Window Trimmers was organized and its journal *Show Window* was launched. For Germany see U. Spiekerman, 'Display windows and window displays in German cities of the nineteenth century. Towards a history of a commercial breakthrough', in C. Wischermann and E. Shore (eds), *Advertising and the European City. Historical Perspectives* (Aldershot: Asgate, 2000), pp. 157–158 and 169 and Ward, *Weimar Surfaces*, pp. 197–201.

19 Y. Suga, 'Modernism, Commercialism and Display Design in Britain. The Reinmann School and Studios of Industrial and Commercial Art', *Journal of Design History*, 2:19 (2006), 137–154; Hermansson, *I persuadörernas verkstad*, p. 95; H. Casson, *Twelve Tips on Window Display* (London: Efficiency Magazine, 1924), p. 12.

20 Walden, 'Speaking Modern', 309.

21 A paramount work including such ideas is John Ruskin, *Lectures on Architecture and Painting* (London: Routledge, 1854).

22 Lomax, 'The view from the shop', p. 283.

23 Walden, 'Speaking Modern', 301. Naturally this also holds for the mass arrangement of identical goods that appeared in the 1930s.

24 Lomax, 'The view from the shop', p. 278.

25 Björklund, *Reklamen i svensk marknad*, vol. 1, p. 419; *Handelsdekoratören. Månatlig Tidskrift för Skyltning* (July 1928), 35.

26 *Skyltfönstret*, 3 (1932), 1.

27 Anders Ekström, *Representation och materialitet. Introduktioner till kulturhistorien* (Nora: Nya Doxa, 2009), pp. 151–155; Klonk, 'Patterns of Attention', 478–480; M. B. Sandberg, *Living Pictures, Missing Persons. Mannequins, Museums and Modernity* (Princeton: Princeton University Press, 2003).

28 'Skyltningens psykologi' (ur Merch. Rec.), *Reklamen. Skandinavisk tidskrift för reklam och fönsterdekoration*, 1 (1923), 4; Casson, *Twelve Tips on Window Display*, pp. 101–117; Feery, *Konsten av skylta*, p. 29; Feery, *Modern Window Display*, p. 23.

29 Bergman, *Handelsplats, shopping, stadsliv*, p. 115.

30 Rosenberg, 'Våra skyltfönster av idag', 103–120; Petterson, *Hur ska jag skylta i mitt fönster*, pp. 8 and 78; *Skyltfönstret*, 10 (1933), 9; *Skyltfönstret*, 1 (1933), 17.

31 G. Pusch, 'Några reflektioner angående skyltfönstrens utformning', *Butikskultur*, 3 (1932), 2.

32 See for example the advice in E. Pettersson, 'Ett par arrangemang för skyltfönster utan bakgrund', *Butikskultur*, 5 (1934), 6; *Skyltning*, 4th letter, correspondence course by Sveriges Köpmannaförbund, 1934, pp. 44–46.

33 O. Lundkvist, 'Skyltfönsterteknikens principer', *Butikskultur*, 1 (1932), 10.

34 G. H. Downing, R.B.A., *Art Applied to Window Display* (Aylesbury: Granville Works, 1929). A second edition of the book was published in 1932 by Blandford Press, London; F. S. Trott, 'The display man as artist', in Ashford Down, *The Art*

of Window Display, pp. 44–48; O. Dahlström, 'Den nya typografiens skapare', *Svensk Reklam: Svenska Reklamförbundets årsbok*, 4 (1932), 77–88; Casson, *Twelve Tips on Window Display*, pp. 14–15.

35 H. Rosenberg, 'Butiken och varan', *Form. Svenska Slöjdföreningens Tidskrift*, 28:2 (1932), 51.

36 Kiesler, *Contemporary Art Applied to the Store and its Display*, p. 27 (elementarism).

37 'En konstnär om butiksskyltningen', *Butikskultur*, 1 (1936), 14. See also Rosenberg, 'Våra skyltfönster av idag', 116.

38 Casson, *Twelve Tips on Window Display*, p. 11. A Swedish translation was published in 1938.

39 Rosenberg, 'Butiken och varan', 51; G. Törnqvist, 'Reklamprofessor suggereras av "Lampan som gör glad"', *Kooperativa Skyltfönstret*, 2 (1936), 4.

40 Pettersson, 'Ett par arrangement för skyltfönster utan bakgrund', 6.

41 Kiesler, *Contemporary Art Applied to the Store and its Display*, p. 102.

42 'Några sammanförande synpunkter på modern skyltning', *Butikskultur*, 2 (1932), 16.

43 *Skyltning*, 4:e brevet, brevkurs i Sveriges Köpmannaförbunds regi, 1934, p. 43; I.L–n., 'Specerihandelns skyltning', *Butikskultur*, 3 (1938), 10.

44 See Introduction, p. 4.

45 *Machine Art*, 6 March to 30 April 1934, Museum of Modern Art, New York, Sixtieth-Anniversary Edition, 1994. A. Staniszewski, *The Power of Display. A History of Exhibition Installations at the Museum of Modern Art* (Cambridge, Mass.: The MIT Press, 1998); Suga, 'Modernism, Commercialism and Display Design in Britain'. After *Machine Art* (1934) there were several exhibitions on industrial products as design. See for example *Useful Objects* (1938) at the Museum of Modern Art in New York and *Exposition Internationale des Arts et Techniques dans la Vie Moderne* (1937) in Paris.

46 H. Ungewitter, 'Fotografiet i reklamens tjänst', *Svensk Reklam: Svenska Reklamförbundets årsbok*, 2 (1930), 79; S. Kracauer, 'The mass ornament', in Thomas Y. Levin (ed.), *The Mass Ornament. Weimar Essays* (Cambridge, Mass.: Harvard University Press, 1995), pp. 74–86 (originally published as 'Das Ornament der Masse', *Frankfurter Zeitung*, 71:420 (9 June 1927) and 71: 423 (10 June 1927)).

47 Kracauer, 'The mass ornament', p. 79.

48 Larsson, *Kortfattad handledning i skyltning*, pp. 3–4.

49 'Några sammanförande synpunkter på modern skyltning', 18.

50 M. Jay, 'Scopic regimes of modernity', in Hal Foster (ed.), *Vision and Visuality* (Seattle: Bay Press, 1988), pp. 2–23.

51 Björklund, *Reklamen i svensk marknad*, vol. 1, p. 420.

52 Staniszewski, *The Power of Display*, pp. 143–189.

53 G. Paulsson, *Vackrare Vardagsvara* (Stockholm: Svenska slöjdföreningen, 1919), pp. 22ff.

54 The basic idea of functionalism was that form should follow function. Aesthetically it implied light colours, smooth surfaces and simple forms. The term was initially used for architecture but subsequently it also influenced graphic design, design,

photography and visual art. Functionalism had its breakthrough in Sweden at the Stockholm Exhibition 1930. See for example *Hemmet, Konstindustrien, Stockholmsutställningen 1930* (Stockholm: Nordisk Rotogravyr, 1930), p. 24; E. Rudberg, *The Stockholm Exhibition 1930. Modernism's Breakthrough in Swedish Architecture* (Stockholm: Stockholmia, 1999).

55 *Stockholmsutställningen 1930. Huvudkatalog* (Uppsala: Almqvist & Wiksell, 1930); Rudberg, *The Stockholm Exhibition 1930*.

56 G. Paulsson, 'Redogörelse [Report] för Stockholmsutställningen 1930', till verkställande [executive board] utskottet för Stockholmsutställningen, 1937, p. 140.

57 G. Paulsson, *Stockholmsutställningens program. Föredrag i Svenska slöjdföreningen 25 oktober 1928*, p. 11.

58 *Hemmet, Konstindustrien, Stockholmsutställningen 1930*, pp. 20–21.

59 *Stockholmsutställningen 1930. Huvudkatalog*, p. 22; *Stockholmsutställningen officiellt vyalbum* (Stockholm: Frans Svanström & Co., 1930).

60 I. Folcker, *Det elektriska ljuset på Stockholmsutställningen 1930* (Stockholm: Svenska föreningen för ljuskultur, 1930).

61 Sigrid Siewerz writes on it in the Swedish Tourist Association's yearbook of 1935 under the title 'The City'. Garnert, *Anden i lampan*, pp. 195–196.

62 The leading artists were: Hans Arp, Sergey Charchoune, Franciska Clausen, Theo van Doesburg, Joe M. Hanson, Jean Hélion, Fernand Léger, László Moholy-Nagy, Piet Mondrian, Henri Nouveau (Heinrich Neugeboren), Amédée Ozenfant, Antoine Pevsner, Sophie Taeuber-Arp, Léon Tutundjian, Georges Vantongerloo, Friedrich Vordemberge-Gildewart and Marcel Wantz. Moreover a number of Swedish artists participated: Christian Berg, Otto G. Carlsund, Lennart Gram, Eric Grate, Sven Jonson, Greta Knutson-Tzara, Stellan Mörner, Gösta Adrian Nilsson (GAN), Wiven Nilsson, Erik Olson, Esaias Thorén and Bengt O Österblom. See catalogue of the exhibition: *Internationell utställning av post-kubistisk konst 19 aug. – 30 sept., Parkrestaurangen, Stockholmsutställningen 1930* (Stockholm: Bröderna Lagerström, 1930).

63 Letter from Carlsund to the director of the Stockholm Exhibition Gregor Paulsson as referred to by by J. T. Ahlstrand, 'Den punkterade zeppelinaren eller "konkretistfiaskot" i Stockholm 1930, in *Otto G. Carlsund och konkretistfiaskot i Stockholm 1930* (Halmstad: Mjellby konstmuseum, 2004), p. 112.

64 Ahlstrand, 'Den punkterade zeppelinaren eller "konkretistfiaskot" i Stockholm 1930', pp. 136–142. See also F. Edwards, *Från modernism till postmodernism. Svensk konst 1900–2000* (Lund: Signum, 2000), p. 81; B. Schaffer, *Analys och värdering. En studie i svensk konstkritik 1930–1935* (Stockholm: Akademilitteratur, 1982), pp. 66–83.

65 The following conclusions are based on fourteen articles and notes published in the Swedish press. Eight of these are referred to in Ahlstrand: 'Point', '"Ismernas" mångfald på Funkis', *Aftonbladet* (19 August 1930), p. 5; Han, 'Sju – ismer framföras i frihet', *Stockholms-Tidningen* (19 August 1930), pp. 1 and 18; Anon., 'Funkisvernissage', *Dagens Nyheter* (19 August 1930), p. 7; K. Asplund, '-Ismer', *Svenska Dagbladet* (20 August 1930), p. 7; E. Rosenberg, 'Geometrisk tavelkonst på Funkis', *Social-Demokraten* (20 August 1930), unpaginated; Nuto, 'Från utställningsmasten. Ny

frälsning', *Dagens Nyheter* (20 August 1930), p. 9; 'På vandringsutställning. Svenskt måleri från tjugo år', *Svenska Dagbladet* (22 September 1930), p. 6; 'Nyaste konsten', *Svenska Dagbladet* (22 August 1930), p. 8; C. G. Laurin, 'Postfunkis. Carl Laurin risar 1930 års utställning', *Svenska Dagbladet* (25 September 1930), pp. 3 and 24; G. Mascoll, 'Konkreta konstens sju skolor', *Stockholms-Tidningen* (25 August 1930), p. 6; H. Wåhlin, 'Konst vid sidan av konsten', *Aftonbladet* (29 August 1930), p. 3; G. Näsström, 'Plejaden i Parkrestaurangen', *Stockholms Dagblad* (2 September 1930), p. 11; H. Wåhlin, 'Stockholmsutställningens principer', *Sydsvenska Dagbladet* (11 September 1929), p. 7; R. Hoppe, 'En internationell utställning av post-kubistisk konst i Stockholm', *Konstrevy*, 4 (1930), 151–155.

66 'Point', 'Ismernas mångfald på Funkis', p. 5.; Anon., 'Funkisvernissage', p. 7.

67 Mascoll, 'Konkreta konstens sju skolor', p. 6.

68 Asplund, '-Ismer', p. 7; Wåhlin, 'Stockholmsutställningens principer', p. 7.

69 Advert for Meeths, *Aftonbladet* (16 May 1930), p. 4 and *Dagens Nyheter* (16 May 1930), p. 31.

70 Rosenberg, 'Våra skyltfönster av idag', 103–120. See also M.-L. Bowallius, 'Tradition och förnyelse i svensk grafisk form 1910–1950', in C. Widenheim and E. Rudberg (eds), *Utopi och verklighet. Svensk Modernism 1900–1960* (Stockholm: Norstedts, 2000), p. 218.

71 C. Kiaer, *Imagine No Possessions. The Socialist Objects of Russian Constructivism* (Cambridge, Mass.: The MIT Press, 2005), pp. 143–197; M. Lavin, *Clean New World. Culture, Politics, and Graphic Design* (Cambridge, Mass., The MIT Press, 2001), pp. 26–49.

72 C. Lodder, *Russian Constructivism* (New Haven: Yale University Press, 1983), p. 230. As referred in Haran, 'Magic windows', p. 72.

73 G. T., 'Stockholmsutställningen – "en modernistisk Värnamo marknad!"', *Skånska Dagbladet* (17 May 1930), p. 4. In the article the Swedish architect Ferdinand Boberg is interviewed and quoted.

74 'Den svenska kapitalismens propagandautställning 1930 blev idag högtidligen öppnad', *Ny Dag* (16 May 1930), p. 1 and 3; Anon., 'Kamp mot den kapitalistiska rationaliseringen', *Ny Dag* (30 May 1930), p. 4.

75 Haran, 'Magic windows', pp. 73–74.

76 Björklund, *Reklamen i svensk marknad*, vol. 1, Author's foreword, p. xxiii. See also the professional journal *Affärsekonomi* that regularly referred to the USA.

77 www.hhs.se/sv/forskning/departments/department-of-marketing-and-strategy/history/ (retrieved 4 December 2016).

78 Birger, 'Svenska Dagbladet skriver om Tom Björklund', *Kompanirullan*, 2 (1961), 27; P. Harnesk, *Vem är vem? Stor-Stockholm* (Stockhom: Vem är vem bokförlag, 1962), p. 157; Björklund, *Reklamen i svensk marknad*, vol. 2, p. 787.

79 For example *Mitt liv i reklamens tjänst. En vägledning i vetenskaplig reklam* (Stockholm: Natur och Kultur, 1928) – Claude C. Hopkins; *Reklamens konst i 294 punkter* (Stockholm: Natur och Kultur, 1930) – Herbert N. Casson.

80 P. Harnesk, *Vem är vem? Stockholmsdelen* (Stockholm: Vem är vem bokförlag, 1945), p. 702. See for example Rosenberg, 'Våra skyltfönster av idag', 103–120; Rosenberg, 'Butiken och varan', 43–53.

81 Björklund, *Reklamen i svensk marknad*, vol. 2, p. 676; *Stockholmsutställningen. Huvudkatalog*, pp. 13–17.

82 Björklund, *Reklamen i svensk marknad*, vol. 1, p. 421.

83 Haran, 'Magic windows', pp. 77–79.

84 V. Bosson, 'En resa genom Otto G. Carlsunds liv och konst', in *Otto G. Carlsund och konkretistfiaskot i Stockholm 1930*, pp. 14–16, 84 and 96.

85 This is in stark contrast to the events that took place in relation to Dan Wolgers' and Anna Odell's artworks in the late twentieth century. See Chapter 4.

86 Linder, 'Wild Kingdom', pp. 126–129 (quote from p. 129).

87 Asplund, '-Ismer', p. 7.

88 Wåhlin, 'Konst vid sidan av konsten', p. 3.

89 Rosenberg, 'Geometrisk tavelkonst på Funkis'. See also Wåhlin, 'Konst vid sidan av konsten', p. 3.

90 J. Hélion, 'Préface', in *Internationell utställning av post-kubistisk konst 19 aug. – 30 sept.*.

91 Wåhlin, 'Konst vid sidan av konsten', p. 3. The same denomination could be found in Nuto, 'Från utställningsmasten', p. 9.

92 Näsström, 'Plejaden i Parkrestaurangen', p. 11.

93 Wåhlin, 'Konst vid sidan av konsten', p. 3.

94 Rudberg, *The Stockholm Exhibition 1930*, p. 189. While the specific quote cited by Rudberg has not been found by the present author in any issue of *Sydsvenska Dagbladet* for September 1930 I accept that Rudberg's characterization of the paper is true.

95 Haran, 'Magic windows', p. 73.

96 G. T., 'Stockholmsutställningen – 'en modernistisk Värnamo marknad!', *Skånska Dagbladet*, 17 Maj 1930, p. 4. The article cites the Swedish architect Ferdinand Boberg who stated there was too much American advertising.

97 S. Giedion, *Mechanization Takes Command. A Contribution to Anonymous History* (New York: Oxford University Press, 1948), pp. 17–112.

98 See for example Näsström, 'Plejaden i Parkrestaurangen', p. 11; Mascoll, 'Konkreta konstens sju skolor', p. 6; Asplund, '-Ismer', p. 7.

3 Magazined art

The relationship between art and fashion has never been clear cut, but has rather been characterized by a complex interrelationship mainly due to the latter's 'intermediate position between the artistic field and the economic field'.[1] Throughout the history of fashion photography there has been an exchange of aesthetics between visual art and fashion imagery, as pointed out by Charlotte Andersen among others.[2] Moreover, a number of photographers have managed to establish themselves as artists *and* fashion photographers simultaneously, such as Edward Steichen, Cecil Beaton, Irving Penn and Richard Avedon, among the most famous.[3] However, historically most of the photographs initially produced for advertising or fashion spreads have been less acknowledged, and less collected and preserved by art institutions, museums and photographers alike.[4] Although the question about whether fashion and fashion photography is art has been debated since the early twentieth century the understanding of fashion photography as foremost an instrumental, lightweight and commercially driven type of image production was still widespread among museum curators, art dealers and the photographers themselves in the late 1970s.[5]

Some ten years later, by the early 1990s, this had changed. As pointed out by a number of scholars, the 1990s mark a decisive break with the dichotomous understanding of art and fashion photography.[6] Susan Kismaric and Eva Respini, who have both been curators of photography at the Museum of Modern Art in New York, conclude that the late 1990s and early 2000s 'have been particularly ripe for exchange between art and fashion'.[7] Thus from the 1990s onwards the boundaries between art and fashion photography have been less pronounced than before and photographers, as well as their pictures, have migrated effortlessly between the art field and the commercial field, between making 'personal' works and carrying out assignments directed by designers, brands and fashion publications. Outstanding examples are photographers like Inez van Lamsveerde, Corinne Day, Juergen Teller, Wolfgang Tillmans and Nick Knight.[8]

A crucial part of this development was the new aesthetics within fashion photography that emerged in the 1990s, a style labelled 'trash realism', 'radical fashion' or 'post fashion', which challenged traditional notions of fashion imagery as primarily being beautiful depictions of garments.[9] Yet I argue that this paradigmatic change within fashion photography in the 1990s was not only a question of new aesthetic ideals. An equally important condition for this change of aesthetic and address was the emergence of new media sites – printed magazines, where these photographs were circulated and displayed.

Mediating apparatus

In his seminal *Système de la Mode*, Roland Barthes pointed out that the magazine has always been a discursive frame that steers the decoding of fashion photography.[10] The 1990s saw an increasing number of printed magazines in Europe and the USA, which were undefined in genre. According to fashion scholar Ane Lynge-Jorlén, who coined the term 'niche fashion magazines', these grew out of style magazines, glossies and art journals, and their trademark was a 'hybridized quality that straddles art, style culture and high fashion'.[11] This dissolving of boundaries between art and fashion was the default mode in magazines like *Dazed & Confuzed* (London, 1990–), *Purple Prose* (Paris, 1992–98), *Blvd* (Amsterdam, 1993–2007), *Dutch* (Amsterdam 1994–2002), *Surface* (New York, 1993–), *Tank* (London, 1998–), *032c* (Berlin, 2000–) and *Sleek* (Berlin, 2002–). These magazines in turn 'helped usher in a boom in fashion photography that focused even further on originality and personal expression', as noted by Susan Kismaric and Eva Respini.[12] From the 1990s onwards artists such as Wolfgang Tillmans were 'taking magazines seriously as a platform for work as an artist'.[13] Thus printed magazines were transformed in the 1990s to become an outlet within the art world and for some photographers they served as exhibition spaces of equal importance to the art galleries and museums.

This chapter seeks to explore the prehistory of these transformational processes by making a close study of two printed magazines that from different positions became sites where art and fashion interfaced in the 1980s. What follows is thus a close reading and cross-examination of the visual and textual discourse on art and fashion in an art journal and a fashion magazine. By looking at this period from two perspectives or two fields, this study defies the typical writings on fashion photography, which are often written from inside the field, in the sense that their scope remains within the fashion world, that is, fashion magazines, 'look books' (a compilation of photographs of a model, photographer, style, stylist, or clothing line) and catalogues. The cases chosen are the American art journal *Artforum* and the British fashion

and style magazine *i-D*.[14] The aim is to consider the magazine as a visual and textual context for these mergers, by paying close attention to editorial content, labelling, aesthetics and layout. Thus I consider the magazine as a site, both as a space for exhibition or exposure and as a material object, that is, a combination of paper, text, images, printing technique, layout. The following analysis is twofold. First, it investigates how certain visual conventions, patterns and designs – images in a more immaterial sense, influence and enhance the encoding of something to be considered as art within the respective magazines. Second, it considers how particular texts, images and layouts, and combinations of the three, challenge clear definitions as regards what image community a particular photographic image belongs to.

The magazines

The journal *Artforum*, dedicated to contemporary art, was founded in Los Angeles in 1962 and based in New York from 1967 onwards. For most of the 1980s the editor-in-chief was Ingrid Sischy, who clearly influenced the scope of the journal over the decade. She had a degree from the Sarah Lawrence art college in New York. Before taking on the position as editor of *Artforum* she had a number on short-term posts in the art world, at galleries, museums and publishers. In 1978, aided by a grant, she curated photography exhibitions at Museum of Modern Art in New York. In 1979, at the age of twenty-seven, Sischy was hired as the editor of *Artforum*.[15] The journal was by that time dominated by presentations of artworks and artists in current exhibitions on its characteristic square, glossy pages. In other words, the magazine was providing the latest news about what was on, and where it could be seen or bought. According to Sara Thornton '*Artforum* is to art, what *Vogue* is to fashion and *Rolling Stone* was to rock and roll. It's a trade magazine.' As the magazine itself put it in an advertisement in the mid-1980s, their aim was to serve 'people who must know what's new, what's good, what's controversial and what's happening' in the art world.[16]

The journal conveyed this information mostly through black and white text-based adverts for current exhibitions in art galleries and museums in the USA and Western Europe. Each issue also featured a large number of reviews on current exhibitions. A regular feature in the magazine throughout the 1980s was a centre spread where different artists presented their work under the headline 'Projects'. This typically comprised two to six pages and featured the work of one artist.[17] Somewhat of a hybrid of the text-based gallery adverts and the project presentations were the regular current exhibition features consisting of a full-page image of an artwork with discrete information about the artist and exhibition context in a small typeface at the bottom of the page. In addition, each issue contained a handful of articles

on different artists, artistic movements or other cultural phenomena of relevance to the visual arts.[18]

The first issue of *i-D* was launched in London in the autumn of 1980. Behind it were the editors Terry Jones, Perry Haines and Al McDowell. Terry Jones, who acted as sole editor from issue number 5 onwards, was educated in commercial art at the West England College of Art, Bristol, and had been art director at British *Vogue* and *Sportswear Europe*. Furthermore, he worked as a photographer and had strong ties to the British music scene where he acted as music video director and produced record covers. The first art director Stephen Male (1983–93) was educated in graphic design at Central St Martins College of Art and Design in London.[19] Having both been educated at British art schools, the two had something in common with another important figure in *i-D*, the photographer Nick Knight. Knight had studied photography at Bournemouth and Poole College of Art and Design and his images appeared in the magazine from issue 10 in 1982. Eventually, he progressed from being just one among other photographers to be a frontman of the magazine as picture editor. As pointed out by Fred Vermorel in *Creative Camera* the dynamics of the British pop and magazine world was indebted to the British art school system with its 'resistance of rationalization and death-like grip on fine art and craft and laissez-faire values'.[20] In short, many in the British music and magazine industry had an art school background and *i-D* was typical in this respect.

i-D initially took the form and layout of a fanzine. It consisted of forty A4 pages, photocopied and stapled together, covered with text produced on a typewriter and simple black and white photographs, in an edition of 2000 copies. Although not explicitly spelled out in the early magazines, an editorial letter in 1983 told readers that they sought to cover the street styles of London.[21] Accordingly, the content consisted mainly of photographs of street fashion in London (i.e. young people posing in full figure), so-called 'straight-ups' combined with written information on the person's name, occupation, interests and musical taste.

The photographers' high profile at *i-D* was apparent right from the start as they were clearly named on the editorial page. The number of advertisements was small and represented local stores for clothing, shoes and accessories in London. The magazine went on to develop and include editorials on the international fashion scene, incorporating typeset texts, colour printing and coated paper. Early in 1983 the magazine declared that they had 'sold out' and were to 'beat the Big Boys at their own game' and abandon the 'street style fanzine' model.[22] This implied a portrait instead of landscape format, the addition of full-page advertisements for international clothing, alcohol and cigarette brands and, last but not least, new forms of fashion photographs. In the first three years of publication, 1981–83, fashion images in *i-D* had

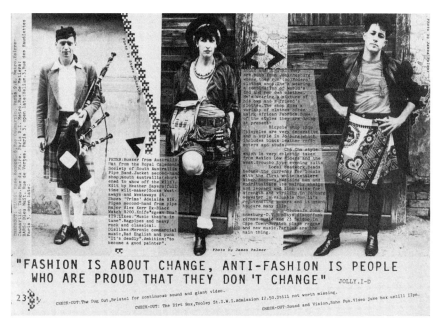

FASHION IS ABOUT CHANGE, ANTI-FASHION IS PEOPLE WHO ARE PROUD THAT THEY DON'T CHANGE" JOLLY.I-D

3.1 Straight ups in *i-D* #10, 1982.

been equivalent to straight-ups. From 1983 these became less and less common and instead studio images of professional models became the standard type of fashion imagery. The transformation from fanzine to fashion magazine happened step by step and by 1987 all visual traces of the initial fanzine such as club reportage, the straight-ups, black and white photographs and rough graphic design had vanished.[23]

When *i-D* was first launched as a 'fashion magazine' in the early 1980s it seemed something of an anachronism. Aesthetically, through graphic design and print quality, it resembled a fanzine and its content did not cover the international fashion industry and famous brands but rather the music scene, clubs and young street fashion of London. Moreover, the early straight-ups had greater affinity with documentary or press photographs. They appeared as much anthropological or social documentations as fashion photographs, as, in addition to information on their clothing, extensive information was provided on the people portrayed.

Fashion in *Artforum*

Since the early 1980s *Artforum* had embraced a broad range of cultural expressions apart from visual art, such as film, popular culture and mediated culture.

In an advert from 1985 the broad scope of the magazine was described as including: 'architecture, dance, film, music, painting, performance, photography, sculpture and theatre, contemporary art and its many forms'.[24] From 1985 onwards this was also announced in the editorial content as regular columns were introduced which dealt with different aspects of contemporary culture such as television, press images, architecture, design, music and fashion. Under the headline 'Like Art' Glenn O'Brian, a former member of Andy Warhol's 'factory' and editor-in-chief of the magazine *Interview*, wrote on art and advertising, which sometimes included fashion imagery. Occasionally, the column 'Turned Out', which considered only fashion, appeared. From the end of 1986 and into 1987 the fashion columns became more frequent, under the title 'Icons at Large'; these were authored by Lisa Liebmann, a writer and critic based in New York.[25] As pointed out much later by Sischy's succeeding editor, Ida Panicelli, *Artforum* was well ahead of its time by seriously considering fashion in the early 1980s.[26]

With regard to the focus of this chapter, the interface between art and fashion photography, two key observations can be made when leafing through the issues of *Artforum* published between 1979 and 1990.[27]

First it is evident that photography was established as a fully fledged art form in the late 1970s and early 1980s. This also happened in conjunction with the establishment of new arenas for displaying photographs. In 1971 The Photographers' Gallery was founded in London and three years later, in 1974, the International Center of Photography in New York. In addition, several galleries dedicated particularly to photographic images emerged in New York and San Francisco in the 1970s and early 1980s, such as Ronald Feldman (1971), Robert Miller Gallery (1977), Fraenkel Gallery (1979), Zabriskie Gallery (1977) and Metro Pictures (1980) to mention some of the most frequent advertisers in *Artforum*.[28] From an overall perspective the interest in photography was considerable in *Artforum* in the early 1980s, which might partly be related to the editor-in-chief Sischy's experience at the photography department at MOMA. The coverage included historical photographs (nineteenth century onwards) as well as contemporary photography. The marketed exhibitions and editorial writings on contemporary photography were limited to art and documentary photography with proponents like Robert Mapplethorpe, William Wegman, Rosalind Solomon, Diane Arbus, Lucas Samaras, Nicholas Nixon, Les Levine and Peter Hujar. Among them Robert Mapplethorpe stands out as the grand figure, regularly appearing in adverts for exhibitions in *Artforum* between 1980 and 1990.[29]

The historical photographs (i.e. those produced before 1975), however, displayed a much greater diversity as regards types of images. The magazine covered everything from nineteenth-century daguerreotype portraits by unknown photographers to the high modernist still-lifes and nudes by Edward

3.2 Typical adpage of *Artforum*, 1981.

Weston and Edward Steichen; from classical documentary and street pho-
tography by Eugene Smith, Walker Evans and Robert Doisneau to the personal
documentaries by photographers like Larry Clark and Nan Goldin. In this
body of images historical fashion photographs also occur through the work
of George Hoyningen-Huene, George Platt Lynes, Irving Penn, Louis Faurer
and William Klein (figure 3.5).

Thus some photographers were primarily presented as 'art photographers'
or 'documentary photographers' in *Artforum* despite the fact that they had
also worked extensively with fashion.[30] Perhaps the most conspicuous examples
among those mentioned are Diane Arbus and Edward Steichen. Contemporary
fashion photography was, however, not visible in *Artforum*. Thus, historical
fashion photography was one example among others of instrumental

photography that was gradually introduced to the market and as noted by the *New York Times* in 1975 there was no doubt that 'the current boom in photography – significantly enlarging the market for photographic prints at the same time it has brought a greatly expanded consciousness of their esthetic value – would sooner or later come to embrace the vast quantities of work produced for the more snobbish, affluent and trend-setting publications of the fashion world'.[31] Thus despite the era's typical scepticism to everything that was not documentary photography, so evident here, this quote attests to an already growing interest in fashion photographs as aesthetic objects and commodities on the art market in the 1970s.

The construction of a history of photography through museum and gallery exhibitions created a legacy, from which contemporary image makers could be understood but also re-evaluated. Thus raising awareness of pioneers and forerunners gave legitimacy to contemporary photography as art, it raised its cultural value and eventually this extended to fashion photography. Although the boundary between art photography on the one hand and applied photography like fashion photography on the other was clearly delineated in most late 1970s writing on fashion photography, there were other voices airing disquiet about separating the genres. Already in 1978 the American photographer Deborah Turbeville had written that her 'pictures walk a tight-rope. They never know. At forty-one I am one of the very few "enfants terribles" still claiming to take fashion photography. I am not a fashion photographer, I am not a photojournalist, I am not a portraitist.'[32]

Second, while not so significant as the new appreciation of photography as art, there was an emerging coverage of fashion from the mid-1980s in *Artforum*. As noted earlier the majority of the material in *Artforum* comprised adverts for gallery and museum exhibitions, and reviews. Thus to get into the pages of *Artforum* one had to be exhibited. Important agents in these processes were museums, galleries and art dealers. Indeed, it appears that museums played a significant role for the inclusion of fashion in the art journal by exhibiting, early in the 1980s, the garments of contemporary and historical designers as well as fashion photographs from past periods.[33] The question whether fashion was art or not was not new at that time; the debate about the status of fashion had been going on since the early twentieth century. However, this debate appears to have been about garments and accessories or, occasionally, prints and drawings; rarely was it about photographic representations or interpretations of the former.[34] When fashion photography truly entered this discourse in the 1980s it was primarily historical photographs and only sometimes contemporary ones that were considered. A paramount example was the exhibition held at International Centre of Photography in 1977 entitled *A History of Fashion Photography*. A comprehensive book with the same title based on the exhibition and written by the

curator at the museum Nancy Hall Duncan was published in 1979. This was the first extensive history writing on photography in fashion, which simultaneously historicized and valorized the genre.[35]

When fashion entered the museums it would eventually also enter the pages of *Artforum*. Such examples include the exhibitions *Intimate Architecture: Contemporary Clothing Design* (1983) at the Hayden Gallery at MIT, which was given an extensive review, and *Irving Penn* (1984) and *Yves Saint Laurent* (1984) at MOMA and the Metropolitan Museum of Art in New York. Other exhibitions announced in *Artforum* were *Socialities & Satellites* and *Mystique and Identity: Women's Fashion in the 1950s* (1984) at Ronald Feldman Fine Art in New York; and *Mode et Photo (1986)* and *Times, Fashion, Morals, Passion* (1987), both at Centre George Pompidou in Paris.[36]

Although the kinds of exhibition varied widely it is possible to conclude that *Artforum*'s inclusion of fashion related topics gradually increased in the period 1980 to 1990. It developed from reviews of museum exhibitions of individual designers and their garments, to the columns on different aspects of fashion as a cultural and aesthetic phenomenon and finally to adverts for exhibitions of fashion photography in galleries.[37] This final stage was possible only when fashion photographs were considered as museum exhibits and as commodities on the art market. Initially, these included only well-established 'masters' such as Richard Avedon, Irving Penn and William Klein but later on also contemporary agents such as Robert Mapplethorpe, David La Chapelle, and Paolo Roversi. As pointed out by British fashion scholar Barbara Burman Baines in 1985 the images that entered the museums comprised 'fashion photography prepared for museum culture, and that entails naming a range of artists who might be collectable'.[38] The writings and adverts on fashion photography in *Artforum* in the 1980s is a clear evidence of this.

Accordingly, the social development of fashion photography can be described as follows. Despite its close relation to the art field and contemporary artistic styles, fashion imagery was for the greater part of the twentieth century mainly seen as instrumental photography used to display and sell garments. Its transformation to being considered as an art form went through several phases. The first step was the organization of museum exhibitions on fashion photography. Thus photographs that had initially been produced to promote a particular brand in an advert or magazine editorial were reused as museum exhibits. Typically, such exhibitions were thematic, in other words, focused on fashion photography in general. By means of the exhibitions they would eventually enter the pages of the art magazine via reviews. Later on, photographs produced for designers or fashion publications simultaneously circulated as part of the oeuvre of an individual photographer in museum exhibitions, auction houses and galleries.

It is evident that there was a lively debate about whether fashion photography and photography in general was, or was not, art in the late 1970s and 1980s in *Artforum* and other publications.[39] Some voices were positive. Susan Sontag, who regularly wrote short pieces on fashion photography for *Vogue* magazine in the late 1970s, argued for example that Richard Avedon's fashion photographs were 'a reflection on the nature of seeing and posing; that is, a reflection about art'.[40] Others were more sceptical. Rosetta Brooks targeted for example the questions of reproducibility in the British journal *Camerawork* in 1980. Despite photographer Guy Bourdin claiming to be an artist and the double spread his canvas, Brooks argued that his 'material is what canvas stands in antithesis to: the texture of mechanical reproduction'.[41] The promotion of fashion photography was also clearly a matter of accepting 'the fictive elements in photography' in a period when documentary was the ideal within the photographic field.[42] Accordingly, this process can be inscribed within a larger postmodern tendency where documentary photography and the notion that photographs are true and authentic documents were re-evaluated. A significant feature of fashion photography, its ability to produce an enhanced, yet realistic image of contemporary culture through staging, was something also taken on by artists in the late 1970s. As pointed out by Charlotte Andersen, fashion photography has acted on or influenced the aesthetic or artistic style it borrows from. Thus while artists in the late 1970s and 1980s questioned the photographic image as document and its alleged one-to-one relation with reality, the same can be said about fashion photographers. However, as Andersen points out, this questioning of the documentary status of photography had been a key element in fashion photography since the early twentieth century.[43]

The writings in *Artforum* were in general positive towards fashion and fashion images in the 1980s. However there were different approaches in the magazine vis-à-vis fashion, which can be described as 'modernist' or 'postmodernist' takes. The modernist approach sought to incorporate fashion into the realm of art through arguments about equality, a recurring theme in the texts on fashion in *Artforum*.[44] These were partly made through an emphasis on its similarities with architecture, sculpture and design and by displaying garments in a modernist white cube, both in exhibitions and in photographic representations, the works by photographers like David Bailey, Irving Penn and Richard Avedon being paramount examples.[45] However, the postmodern approach was dominant in *Artforum*. This strand instead explored and undermined the boundaries between visual art, applied art and mass-produced consumer products. Thus *Artforum*'s writers considered popular music, movies, advertising and fashion imagery, and press and documentary photography. This flair for vernacular, visual culture was especially pronounced in the special issue of February 1982, which sought

to 'confront art making that retains its autonomy as it enters mass culture at the blurred boundary between art and commerce' as the editors' letters read. Furthermore, it declared that '*Artforum* is not to limit its territory to one visual world, and the borders of its coverage have fluctuated in order to maintain a fluidity toward, and a discussion of, the very definition of art' (plate 6).[46]

Thus the journal defied antagonisms and distinctions between the serious and frivolous, high and low, pure and impure, the unique and the multiple, the useless and the useful, between elite and vulgar. These arguments were not about re-evaluating fashion but about emphasizing similarities that had always been there. Writer William Wilson, for example, pointed out the similarities between the practices of appropriating or copying within contemporary art and the constant flux of fashion an 'industry that is all about copying'.[47] Furthermore, the special issue of 1982 informed readers that it would cover key examples from advertising, television, tabloids, political imagery and music. The editorial letter was accompanied by a colour photograph of a model wearing an Issey Miyake design.[48] This was followed by a two-page spread on the Japanese designer with a photograph displaying a 'transformation coat' from Miyake's autumn/winter collection of 1976. The cover also included a colour photograph of a rattan and bamboo bodice and nylon and polyester skirt from the Issey Miyake spring/summer collection of 1982. The photographs were taken by the Japanese photographers Eiichiro Sakata and Moriaki Yokosuka. At that time the former, a pupil of Richard Avedon in the 1960s, was an established artist who later worked as a freelance photographer for Italian, German and French *Vogue*.[49]

The modernist approach, elevating fashion to art by borrowing the display methods, concepts and aims of art practice, was initially confined to garments. It was, at first, contemporary garments and not their photographic representations that caught the attention of *Artforum*. Important trends in fashion of the 1980s were an overall geometrical design and experimentation with different materials and techniques. Japan was the inspiration aesthetically and during the decade several Japanese designers won international fame.[50] Thus it was no coincidence that *Artforum* chose to present Miyake's high-tech fashion on its cover in 1982. Fashion was strongly connected to construction and spatiality and eventually this extended to fashion photography. In 1988 Mark Holborn remarked in *Artforum* that Irving Penn's photographs of Issey Miyake's garments were not only representations of the latter's work, 'they are an extension of the work itself'. Thus they could themselves be considered as works of art.[51]

The exhibition *Intimate Architecture* at the Hayden Gallery, MIT in 1982 is an emblematic case in point. First, in the title itself; second, in the way the garments were shown, hanging on limbless mannequins suspended from

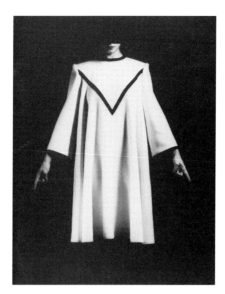

Cover of the catalogue for the *Intimate Architecture* exhibition, 1982. Photograph by **3.3**
Robert Mapplethorpe.

the ceiling and thus moving simultaneously as the visitors walked around the display. In effect, the exhibition had a strong focus on the garments owing to the lack of limbs and heads or of accessories, hairstyle and make-up. Furthermore, they were installed in a white cube and thus tied in to a long modernist tradition. Ever since the *Machine Art* exhibition at MOMA in 1934, the appearance of everyday products and craft in the art museum had implied stripping away of the visual and functional context of the objects.[52] The Hayden Gallery catalogue described the early 1980s as 'a time when the boundaries between disciplines are rendered indistinct and when a comprehensive discussion of fashion is appropriated from its own commercial sponsors to the pages of literary or art journals'.[53] Moreover, the designers were labelled 'artists' and their work – that is, fashion – was described as acts of containing and defining space. In the exhibition review in the *New York Times* the garments were also referred to as sculpture and design and the participating designers as engineers of fashion.[54]

The references to architecture, sculpture and design were certainly a way of advancing fashion. According to the curator, as explained in the catalogue, the 'expressive tools that are a traditional part of the designer's trade coexist with a preoccupation for solving spatial and structural problems more commonly expressed in architecture'.[55] Moreover, the photographs in *Artforum*'s review of the exhibition are telling. Beside a shot of the exhibition display are two photographs by Robert Mapplethorpe from the accompanying

catalogue. The choice of such a well-known photographer, currently celebrated in the art world, obviously added value to the reviews and increased the attention the exhibition received. The model, Lisa Lyon, was also famous. She was a professional body builder who had modelled for Mapplethorpe and the equally famous photographer Helmut Newton. Thus both model and photographer had strong ties to the art world. Moreover, the photographs appear more as expressions of Mapplethorpe's personal style as a photographer than as expressions of the style of the different fashion labels they depicted. Their being commissioned especially for the exhibition emphasized that fashion was a fully fledged art form which, just like architecture and sculpture, needed an artistic interpretation or agent when represented in two dimensions. In retrospect it appears that engaging Mapplethorpe to take photographs of the garments, and reproducing the exhibits at the Hayden Gallery was in fact an important step not only in elevating the fashion garment to art but also in considering the photographic *representations* of fashion garments as art in itself.

Taken together, the reviews as well as the columns dealing with dress and fashion photography in *Artforum* clearly express an ambition of making art and fashion equal from the mid-1980s. While the ultimate aim of the modernists and postmodernists was the same, to seriously consider fashion photography as a cultural and aesthetic expression, their broader implications were somewhat different. The modernist take implied a re-evaluation and elevation of fashion, yet the idea that there was a hierarchy of cultural products remained. In contrast, with the postmodernist take – an interest in mixed media and mixed genres, the definitions, categories and hierarchies eventually imploded.

While *Artforum* questioned a clear-cut dichotomy between art and fashion in its editorial content, the graphic design and layout of the journal remained conventional. This was in stark contrast to *i-D* which broke not only with labelling practices but also with the visual form of the fashion magazines.

Visual and textual content in *i-D*

A hallmark of the niche fashion magazines that appeared in the late twentieth century was the experimentation with boundaries between text and image; and with graphic design, and labelling.[56] This, I argue, could be found in *i-D* some five to ten years earlier (plate 7 and 8).

Right from the start, *i-D*'s subtitle was 'Fashion Magazine' despite its strong deviation from the appearance of magazines like *Vogue* and *Harper's Bazaar*. Thus at the time when the magazine still had the material form and layout of a fanzine, the concept of fashion was highlighted.[57] Moreover, every issue of *i-D* had an individual number and from 1984 every issue also

had a theme – e.g., the *Art Issue* (#28), *Love Issue* (#27), *Chaos Issue* (#79) and *Anarchy Issue* (#82) – which tied it into the realm of professional and academic journals rather than that of fashion magazines.

The categories of contributor on the editorial page are also telling. In the first six issues they were limited. Besides the editors, the only contributors named were the photographers. Although the list was short, reflecting the small scale of the magazine at this point, it is interesting to note the emphasis on the photographers. The fact that the graphic designers, writers and other contributors were not highlighted, despite fashion spreads being a truly collaborative work, reinforces the significance of the photographers. From 1982 the editorial notice included more subcategories; besides the editors and administration were 'Art', 'Words', 'Photographs', 'Vibes', 'Styling' and 'Features'. Information on the model, photographer and stylist of the cover image also appeared at this time.[58] While some categories on the editorial page changed from issue to issue the headline words, photography and art, where the latter represented layout, remained until early in 1987.[59] Thus it was not the photographs that were labelled art but the way they were added to the pages together with text. From May 1987 all names on the editorial page appeared under the heading 'contributors'.[60] This parallels the contemporary discourse on the dissolution and mixing of genres and mediums within the art field. Moreover, it emphasizes the collaborative nature of the magazine. It signals that the pages of *i-D* were to be seen as an aesthetic, indivisible whole.

A similar labelling practice can be observed in the later niche fashion magazines that outspokenly merged fashion and art. The German *032c* (2000–) initially had, for example, 'words' and 'images' in their contents lists.[61] Taken together such labelling practices in *i-D* and the successive niche fashion magazines, with a focus on modality and not editorial content, have several implications. First, they display the mediums of the magazine. Second, and more importantly, they represent text and image as equally important components of the magazine. As the contents page typically includes the kinds of editorial material found in the magazine, this forward placing of the images can be interpreted as advancing the photographic image. Even the title of *i-D* attests to this play between image and text. Despite being composed of letters, the combination of a lower-case i, a hyphen and upper-case D forms a schematic image of a smiling, winking person. From issue 5, 1981, every cover also included a photographic portrait of the same thing, a smiling person, winking his or her right eye.

i-D's creators did not only challenge the labelling practices of the magazine's content. They also experimented with the graphic design and visual appearance of the journal, and eventually with the images themselves. When *i-D* appeared in the early 1980s the understanding of photography among curators and

educators was still very much influenced by the discourse of the 1970s. While historical photographs of all genres were increasingly circulated and appreciated by museums, galleries and dealers in this period, their interest in contemporary work was largely limited to photographs in a documentary style. These were highly esteemed, while more commercially viable applications of photography such as fashion photographs were not. A typical statement from the period comes from Rosetta Brooks writing in the British photo journal *Camerawork* in 1980, where she argues: 'Fashion photography is traditionally regarded as the lightweight end of photographic practices. Its close relationship to the economic imperatives of turnover makes the fashion photograph the transitory image *par excellence*.'[62]

The content of fashion imagery, as sexist, racist and exploiting capitalism, was also critiqued well into the 1980s. Janice Hart, for example, declared in *Creative Camera* in 1985 that contemporary fashion photography rather looked to 'pornographic photographs than to representations of a progressive, autonomous feminism'.[63] Another strong impetus in photography was the focus on personal style. To be apprehended as an artist a photographer needed an individual and consistent style and there was a common understanding that such personal expressions were not possible within commercial assignments like fashion. On the contrary, they seemed to be mutually exclusive, as pointed out by Carter Ratcliff in *Art in America* in 1979: 'Fashion belongs to commerce and genuine style belongs to art. This is true, but art is hardly independent of commerce.'[64] Thus Ratcliff admits that art, at least partly, belongs to commerce too. Yet personal style was confined to art, and only art. The same year *Artforum* published an article in which the current curator of photography at MOMA John Szarkowski was quoted on the same topic: 'all photography has become "personal", or even "private"' and in consequence 'all photographers are becoming artists. All are now coming to think of themselves as artists' he argued.[65] Indeed, it seems that the notion of personal style became vital in photography from the 1980s and onwards and it is evident that this was an important stepping-stone for the entry of fashion photography, and photography in general, into the art world.

The initial use of photographs in *i-D* was clearly imbued by the 1970s appraisal of documentary photography. Indeed, the editor and founder Terry Jones referred to documentary photography when later asked about role models.[66] According to Jones the first kind of fashion image that appeared in the magazine, the straight-up, was inspired by August Sander's photo classification of German workers in the 1920s and Irving Penn's studio portraits.[67] His identifying these sources of inspiration has several implications. First, they were historical and not contemporary, and therefore precluded the many obvious and closer precursors like Diane Arbus, who undertook both fashion assignments and artistic work in the 1970s.[68] Second, the

photographers referred to, Sander and Penn, were already well established within the art world in the early 1980s; they were exhibited in museums and galleries and were highly valued on the art market. However, the straight-ups had forerunners other than in the documentary genre. Full-figure photographs had been common in fashion photography since its introduction in the nineteenth century and they were the standard images in trade catalogues and also in more recent 'look books' as pointed out by Abraham Thomas.[69]

From 1985 onwards there was an increasing experimentation with layout and image editing in *i-D*. Unorthodox typefaces were used and the text and images intermingled on the page. Letters of the alphabet were free-floating on the pages, tilted, distorted and laid over the images. Moreover, fragments of images, which could be stills from video recordings or photographs, were put together in complex montages.

In the mid-1980s, three British photographers dominated the fashion editorials: Nick Knight (1958–), Mark Lebon (1957–) and Eamonn McCabe (1948–).[70] By 1990, however, *i-D* had developed into a platform that included an international group of photographers. Until this point *i-D* had evidently been very much a British enterprise but now Knight and the others were joined by internationally renowned photographers like Jean Baptiste Mondino (Fr., 1949–), Paolo Roversi (It., 1947–), Juergen Teller (Ge., 1964–), Anton Corbijn (Neth., 1955–) and Wolfgang Tillmans (Ger., 1968–).[71]

At the same time as this extensive experimentation with graphic design, different types, styles or aesthetics of the fashion editorials also emerged. Some of these fashion spreads contained full figures of models in studio or other milieux that efficiently displayed the garments and accessories they were promoting. However, there were also other kinds of fashion editorials that did not adhere to this format. By the mid-1980s, I argue, there were two types of fashion editorials in *i-D* besides the more straightforward studio shots of models. Both of them advanced the photographic image, but in different ways.

Visual and textual stories

The first type of fashion editorial that appeared in *i-D* in the mid-1980s had a clear, narrative set-up and contained images in a documentary style. Thus they were related to the initial straight-ups and the predilection for documentary photography. Occasionally, the photographs in these fashion spreads were difficult to separate visually from photographs in *i-D*'s feature material such as reportages and interviews.

A typical case is an eight-page spread in the October issue of 1984 with photographs taken by Mark Lebon (plate 9 and 10).[72] The pages contained

either one or several photographic images, accompanied by text. Each text paragraph in turn began with factual information on the time, date and location of the event that took place – information typically found in news or police reports. However, this was followed by a rhapsodic story, which in turn was followed by information on the garment on display and the names of the model and the photographer. The photograph on the last page, depicting a young woman sprawling on an unmade bed, included the following text:

> 23.15 / 5.9.84 / London W1/ Boys are boring. A new opinion poll published today reveals that eight out of ten girls find boys a real bore. 'I agree', said Amanda of Loraine Ashton. 'I can hardly stay awake when boys are around.'

This was followed by information on the clothes worn in the picture and where they could be bought: 'Men's underwear from M&S, customized jean jacket from Camden Lock.' The same held for the other seven pages, which all presented new characters somewhere in London during different hours of the day. Taken together, there is an evident tension between the images and the texts as well as within the texts as regards genre. The photographs have rather the look of documentary or journalistic photography as the garments play a subordinate role. The visual focus is instead on the faces of the models, and the milieux where they appear. Moreover, the models' poses and expressions, the camera angles, lighting and milieux also tie into a documentary look. The magazine context and the accompanying texts, on the other hand, anchor them as fashion photographs, as clothes labels are included. In addition, the texts' mix of factual and rhapsodic paragraphs changes the reading of the photographs. Indeed, this undermines them as documents, making it uncertain whether they are staged or actually portraying the named individuals, events and utterings. By the 1990s this kind of documentary aesthetic had become the convention in fashion photography as pointed out by Eugénie Shinkle.[73] It appears that *i-D* was an early adopter of this practice.

The second type of fashion editorial that emerged in the 1980s can be described as a stream, or collage, of images. A typical case appeared in the July issue of 1987 (plate 11).[74] It consisted of an introductory page presenting the theme 'Superbad' which was followed by nineteen pages filled only with photographs, all taken by Nick Knight. The photographs were a combination of close-ups taken against a white background and models in half or full figure in different urban indoor and outdoor milieux. Some of the images clearly displayed garments and accessories, while others did not because of the use of heavy blurring and image cropping. The pages consisted of large borderless pictures, or montages of several smaller images; sometimes the same image was duplicated on the same page. A recurrent feature was images that spread out partly over two pages, which emphasized the totality of the spread over the individual page. The images' theme was 'the tough dress up' and the milieux

suggested in the background were nightclubs, restaurants and urban street life. Despite the fashion editorial having a title and an introductory text the images did not present a clear narrative as in the example above. There is no explanatory story; no locations are given and no recognizable events are taking place. The twenty-first and last page of the editorial had a completely different layout. It consisted of miniatures of the preceding pages and extensive written information on the brands and prices of the garments on display, as well as on the individuals involved in the production.

Common to both the documentary-like fashion spread and the text-free photo-collage is their emphasis on and therefore re-evaluation of the photographic image. Thus they demonstrate that fashion photographs are more than just vehicles for promoting and representing a certain brand or garment. Instead, their aesthetics together with the way they are combined with the editorial text highlights that fashion photographs are artistic expressions which may differ in style and address. The very different and elaborated aesthetics of these spreads also signal that the collaborative work of photographers, editors and graphic designers may be seen as an artwork in itself.

Gradually, these two types of fashion editorials, the documentary style and the image collage, converged. The resulting spreads can be described as a mix of documentary, fiction, fashion and art. These fashion editorials combined an unorthodox aesthetic as regards the fashion field, with an editorial textual framing unorthodox for magazines in general. Accordingly they conveyed very little information on the garments on display.

Many of these fashion editorials were labelled 'stories', which in turn emphasizes that combinations of images alone may convey a narrative. Moreover, the label stories highlight that what follows is a construction, a compilation of events or happenings, fictional or real. In addition, the word stories implies that there is a narrator, a creator of content, to use the terminology of Mieke Bal.[75] While the notion of stories is commonly used in fashion editorials today in the early twenty-first century, *i-D* seems to have been a forerunner in this respect. Its sister magazine *The Face* did not, for example, advertise fashion editorials as stories in the 1980s and 1990s though they often began with a short, written narrative.[76]

It appears that the photographers invited to do such stories were given space to express a personal style in the images. One such story produced by the German photographer Juergen Teller from the August issue of 1990 serves as an illustrative example (plates 12 and 13).[77]

The ten-page editorial entitled 'Paradise Lost? România Spring 1990' was presented as a 'story by Juergen Teller and Venetia Scott', where the latter was stylist. It consisted of black and white photographs tinted with in sepia, blue and purple.[78] Besides the photographs of models in a rural milieu were text

lines, one for each of the five spreads: 'You don't have to be guilty to suffer punishment' / 'Look what happened to the flower!' / 'It had just appeared, pink among leaves' / 'and the big animal came' / 'and blew an insult over it'.

At a glance, the images on these spreads look like documentary photography, in terms of both motif and aesthetics. The models appear to be 'ordinary people' and again the visual focus is on the models' faces and their environment and not on their clothes. Several of the images have evident similarities to Walker Evans's classical documentary photographs of rural people in 1930s America, with half-length portraits against the plain, rough background of a wooden wall.[79] They also have clear affinities with contemporary photo-based art with the accompanying text lines, which do not have a descriptive character or clear relationship vis-à-vis the images. They are rather surrealist elegies. Yet they are clearly anchored as fashion images on every page by the adjoining text stating the brands of the models' dress. Alongside the photograph of a girl smoking a cigarette on the second spread is, for example, the text, 'Navy jacket with fake fur collar by JP Gaultier available from Harvey Nichols, Browns and A La Mode'. Overall, there is an evident intangibility in this combination of text and images, which defies categorization. Without the factual text on the clothes worn, this combination of text and images could just as well have appeared in a museum or gallery exhibition or in an 'artist book'.

Since the rise of the illustrated press in the nineteenth century, the basic components of a printed magazine have been the combinations of text and image where the text has typically anchored the reading or understanding of the image it accompanies. Accordingly, text-free zones in a printed magazine clearly break a norm. What can be termed the media specificity of the printed magazine lies in its combination of text and image and the set chain of pages produced by the binding. The latter, the set of chain of images, it shares with film and television. By clearing the pages of text the fashion editorials break with the first of these traits of the magazine. In the case of *i-D* such text-free zones not only broke with the grammar or media specificity of magazines in general but also with the basic grammar of fashion and advertising, which typically have a corresponding text, as pointed out by Roland Barthes in 'The rhetoric of the image'.[80] Ambiguity as regards the editorial text was likewise atypical of magazines at the time and of instrumental uses of text and image in general. This kind of ambiguity has, however, been a standard feature of visual art, particularly since the late 1970s, with the work of artists like Martha Rosler, Barbara Kruger and Cindy Sherman.[81]

Taken together the text-free pages of *i-D* not only enhanced the value of and focus on the images themselves; they also alluded to other media forms. Indeed, the montage of several successive images underlined the cinematic character of the magazine editorial. The editor and founder of *i-D*, Terry

Jones, pointed out such a line of thought in a later interview where he
declared that 'a magazine at its best is like a film which flows front to back
and also from back to front – for the casual flipper'.[82] To sum up, *i-D*, with
its sequential, textless pages, was just like the contemporary magazine *The
Face*, which was 'not read so much as wandered through' as pointed out by
sociologist Dick Hebdige in 1985.[83]

It appears that the experimentation with images and graphic design on
the pages of *i-D* had several effects. The play with typography and graphic
design enhanced the image character of the text while the experimentation
with the image aesthetic enhanced the textual character of the images.
Consequently, there was a reciprocal transformation where text became
image and image became text. According to a later comment on the new
magazines of the 1990s, their 'youthfulness was also evident in the magazine's
design and layout' as they targeted 'visually erudite youngsters' who had
grown up with television and MTV where 'image and text must be evenly
matched'.[84] In this respect also *i-D* appears to have been a forerunner.

In 1989 David Chandler pointed out that the function of fashion imagery
had changed, as it's 'role as a kind of foreplay to the act of consuming is
less apparent. We have come to a point where the idea of "just looking" has
a wider significance in the whole process. As much as it reflects and conditions
lifestyle, the act of looking at fashion images has become a lifestyle in itself,
one of flickering illusions and seductive, ambivalent stories.'[85] This development
can be discerned in *i-D* and is particularly evident in an issue from 1990,
which included four photographs by Paolo Roversi depicting the model
Kersten Owen in a dress belonging to the photographer's mother and thus
not available on the market.[86] Although this spread does not present the
dress visually to any larger degree, a feature that became common in fashion
photography in the 1990s, it can also be inscribed in the larger context of
postmodern advertising that did not put the product in the centre.[87] These
pages challenge the fashion magazine as format more than any of the above
in the sense that they have cut another link. While the garment and its
brand and price were downplayed in fashion editorials by Mark Lebon, Nick
Knight and Juergen Teller, here they are completely absent. It is as much a
fashion editorial as it is about dress and fashion, but without being the
foreplay to the act of consuming. This not only implies a new kind of aesthetic
in fashion photography but also attests to the fact that the professional role
and identity of agents within the fashion field had changed.

Magazined art

It is evident that the 1980s mark a decisive period when a number of converging
movements in different fields induced changing attitudes towards fashion

photography. It transformed from being identified as a transient, commercial and 'lightweight' photographic genre to being associated with artistry and experimentation. As shown above this process of adaption took place at the interfaces between the fields of art, applied photography and printed press and graphic design and was visible, yet differently, on the pages of *Artforum* and *i-D*. These transformational processes were due not only to ideological and aesthetic factors discussed above but also to economic, material and technical circumstances. Indeed, there was an interest within the postmodern art field in mixed media and mixed genres and an awakened photo historical interest in museums and among representatives of the art market. In addition, the 1980s was characterized by an economic boom in the western world and consequently the availability of funds was generally good, in both the art world and the fashion world. This series of events also coincided with the release of new tools for graphic design. In 1985 the software Page Maker was launched and only two years later the more advanced software for graphic design, QuarkXPress, became available on the market. With this software, text and images could be moved freely on the pages, text could be laid on top of semi-visible images, and images and texts could be twisted and distorted.[88]

As discussed above, the interest in the world of fashion was clearly spelled out in the art journal *Artforum*. An interest in, or affinity with, the art world was however not spelled out in the same direct way in *i-D*. The magazine did not present itself overtly as one that considered fashion and art in the 1980s, unlike the succeeding niche fashion magazines of the 1990s and onwards. However, several of the editors, photographers and graphic designers behind the magazine had close ties to the art world as they were educated at art schools. A hint of the magazine's standpoint on this can be found in an editorial letter from 1985, the *Art Issue*, where *i-D* suggest an answer to the perennial question of what art is:

> Many things are disguised as art, and much art goes unrecognized – art is everywhere, maaaan! *i-D* says bring back culture: drown ugly art and drag good-looking art overground! Develop all untapped sources and see for yourself that art is in the mere flick of a switch, the mere wink of an eye … not art for art's sake but art for heart's sake.[89]

Although short and written in casual language this editorial letter includes several important statements about art. First, it acknowledges a broad concept of art, that 'art is everywhere'. It also argues for beauty, the 'good looking', as a vital part of art. Finally, it establishes a connection between the magazine itself and art when it says that art is 'in … the mere wink of an eye' – that is a reference to the trademark of *i-D* itself. All told, it is evident that the discourse on fashion and on fashion photography as an art form was going on simultaneously in *Artforum* and *i-D* in the 1980s. However, it was primarily a textual

discourse in the former and a visual discourse, and thus less tangible, in the latter.

From an overall perspective there were several similarities between *Artforum* and *i-D* in the 1980s. Both magazines promoted fashion photography. The documentary tradition and discourse from the 1970s were still strong during the first half of the 1980s and this permeated the coverage of contemporary photography in *Artforum* as well as the fashion photographs in *i-D*. Moreover, the two magazines used similar layout strategies with their futher implications.

In both magazines there was an evident downplay of text, and the use of pages only containing images. Indeed, the fashion spreads that appeared in *i-D* from the mid-1980s onwards have clear affinities to the presentation of artworks, the so-called 'projects' in *Artforum* in the 1980s.[90] In most cases the projects in *Artforum* took the form of a number of pages with only artworks and no editorial text. The projects were briefly presented by text either at the beginning of the section or at the end, and generally looked very much like the fashion editorials of *i-D* during the same period. In both, the images dominated the spreads and they occasionally included non-descriptive words or text fragments.[91]

Another significant similarity between the presentations of projects in *Artforum* and the new type of fashion spread in *i-D* was that they included pages open to personal expression, in the sense that the typography, layout and style did not conform with the graphic identity of the rest of the publication. This is particularly evident in *Artforum*, which to a great extent consisted of square, textual ads in black and white (figure 3.2). Thus the 'free space' given to the artist deviated heavily in style from the rest of the magazine with the use of large borderless images, abundantly coloured, and different typography. Two projects that explicitly consider fashion can serve as typical cases here. The first, published in 1985, presented Italian Cinzia Ruggeri who 'practices polygamy in her studio in Milan. Simultaneously married to the natural and the artifice the raw and the cocked, she knits a multilingual fabric of architecture, fashion, design, photography, anthropology, geology, and the ecology.' (plate 14)[92] The two-page spread is a collage of photographs of models in garments, with accessories like shoes, bags and gloves, a wine glass and a crocodile. The photographs appear on a marble-like background and on top is a bird's egg, a string of beads and splashes of red paint. The composition not only defies genre categorization but also combines representations of three-dimensional objects and two-dimensional pictures. This kind of cut and paste and play with several layers of representation was a core feature in the fashion editorials in *i-D*.

Another example was published in 1990. This project, consisting of two pages, reproduced two black and white pastel drawings of a model in a dress

which were accompanied by the text 'Romeo Gigli Spring/Summer collection 1990. A project for Artforum' and 'Drawn for Romeo Gigli by Mats Gustafsson'.[93] There is an obvious ambiguity as regards who the artist is and what the project – the artwork – is. The text implied that it is a project by the designer Romeo Gigli. However, the two images dominating the pages clearly bear the style of Gustafsson, famous for his elaborate fashion illustrations in watercolour and pastel. The combination of text and image not only presents a puzzle about who the artist is. It also explicitly attests to the collaboration between a designer and the one making a representation of the design, as a vital element of all fashion images, be it photographs or drawings.

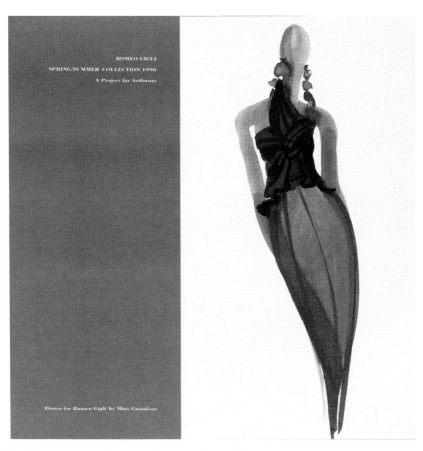

3.4 An *Artforum* project drawn for Romeo Gigli by Mats Gustafson, 1990.

In her inaugural editor's letter in 1980 Ingrid Sischy declared that her ambition was to give free space for artists in *Artforum* and that the artists included: 'represent a wide range of views but they have in common an admitted, proven exemplary commitment to using the page as ground. Apart from the reviews none of the pages in this issue is a reproduction of a work of art, all *are* primary art intended for this, and only in this format'.[94] According to American art critic Clive Phillpot, such publications were examples of magazine art, defined as: 'art conceived specifically for a magazine context and, therefore, art which is realized only when the magazine itself has been composed and printed'.[95] Within the art field, magazine art still implied, in 1980, a radical position as it undermined the idea of the unique, handmade art object. According to Phillpot this kind of enterprise had been done since the 1960s when a number of artists sought to produce magazines to question the nature of artworks and to make art 'specifically for dissemination through a mass communication medium'.[96] In *Artforum* the frequency of such project pages substantially increased after 1988 when the new editor-in-chief, Ida Panicelli, took over. In a later interview she declared that her agenda was to give more space to artists' projects because she wanted to signal that '*Artforum* belonged to artists'.[97]

Consequently, the experiments with graphic design and fashion photographs in *i-D* in the 1980s cannot only be contextualized in the punk, fanzine and the do-it-your self culture of 1970s and 1980s London, as has been put forward by the editor and photographers behind the magazine, and later writers.[98] Indeed, it can also be connected to artists' magazines of the preceding decades as well as to practices within the contemporary *Artforum*. Already in 1980 the journal *Camerawork* reported that fashion photographers were 'beginning to talk about being "given free rein" by magazines'.[99] Thus when *i-D* successively granted photographers 'freedom' to produce fashion editorials in a personal style this was already a topic within the photographic discourse and a practice within *Artforum* (plate 15).

Within the art field, magazine art took a radical position with its multiple low-cost artworks. In addition, the collaborative nature of a magazine, also the default working method for producing fashion photographs, bears in itself a critical dimension as it defies a single originator. Magazines like *i-D* and its successors in the 1990s and onwards, can thus be described as a kind of commercialization of this radicality. The editorial text, the downplay of the garments and the relative freedom in which different photographers could work in *i-D* were in fact not only challenging the fashion world and the trade of fashion photography. They also challenged the notion of art because what remains when the editorial text and the depiction of saleable goods are downplayed, or even completely subtracted, is a strong focus

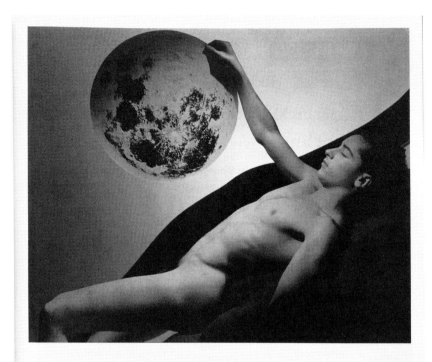

3.5 Advertisement for George Platt Lynes' exhibition in *Artforum*, 1981.

on the surface of the image, or more specifically on the printed magazine itself as a commodity, object or artwork. As a result, the magazine is *itself* the end product, not just a vehicle for representing and/or selling other products. It became not only an alternative space for photographers to display their work, but also a new medium for producing and distributing work. Accordingly the niche fashion magazines that flourished in the 1990s and onwards can be described as one among many outlets for contemporary photographers, which worked in tandem with photographic prints for exhibitions, photo books and assignments for fashion catalogues and magazines.[100] Consequently, the magazine was itself a medium for artistic expression; it was not only an alternative media space or place for consuming art but an alternative platform for artists. For photographers like Wolfgang Tillmans and Juergen Teller the printed magazines became the means through which

they could question the art world's established routines for display and selling. This new platform and medium consequently not only questioned the divide between art and fashion; magazined art also challenged the divide between elitism and mass circulation on the one hand and commerce, consumption and an anarchic rejection of such capitalist driven processes on the other.

Notes

1 For an extensive overview of the relationship between art and fashion see A. Gerczy and V. Karaminas (eds), *Fashion and Art* (London: Bloomsbury, 2012). Quote from P. Bourdieu and Y. Delsaut, 'Le Couturier et sa griffe. Contribution à une Théorie de la Magie', *Actes de la Recherche en Sciences Sociales*, 1:1 (1975), 7–36. As referred in J. Entwistle and A. Rocamora, 'The Field of Fashion Realized. A Case Study of London Fashion Week', *Sociology*, 40:4 (2006), 739.
2 A comprehensive historical overview of these relations can be found in C. Andersen, *Modefotografi. En genres anatomi* (Copenhagen: Museum Tusculum Press, 2006). See also E. Shinkle, 'Introduction', in E. Shinkle (ed.), *Fashion as Photograph. Viewing and Reviewing Images of Fashion* (London: I.B. Tauris, 2008), pp. 1–14.
3 Such paramount photographers form the bulk in classical overviews of the history of fashion photography such as N. Hall Duncan, *A History of Fashion Photography* (New York: Alpine Book Company, 1979) and F. Ducros, 'The dream of beauty. Fashion and fantasy', in M. Frizot (ed.), *A New History of Photography* (Köln: Könemann, 1998), pp. 535–553.
4 For collecting practices see R. Muir, 'A Subversion Genre', in *Addressing the Century. 100 Years of Art and Fashion* (London: Hayward Gallery, 1999), pp. 100–105 and G. Thornton, 'Fashion photography. An art of democracy', in *Fashion Photography. Six Decades* (New York: Emily Lowe Gallery, Hofstra University, Hempstead, 1976). For examples of reviews see Cecil Beaton's biography in T. Pepper, 'Reviewing the reviews of "Cecil Beaton – The authorized biography" by Hugo Vickers', *Creative Camera*, 252 (December 1985), 11–12.
5 For examples from the debate of the late 1970s see pages 105 and 110. For an early example of this debate see Anon., 'The junior member of the fine arts', *Vogue* (February 1914), pp. 19–21.
6 See for example Gerczy and Karaminas, *Fashion and Art*; C. Nickerson and N. Wakefield, *Fashion. Photography of the Nineties* (Zürich: Scalo, 1998); U. Poschardt, M. de Beaupré and S. Baumet, *Archeology of Elegance, 1980–2000. 20 ans de photographie de mode* (Paris: Flammarion, 2002); S. Kismaric and E. Respini, *Fashioning fiction in photography since 1990*, (New York: Museum of Modern Art, 2004).
7 Kismaric and Respini, *Fashioning Fiction in Photography since 1990* p. 12; M. Wawrzyniak (ed.), *Purple Anthology. 1992–2006* (New York: Rizzoli, 2008), p. 1. See also S. Kismaric and E. Respini, 'Fashioning fiction in photography since 1990', in Shinkle, *Fashion as Photograph*, p. 30.

8 I do not use the designation 'fashion photographer' in this chapter as photographers have typically worked with many different kinds of assignments simultaneously. Nevertheless, I use the notion 'fashion photographs', defined as photographs aimed to promote a designer or brand of garment/accessories, or photographs produced for fashion publications like catalogues or magazines.

9 For examples see Poschardt, Beaupré and Baumet, *Archeology of Elegance, 1980–2000*; Andersen, *Modefotografi*; S. Gaensheimer and S. von Olfers (eds), *Not in Fashion. Photography and Fashion in the 1990s* (Bielefeld, Ger.: Kerber, 2010).

10 R. Barthes, *The Fashion System* (Berkeley: University of California Press, 1990) [*Système de la mode*, 1967]. See also P. Garner, 'The celebration of the fashion image. Photograph as market commodity and research tool', in Shinkle, *Fashion as Photograph*, pp. 46–53.

11 A. Lynge-Jorlén, 'Between Frivolity and Art: Contemporary Fashion Magazines', *Fashion Theory*, 16 (2012), 7–28.

12 Kismaric and Respini, *Fashioning Fiction in Photography*, p. 20.

13 J. Verwoert, *Wolfgang Tillmans* (London: Phaidon, 2002), p. 18 as referred in A. Krause Wahl, 'Page by page. Fashion and photography in the magazine', in Gaensheimer and von Olfers, *Not in Fashion*, p. 28.

14 In 1980 the magazine *The Face*, devoted to music, fashion and youth culture, also appeared in the UK. Despite its similarity with *The Face*, *i-D* has been chosen for this case study for two reasons. First, *i-D* included more fashion editorials in the early 1980s. As pointed out by Jobling there were only fourteen fashion features published between 1980 and 1983 in *The Face*. Second, the graphic forms and layout of *i-D* were more experimental in the early 1980s. See P. Jobling, *Fashion Spreads. Words and Images in Fashion Photography Since 1980* (London: Berg, 2010). For comparison I have browsed a number of magazines on photography and fashion such as the British photo journal *Creative Camera* (1980–85), the German magazine *032c* (2000–8), the German magazine *Sleek* (2006–7), and the French magazine *Purple Prose* (1992–98).

15 Sischy was editor-in-chief from the February 1980 issue to the February 1988 issue.

16 S. Thornton, *Seven Days in the Art World* (New York: W.W. Norton, 2008), p. 145; *Artforum* subscription advert in *Artforum* (October 1985), p. 140.

17 See for example 'Strike. A Project by Jonathan Borofsky', *Artforum* (February 1981), pp. 50–56; 'A Project by Nicholas Nixon', *Artforum* (December 1981), pp. 44–48; 'Putting Together Thoughts on the New Painting. Dorotea Rockburne, *Artforum* (October 1984), pp. 72–75; 'Shadow Captions', *Artforum* (January 1985), pp. 52–81; 'A Project by Antoni Tapies', *Artforum* (October 1985), pp. 109–112; 'A Project by Cinzia Ruggeri', *Artforum* (October 1985), pp. 118–119; 'The Red and the Black. Alighiero Boetti Project for Artforum', *Artforum* (Summer 1986), pp. 98–102; 'The World of Photography. Michael Smith and William Wegman', *Artforum* (October 1986), pp. 106–111; 'Sorcerers and Apprentices. A Project for *Artforum* by Pat Oleszko', *Artforum* (November 1986), pp. 117–121; Baptism – Layout! Jeff Koons', *Artforum* (November 1987), pp. 101–108; Meg Wester, 'Home. A Project', *Artforum* (Summer 1988), pp. 109–115; 'Narcotics of Surrealism. A

Project for *Artforum* by Gretchen Bender', *Artforum* (December 1988), pp. 90–91; 'Sorry. A Project for *Artforum* by Guillaume Bijl', *Artforum* (January 1989), pp. 79–82; 'The Passageway. A Project for *Artforum* by Wolfgang Laib', *Artforum* (April 1989), pp. 136–141; 'Mother as Mountain. A Project for *Artforum* by Anish Kapoor, Sylvie Primard and Pier Luigi Tazzi', *Artforum* (September 1989), pp. 126–131; 'Japanese Moments. A Project for *Artforum* by Ange Leccia', *Artforum* (January 1990), pp. 101–104; 'See. Speak. Hear. Heads. A Project for *Artforum* by Jeanne Dunning', *Artforum* (May 1990), pp. 165–167.

18 See for example T. Papageorge, 'From Walker Evans to Robert Frank. A Legacy Received, Embraced and Transformed', *Artforum* (April 1981), pp. 33–37; M. Kozloff, 'The Extravagant Depression. John Gutmann's Photographs of the Thirties', *Artforum* (November 1982), pp. 34–41; R. Brooks, 'Gilbert & George Shake Hands with the Devil', *Artforum* (Summer 1984), pp. 56–60.

19 www.stephenmale.com (last retrieved 6 March 2015).

20 F. Vermorel, 'Review of *The Face* exhibition', *Creative Camera*, 247/248 (July/ August 1985), 67.

21 Editorial letter *i-D* #14 (April 1983), p. 1.

22 Editorial letter *i-D* #14 (April 1983), p. 1.

23 See issues of *i-D* #1, 1980 to #42, 1986.

24 Advert in *Artforum* (October 1985), p. 140.

25 Glenn O'Brian's column 'Like Art' appeared from the September 1985 issue to the December 1990 issue, the last issue of this survey. The column 'Turned Out', written by William Wilson and Sunil Sethi, appeared in the following issues: September 1985, p. 7; October 1985, p. 8; March 1986, p. 8. Lisa Liebmann's 'Icons at Large' column appeared in the following issues: November 1986, pp. 8–9; December 1986, pp. 4–5; February 1987, p. 7; April 1987, pp. 2–3; May 1987, p. 11; September 1987, pp. 2–3, October 1987, p. 10. See also http://glennobrien.com/ site/#/bio and http://artforum.com/news/id=40529 (last retrieved 25 March 2015).

26 A. Mammi, 'Ida Panicelli. Interviewed by Allesandra Mammi', *Artforum* (September 1993), p. 180.

27 The following conclusions are based on an examination of the editorial texts and images and advertisments in all issues of *Artforum* between the January issue of 1979 and the December issue of 1990.

28 See individual gallery websites for further information on their foundation etc.: www.icp.org/about; www.robertmillergallery.com/#!about/c1b1x; http:// thephotographersgallery.org.uk/history; www.zabriskiegallery.com/about; https:// fraenkelgallery.com/gallery; www.metropictures.com/info/; www.feldmangallery.com/ pages/home_frame.html (last retrieved 25 March 2015).

29 See in the *Artforum* issues of November 1980, March 1981, April 1981, September 1981, November 1982, March 1983, October 1984, January 1985, May 1985, September 1985, January 1987, March 1987, May 1987, November 1987, November 1988, December 1988, March 1990, May 1990.

30 The same pattern can be seen in overviews of the history of photography. See for example B. Newhall, *The History of Photography*, 5th edition (New York: Museum of Modern Art, 1982), p. 266.

31 H. Kramer, 'The Dubious Art of Fashion Photography', *New York Times* (28 December 1975), p. 100.

32 D. Turbeville, *Wallflower* (London: Quartet Books, 1978).

33 Kismaric and Respini, *Fashioning Fiction in Photography*, p. 20; V. Williams, 'A Heady Relationship. Fashion Photography and the Museum 1979 to the Present', *Fashion Theory. The Journal of Dress, Body & Culture*, 12 (2008), 197–218; M. Riegels Melchior, 'Introduction. Understanding fashion and dress museology', in M. Riegels Melchior and B. Svensson (eds), *Fashion and Museums* (London: Bloomsbury Academic, 2014), pp. 7–12.

34 See for example, Anon., 'Costume Branch for Metropolitan. Museum Adds Institute of Fashion in Step to Stress Style Design as Art', *New York Times* (12 December 1944), p. 20 and N. Norell, L. Nevelson, I. Sharaff et al., 'Is Fashion Art?', *Metropolitan Museum of Art Bulletin*, 26:3 (November 1967), 129–140.

35 Hall Duncan, *History of Fashion Photography*. There was also a book published in conjunction with the exhibition *Fashion Photography. Six Decades* at Emily Lowe Gallery, Hofstra University, Hempstead, New York, 30 October – 14 December 1975. While being an early example of a history of fashion photography, the latter is limited, comprising only three pages of text. See Thornton, 'Fashion Photography. An art of democracy'.

36 R. Flood, '"Intimate architecture. Contemporary Clothing Design", Hayden Gallery Massachusetts Institute of Technology' (review), *Artforum* (November 1982), pp. 78–79; L. Liebmann, 'Yves Saint Laurent', Metropolitan Museum of Art (review), *Artforum* (May 1984), pp. 81–82; Advert for the exhibitions 'Socialities & Satellites' and 'Mystique and Identity: Women's fashion in the 1950s', Ronald Feldman Fine Art, 31 Mercer Street, NY, *Artforum* (April 1984), p. 11; D. Zacharopoulos, 'Times, Fashion, Morals, Passion', *Artforum* (October 1987), p. 148; 'Mode et photo', Centre George Pompidou Paris, *Artforum* (September 1986), pp. 58–59; Anon., 'Art & advertising. Commercial Photography by Artists. International Center of Photography', *Artforum* (November 1986), p. 136; Advert for David La Chapelle at Bleeker Gallery, New York, *Artforum* (Summer 1988), p. 81; Advert for David La Chapelle at Trabia McAfee Gallery, New York, *Artforum* (January 1989), p. 65; Advert for David La Chapelle at Trabia Gallery, New York, *Artforum* (April 1990), p. 110; review of exhibition of William Klein at Zabriskie Gallery, New York, *Artforum* (April 1990), p. 186.

37 See for example articles on fashion C. Squiers 'Slouch Stretch Smile Leap', *Artforum* (November 1980), pp. 46–54; M. Kozloff, 'A Double Portrait of Cecil Beaton', *Artforum* (October 1986), pp. 118–124; W. Wilson, 'Turned Out' [Richard Avedon], *Artforum* (September 1985), p. 7 and adverts for the George Platt Lynes exhibition at Robert Miller Gallery, New York, *Artforum* (October 1981), p. 23 and Hedy Klineman, Govinda Gallery, Washington DC, *Artforum* (Summer 1984), p. 20.

38 B. Burman Baines, I. Jeffrey and J. Williamson, 'Three Responses to "Shots of Style" at the V&A', *Creative Camera*, 252 (December 1985), 9. *Creative Camera* was a monthly magazine on visual art photography and documentary photography published in England between 1968 and 2001.

39 See for example C. Ratcliff, 'Fashion, Style and Art', *Art in America* (July/August 1979), 91–97; C. L. Westerbeck, Jr, 'Photography Now', *Artforum* (January 1979), pp. 20–23; R. Hennessy, 'What's All This About Photography?', *Artforum* (May 1979), pp. 20–25; Hall Duncan, *History of Fashion Photography*; K. Steinworth, 'The Arrested Glance', *Photographis*, 15 (1980), 8; R. Brooks, 'Double-Page Spread. Fashion and Advertising Photography', *Camerawork* (January/February 1980), 1–3; Burman Baines, Jeffrey and Williamson, 'Three Responses to "Shots of Style"', 9; *Shoots of Style. Great Fashion Photographs Chosen by David Bailey* (London: Victoria & Albert Museum, 1985). See also pp. 96 and 110 below.

40 S. Sontag, 'The Avedon Eye. Looking with Avedon', *Vogue* (April 1979), p. 508.

41 Brooks, 'Double-Page Spread', 2.

42 Kramer, 'The Dubious Art of Fashion Photography', p. 100.

43 Andersen, *Modefotografi*, pp. 131 and 209.

44 See for example W. Wilson, 'Turned Out', *Artforum* (October 1985), p. 8; G. O'Brian, 'Like Art', *Artforum* (March 1986), p. 9; Anon., 'Art & advertising. Commercial Photography by Artists' , p. 136; M. Holborn, 'Image of a Second Skin', *Artforum* (November 1988), pp. 118–121.

45 For analysis of the white cube in fashion photography see for example Sontag, 'The Avedon Eye', p. 507 and Holborn, 'Image of a Second Skin', pp. 118–121.

46 I. Sischy and G. Celant, 'Editorial', *Artforum* (February 1982), p. 34.

47 Wilson, 'Turned Out' (October 1985), p. 8.

48 I. Sischy and G. Celant, 'Editors' Letter', *Artforum* (February 1982), pp. 34–35.

49 'Anon., Issey Miyake. Sewing a Second Skin', *Artforum* (February 1982), pp. 56–57.

50 For descriptions of this historical process see V. Steele, *Japan Fashion Now* (New Haven, Conn.: Yale University Press, 2010), pp. 17–23 and Y. Kawamura, *The Japanese Revolution in Paris Fashion* (Oxford: Berg, 2004).

51 Holborn, 'Image of a Second Skin', 121.

52 A. Staniszewski, *The Power of Display. A History of Exhibition Installations at the Museum of Modern Art* (Cambridge, Mass.: The MIT Press, 1998), pp. 141–206. See also the review of the exhibition 'Fashion Plate' at Metropolitan Museum of Art, New York: B. Morris, '2 Centuries of Fashion as an Art Form', *New York Times* (20 October 1971), p. 42.

53 S. Sidlauskas, *Intimate Architecture. Contemporary Clothing Design*, 15 May – 27 June 1982, Hayden Gallery (Cambridge. Mass.: Massachusetts Institute of Technology, 1982), unpaginated.

54 J. Duka, 'Clothing as architecture at M.I.T', *New York Times* (17 May 1982), p. 10.

55 Sidlauskas, *Intimate Architecture*.

56 See particularly *Purple Prose* (1992–98) and *032c* (2000–) and also more recent publications such as *The Archivist* (London, 2012–), *Modern Matter* (London, 2011–) and *Verites* (London, 2011–).

57 Later, when the magazine's content conformed to a greater degree with other fashion magazines, the subtitle was first 'Manual of Style' and then 'Worldwide

Manual of Style'. Fashion Magazine (# 1–6, 1980); Manual of Style (# 7–10, 1982): Worldwide Manual of Style (# 11–43, 1983–87).

58 Art, Words, Photographs (#7, 1982–); Styling (#14, 1983–); Fashion editor (#24, 1985–).

59 No. 46, April 1987. Under the headline 'Art', art directors like Moira Bogue, Stephen Males and other were listed. See for example, T. Blanchard, 'A Wink and a Smile', *Guardian* (25 March 2001) (www.theguardian.com/theobserver/2001/mar/25/features.magazine37).

60 See *i-D* from issue 1 autumn 1980 to issue 99 December 1989. This was used for everybody related to the content (i.e. not administration) until the end of 1990, which has been the end point for this survey.

61 See issues 1–15 of *032c* published between 2000 and 2008. For the history, initial aim and scope of *Purple Prose* see M. Wawrzyniak (ed.), *Purple Anthology. 1992–2006* (New York: Rizzoli, 2008). *Sleek*, launched in 2000 bore the subtitle 'Magazine for Art and Fashion' while *032c* changed its subtitles. It was, for example, 'Fashion, Art & Conflict' in issues 8 and 9, 2004/2005. The magazine is currently presented as a 'fashion and art magazine' on their website. http://032c.com/archive/issues/

62 Brooks, 'Double-Page Spread', 1.

63 J. Hart, 'What's Wrong with Fashion Photography? (Apart from being Sexist, Racist and Capitalist)', *Creative Camera*, 252 (December 1985), 27–29; Burman Baines, Jeffrey and Williamson, 'Three Responses to "Shots of Style"', 8–10.

64 Ratcliff, 'Fashion, Style and Art', 96.

65 Westerbeck, 'Photography now', p. 23.

66 The term 'documentary' entered the photographic discourse in the 1930s and was coined by the British filmmaker John Grierson in 1926. For an overview of the history, practice and contradictions of documentary photography see M. Rosler, 'In, around, and afterthoughts (On documentary photography)', in R. Bolton (ed.), *Contest of Meaning. Critical Histories of Photography* (Cambridge, Mass., MIT, 1992), pp. 303–343 and A. Solomon Godeau, *Photography at the Dock. Essays on Photographic History, Institutions, and Practices* (Minneapolis: University of Minnesota Press, 1991), p. 169.

67 A. Thomas, 'Irony and mythology. The fashion magazine reconsidered', in S. Stanfill (ed.), *80s Fashion. Club to Catwalk* (London: Victoria and Albert Museum, 2013), p. 78. It is also evident that the photographer David Bailey, active from the 1960s, was an inspiration.

68 An overview of Diane Arbus's large number of images commissioned and published by the press between 1960 and 1971 can be found in D. Arbus and T. Southall, *Diane Arbus. Magazine Works* (New York: Bloomsbury, 1984), pp. 172–175.

69 Thomas, 'Irony and mythology', p. 81.

70 Eamonn McCabe (b. 1948, London) and Nick Knight (b. 1958, London) studied photography at Bournemouth and Poole College of Art and Design; Marc Lebon (b. 1957, London) studied at West Surrey College of Art and Design and Communications Design, North East London Polytechnic. See http://showstudio.com/

contributor/mark_lebon; www.vogue.co.uk/spy/biographies/nick-knight-biography (last retrieved 25 March 2015).

71 Jean Baptiste Mondino in issue 80, May 1990; Paolo Roversi and Juergen Teller in issue 82, July 1990; Anton Corbijn in issue 84, September 1990; Wolfgang Tillmans in issue 99, December 1991.

72 *i-D* #19 (October 1984), pp. 30–37.

73 Shinkle, 'Introduction', p. 11.

74 *i-D*, #49 (July 1987), pp. 48–68.

75 M. Bal, 'Telling objects. A narrative perspective on collecting', in J. Elsner and R. Cardinal (eds), *The Cultures of Collecting* (London: Reaktion Books, 1994), pp. 100–102.

76 This has been confirmed by Paul Jobling in an email to the author (24 august 2016). For an extensive overview over fashion photography in *The Face* in this period see Jobling, *Fashion Spreads*.

77 *i-D*, #83 (August 1990), pp. 46–55.

78 Venetia Scott, stylist, later photographer and partner of Teller. Teller was then acting as photographer while Scott was stylist: http://showstudio.com/contributor/venetia_scott

79 For an overview of the photographs produced within the Farm Security Project between 1935 and 1944 see the collection and archive at Library of Congress: www.loc.gov/pictures/collection/fsa/

80 R. Barthes, 'The rhetoric of the image', in *Image/Music/Text* (London: Fontana Press, 1977), pp. 32–51.

81 For presentations of these artist see D. Crimp, 'Pictures', *October*, 8 (Spring 1979), 75–88; Solomon Godeau, *Photography at the Dock*.

82 Thomas, 'Irony and mythology', p. 84.

83 Thomas, 'Irony and mythology', p. 93 referring to D. Hebdige, 'The Bottom Line on Planet Obe. Squaring Up To *The Face*', *Ten8*, 19 (1985), 43. 'This experimental and performative nature of style magazines was evoked by the sociologist Dick Hebdige, who observed …'

84 J. Lamoree, J. Teunissen and H. van der Voet (eds), *Everything but Clothes. Fashion, Photography, Magazines* (Arnhem: ArtEZ Press, 2015), p. 66.

85 D. Chandler, *Out of Fashion. Photographs by Nick Knight and Cindy Palmano*. Catalogue from The Photographers' Gallery.

86 *i-D*, #82 (July 1990), pp. 54–55.

87 Andersen, *Modefotografi*, pp. 213–231 (blurring); Joan Gibbons, *Art and Advertising* (London: I.B. Tauris, 2005), p. 68.

88 See https://en.wikipedia.org/wiki/Desktop_publishing#DTP_applications; https://en.wikipedia.org/wiki/QuarkXPress; https://sv.wikipedia.org/wiki/Pagemaker; https://en.wikipedia.org/wiki/Desktop_publishing (last retrieved 25 March 2015).

89 *i-D*, *Art Issue* #28 (August 1985), Editorial letter, p. 1.

90 See for example *i-D*, #22 (February 1985), pp. 34–35; *i-D*, #35 (April 1986), pp. 37–41; *i-D*, #79 (April 1990), pp. 48–61; *i-D*, #85 (October 1990), pp. 46–58.

91 For examples in *Artforum* see note 17.

92 'A Project by Cinzia Ruggeri', *Artforum* (October 1985), pp. 118–119.

93 'A Project for Artforum. Drawn for Romeo Gigli by Mats Gustafson', *Artforum* (March 1990), pp. 150–152.

94 Ingrid Sischy, editor's letter, *Artforum* (February 1980), p. 26.

95 C. Phillpot, 'Art Magazines and Magazine Art', *Artforum* (February 1980), p. 52.

96 Phillpot, 'Art Magazines and Magazine Art', pp. 52–54.

97 Mammi, 'Ida Panicelli', 180–181.

98 See Chandler, *Out of Fashion*; Thomas, 'Irony and mythology', p. 82; 'Hinterview Terry Jones', *Hint Fashion Magazine*, www.hintmag.com/hinterview/terryjones/terryjones1.php

99 Brooks, 'Double-Page Spread', 2.

100 See for example the presentations of Wolfgang Tillmans, Juergen Teller and Paolo Roversi: http://tillmans.co.uk/biographybibliography-menu3–6–sp-1609089096/6–bibliography-englishdeutsch, http://www.lehmannmaupin.com/artists/juergen-teller and www.paoloroversi.com/images/pdf/biography.pdf (last retrieved 25 March 2015).

Imposter art **4**

This chapter deals with artworks that have migrated from the context of the art world to those of the law and news, literally from the gallery to the courtroom and the pages of the daily press. Artworks that cross legal boundaries and are judged as illegal acts or objects are illuminating examples of how the notion of art is continuously negotiated by different agents in different contexts. This chapter seeks to discuss news media as one such agent and context. Historically, there have been many instances where the notion of art has been negotiated through legal processes. As pointed out by Sadakat Kadri, the courtroom serves as 'a stage on which contested attitudes towards the value of creativity can be publicly resolved'.[1] Yet I argue that the same can be said about the pages of daily journals and news reporting in other media. Indeed, it appears that news media also serve as a stage where the notion of art is publicly negotiated. This is particularly pertinent in cases when art violates the public perception of what is legally right.

The three Swedish artworks in focus in this chapter were judged as illegal acts in 1967, 1993 and 2009. Thus, they share the capacity of simultaneously being judged as artistic statements and real illegal deeds. In the Swedish art field they were all seminal events that triggered huge debate. The first example considers two graphic prints whose contents were subject to legal penalty. These prints were later listed among the 150 most important cultural products in Sweden during the last 150 years.[2] In the case of the two latter artworks, however, it was the *acts* of the artist that were deemed illegal. In these two cases it also seems that the intertwining of the act of the artist and the (re) actions of the public, and their dissolved bounds between artwork and public space made them especially challenging in relation to agents outside the art world.[3]

Art and media

One underlying aim of this chapter is to explore the mediatization of contemporary art, that is to say, how the mass media, such as the daily press,

professional journals and television interpreted the duality between the legal and artistic aspects of these events and how the media discourse intervened and acted in these respective processes. Mediatization is here understood as the structural transformations of practices, cultures and institutions imbued by media, in this case the notion of art.[4] Accordingly, this study expands its focus beyond the typical agents of the art world such as curators, critics and art historians to include statements and writings from representatives of politics, media, entertainment, law and the general public. Hence, this study moves outside the aesthetic regime where art is free 'from any specific rule, from any hierarchy of the arts, subject matter, and genres'.[5] The cases considered are the artworks by Carl Johan De Geer in the exhibition at Karlsson Gallery in Stockholm 1967, Dan Wolgers' participation in the exhibition *Ecce Homo Se människan* in Stockholm in 1992 and Anna Odell's project 'Unknown woman 2009–349701' performed in central Stockholm in 2009. Even though these cover a time span of forty years and these artists and their artworks differ in many respects, they share a legal epilogue as well as extensive media coverage and debate.

Most studies of art and media have focused on art criticism or cultural critique in a broad sense, which also mirrors the majority of media texts on art where artists and their work are typically considered in the form of reviews of exhibitions.[6] Moreover, the mass media has been used by artists. Historically, there are many examples of how individual artists and advocates for artistic movements have used mainstream mass media to convey their works and ideas.[7] Thus, since modernity and the development of the printed press there has been a dual exchange between mass media and the art field as they have been mutually dependent and have exchanged services. Yet the artworks and the media coverage discussed in this chapter differ in the sense that these artworks were treated as news and considered as any other event on the news pages in the daily press. The commodity of news media is news, often a narrative consisting of sudden happenings and conflicts. As will be shown below, art that is deemed ethically or legally wrong smoothly fits into this general logic of news media. Moreover, as two of these cases will demonstrate, media may play another role vis-à-vis art and may in fact spur events that will later become part of an artist's oeuvre.

Incitement or artistic expression

My first example relates to the legal and media aftermath of an exhibition of three graphic prints by Swedish artist Carl Johan De Geer in the spring of 1967. They were silk-screen prints depicting the Swedish and the American flags combined with anti-war and anti-nationalistic written messages such as the phrases 'refuse arms', 'desecrate the flag', 'desert the motherland', 'be

un-nationalistic' and 'USA killers'. The latter appeared with the American flag, and its stars had been replaced with swastikas. De Geer was part of the young left-wing movement in Stockholm at the time and the text lines in the prints expressed his pacifist beliefs, especially in connection with what was going on in Vietnam.[8] The prints, which were produced in an edition of around a hundred copies in total, were included in an exhibition which the artist held together with his wife Marie Louise De Geer at the Karlsson gallery in Stockholm. The opening took place on Saturday 29 April.[9] The following day, at 11 p.m., the police broke in to the gallery and confiscated all three prints. The search warrant was issued when some patrolling policemen had accidently spotted the print, *USA killers*, in the gallery window facing the street.[10]

Two days later, on 2 May the national daily paper *Svenska Dagbladet* and the evening paper *Expressen* reported that the police had conducted a house search on Sunday 30 April, that is, the day after the opening of the exhibition. The reason was the visual motif as well as the text on the prints, and the alleged crime was desecration of national symbols and incitement.[11]

As the representations themselves and their dissemination were subject to prosecution the prints were never reproduced or presented visually in the media coverage. However, all the textual content was reported, except for the word 'cock' which was instead circumscribed by alternative wordings – 'sex word', 'dirty word' and 'four-letter word', for example.[12]

These two articles appeared on the news pages of the papers, although as yet there had been no comments or reviews by art critics on the cultural pages of the newspapers. These came a week later. On 10 May there was a review of five current art exhibitions in the conservative *Svenska Dagbladet*, including De Geer's at the Karlsson gallery. Strangely enough there was no mention of the dramatic events and intervention by the police. At that point the event was clearly a legal matter. De Geer had been interrogated by the police on 8 May and another eighteen prints were confiscated at the artist's home on 11 May.[13] The critic, however, wrote appreciatively about De Geer's patterns on cloth which were was also part of the exhibition and did not mention the controversial prints at all. Apparently, the graphic prints had been taken away from the gallery when this article ran in the paper.

Whether the art critic had indeed visited the gallery on the opening and seen the prints, or only later and missed them, is not clear. However, the critic must have been aware of the events, since it had been mentioned on the first page in the same paper (figure 4.1).[14] In any case, this indicates that there was a distinct demarcation between the cultural pages and the news pages in the paper. The other national daily paper, the liberal *Dagens Nyheter*, did on the contrary pick up on the legal process and its implications and it also appears to have held the most positive attitude to De Geer's

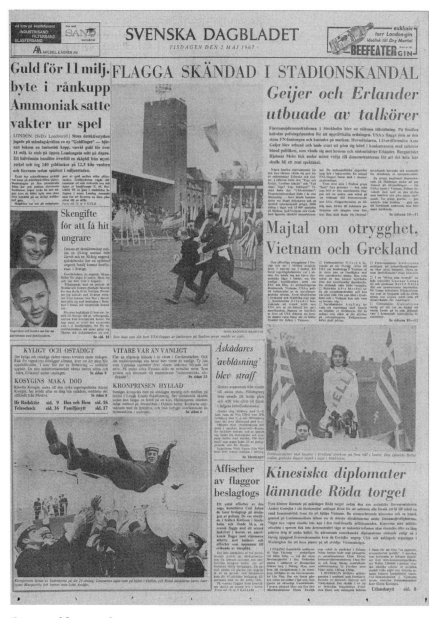

4.1 'Posters of flags confiscated'. Small note on the front page of *Svenska Dagbladet*, 1967.

artworks at the time. On 3 May it had published an article by lawyer and alderman Jan Gehlin on the general implications of the law on violating the national flag.[15] On 11 May it also published a thematic article on revolutionary art by the art critic Torsten Bergmark.[16] Bergmark's article considered De Geer's artworks in a broader historical context. For example, he remarks that the conventions on what was art, and what was not art, were previously much more rigid and valid, while today artistic conventions as well as the notion of art itself were questioned, as could be discerned in international art journals. In the international discourse 'the modern' or the 'radical' is rather noted as the 'finest blossom of Western culture' as it is evidence of its 'freedom and progress', as Bergmark conluded. In this context De Geer's artworks were mentioned, as were two other contemporary Swedish artists, Håkan Nyberg and J. E. Olzon, also holding exhibitions in Stockholm at the time. According to Bergmark, De Geer's artworks were 'unassailable aesthetically' while their content was 'dangerous' according to the police. This was followed the next month by a final comment in the paper linking De Geer to art historical predecessors who had likewise been attacked and even imprisoned on account of their artworks, such as Honoré Daumier.[17] Around the same time, the conservative *Svenska Dagbladet* reported that the artist had been charged with incitement and dishonouring the national symbol of Sweden and that of a foreign country.[18]

In September, three months later, it was reported that the artist had been judged by the Stockholm District Court and fined 1125 Swedish kronor. Exactly the same text appeared in *Svenska Dagbladet* and in *Expressen* on 7 and 8 September, which indicates that it was based on the same press release or news telegram.[19] The final reports on the events came in December 1968 when the daily papers reported that the verdict had been finally established by the Supreme Court, following the trial and appeal in the local and regional courts. According to these reports, the number of graphic prints was seventy-nine, not sixty-one as reported earlier, and all of them had now been confiscated by the state.[20] The artworks and the events that took place in April 1967 would have a long epitaph, yet at this point, after a total of eleven daily press articles, the immediate press coverage of it ended.[21]

There were no questions about whether the producer of the prints was an artist or not at the time of the event. In fact, he was either presented anonymously as a '28-year-old artist' or as 'the artist Carl Johan De Geer'. Whether the prints themselves were art was, however, indirectly questioned as they were dismissively labelled as 'posters' by *Svenska Dagbladet*.[22] Moreover, the media raised no objections to the court's decision to forfeit, that is, to destroy, the artworks.

For more than twenty years the unlawful graphic prints were barely mentioned in the press. Apparently some copies of the artwork had escaped

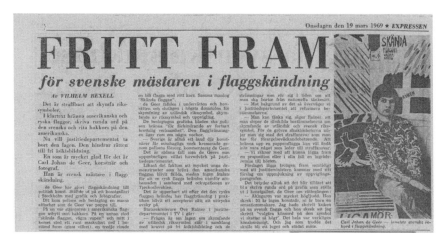

4.2 'The coast is clear for the Swedish master of flag desecration'. *Expressen*, 1969.

destruction, however. Some nine years after the events, in 1976, they appeared at Norrköpings museum as part of the exhibition *What the Fight was About* (*Vad kampen gällde*). The exhibition was reviewed by the left-wing evening paper *Aftonbladet* and one of the prints was reproduced in the report.[23] This was, however, a single case and the prints were not featured by the press until the early 1990s. In 1991 three prints were reported to have been sold at the auction house Stockholms auktionsverk.[24] The same year Norrköpings museum acquired three prints. These were bought directly from the artist and made up a part of a composite artwork *The Yellow Room* (*Gult rum*).[25]

It was in connection with an exhibition held at Moderna Museet in 1999 on the art of the 1970s that the prints were fully revived and from then on they were also repeatedly reproduced in the press.[26] In connection with the presentation of this exhibition it was also revealed that a copy of each of the three prints had been acquired for the collection of the Nationalmuseum, Stockholm in 1968. This was most probably initiated by the current director of the prints department, Per Bjurström.[27] This meant that copies of the artwork would have been held in a public museum collection since the late 1960s, and hence been, at least in theory, accessible to the general public, although they were not exhibited in the museum until some twenty years later. According to the acquisition register the prints were bought directly from the artist on 29 November 1968, apparently just before the final verdict in the Supreme Court on 9 December 1968.[28]

As the content of the artwork was in itself criminal, its presentation was somewhat circumscribed and, in consequence, partially obscured in the press. For example, the documentation from the first trial in the Stockholm court

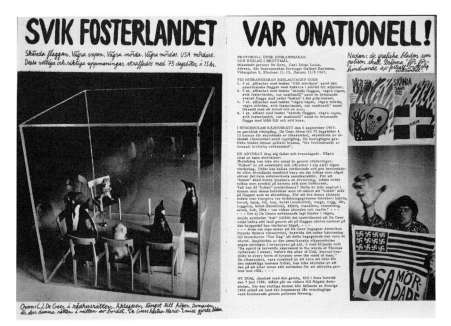

Editorial in the radical magazine *PUSS*, 1968. **4.3**

described the evidence as three photographs, most probably photographs of the prints. These are no longer among the archived documents on the legal process in the public archive, unlike other evidentiary items that underpinned the lawyers' arguments, such as newspaper clippings and magazines. Either they have never been included in the files or they have been removed prior to the records going into the public archive.[29] The reports in the daily press on the legal process in 1967 and 1968 included neither representations of the artworks nor verbal descriptions of their content. However, in 1968, the underground magazine *PUSS*, produced by De Geer and a group of other artists, had reproduced all three prints together with a satiric sculpture of the legal process produced by artist Marie Louise De Geer.[30]

The first visual reproduction in mainstream press of *Desecrate the flag*, however, appeared in an article in the liberal evening paper *Expressen* 1969, which reported that the law on desecration of national symbols was to be rewritten. The article was illustrated by a photograph of Carl Johan De Geer, 'the Swedish master of flag desecration', posing in front of one of the prints.[31] The next time a reproduction of his artwork appeared in the major press was some twenty years later. In 1989 the art and cultural critic Leif Nylén at *Dagens Nyheter* wrote an article on 'illegal art' in which one of the prints was reproduced. The article was illustrated by a photograph of De Geer holding another print, *USA killers*, in front of himself. The next reproduction

of the proscribed prints was in 1999 in connection with the exhibition at Moderna Museet in Stockholm.[32] The introductory illustration in the exhibition catalogue was *Desecrate the flag*, the one combining a political message with a four-letter word, which later became the emblematic image from the series.[33]

Despite the fact that the prints were no longer considered to be 'criminal' from 1971 when the law was changed, they continued to be controversial for a long time.[34] Indeed, their reproduction in the printed media was scarce before 1999. In 2000 when copies were on view at the auction house Bukowskis in Stockholm, they were reportedly hung in a secluded booth.[35] Four years later, when they were once again on sale at Bukowskis, they were in fact withdrawn from public view.[36]

By 2000, however, the prints had become an important reference point in Swedish art history and were regularly reproduced in the mass media (plate 16). A few years later, around 2005, De Geer produced new copies of all three prints which were sold via his gallerist. In 2009 he also sold through Bukowskis his paper transcript of the verdict from 1968.[37]

The question of public space was vital for the police action and subsequent legal process in the case of De Geer. First, the prints were spotted by some patrolling policemen while they were on display in the window of the Karlsson gallery. Second, the fact that they had been on public display both inside the gallery and facing the street in a window was an important consideration in the verdict that followed.[38]

Two points can be drawn from this media process. First it is clear that the legal process influenced the artworks' acclaim. Of the three prints the one which was not proscribed, *Vägra vapen*, was not reproduced in the press. In addition the print that included both a radical political message, and sexual content – the four-letter word 'cock' – was the one that was most widely circulated in the daily press. Second, the reproductions of them gradually appeared visually. First, they were reproduced in the background to the artist in a relatively small format; secondly, at the side of the artist still in relatively small format; and finally as large format reproductions of the artwork itself.[39]

Thief or artist

My second example considers the Swedish artist Dan Wolgers' artwork, which led to a trial and conviction in 1992 and 1993. Wolgers was invited to take part in the group exhibition *Ecce Homo Se människan* at Liljevalchs public art gallery in Stockholm, which ran from 20 November 1992 to 10 January 1993.[40] Under the pretence of including them in an installation, Wolgers borrowed two valuable benches from the gallery to make photographs of

them a month before the opening. But a couple of weeks before the opening, and without giving the gallery notice, he sold the benches at an auction house in Stockholm. The gallery knew nothing of this until three days before the opening.

When the exhibition opened, the only visible thing in the gallery space allotted to Wolgers was his nameplate. The rationale for Wolgers' act was indeed art political, although this was not communicated to the curator of Liljevalchs or the media at the time. The idea was to reverse the usual roles in the art world, where the artist provides the gallery with exhibits without receiving compensation for materials and hours worked. Through this act, the artist would be taking something from, rather than giving away something to, the gallery. A couple of weeks later the benches were recovered. As it turned out, they had been sold to a hairdressing salon in Stockholm. Thus within a month of the opening of the exhibition the benches were repossessed by the gallery and put on display together with newspaper clippings and photographs of their temporary placing in the salon (plate 17). Later the same year, Wolgers' actions were reported to the police by two private individuals, and the artist was subsequently convicted of misappropriation.[41]

There was extensive media coverage in the Swedish daily press, in art journals and on television concerning the actions of the artist and the gallery and the ensuing legal process. In fact, the mass media played a crucial part in the legal epilogue as both informants referred to information from the press and included clippings from daily journals to attest to the matter.

The first media report on the event was published through the national TT News Agency on 19 November 1992 under the headline 'Benches of the Liljevalchs Gallery stolen and sold'. Thus this information was leaked to the media before the opening, and even before the press preview, which suggests that Liljevalchs was actually the first to inform the media.[42] With regard to the media coverage, one might easily believe that the art journals, with a smaller and more knowledgeable readership, would generally be more favourable to the artist's action than the daily papers. Yet the media structure appears to have been more complex. In fact, the divide between those who condemned Wolgers for making bad art or even dismissed it as art and those who embraced his artwork as accomplished and up-to-date was represented in both. Nevertheless, there was a detectable pattern. The harshest criticism appeared in evening press, particularly the left wing *Aftonbladet*, and also in provincial daily papers and the free newspaper *Metro*, while the national newspapers were more sympathetic.

For the opposing side, the debate that followed was largely a discussion on the definition of art. The evening paper *Aftonbladet* published such an article on the day of the opening under the title 'Art or theft? Dan Wolgers' artwork: To sell the museum's benches'. The article appeared on the news

pages and was written by the general reporter Kerstin Nilsson.[43] Much of
the article considered the monetary aspects of the process –that Wolgers
sold the benches for 2500 kronor despite their being worth 10 000 kronor
each, and that he was, at the same time, entitled to a honorarium of 5000
kronor from the gallery like all the other artists participating in the exhibition.
The article was filled with pejorative phrases regarding the artist and the
artworks. First, the word 'artwork' was deliberately put in quotation marks
throughout the text to demonstrate contestation. Moreover, the artist was
said to have shown paltriness and shoddiness. The first article in *Aftonbladet*
was followed by another the next day written by another general reporter.
The subtext drew from 'The emperor's new clothes' where the main character
was instead an arrogant artist who tried to fool the general public. Wolgers
had shown no evidence of labour and produced nothing, the article asserted.
The journalist explained that this type of art was 'snobbishly called installation'
and she further pointed out that such an artwork could include 'the report
to the lawyers at the Stockholm municipality' as well as 'your anger', that
is, of the readers of the tabloid.[44] Note that it appears from the article that
reports to the police had already been made. Yet none had been made despite
the evening paper *Aftonbladet* having mentioned it in two successive articles
(plate 18).[45]

The dismissive media coverage in the Swedish daily press circled around
two themes. First it considered the nothingness, as critics focused on the
empty gallery space, illustrating to the audience an absence of labour and
experience. The lack of an explanation or further discussion regarding the
artwork from the artist further spurred the press to emphasize the work's
incomprehensibility. This can be read into the descriptions of the artist as
a 'humbug', 'a bad boy', 'provocateur' and the artwork as an 'artistic prank'.
The monetary and legal aspect of the event was also much in focus in the
daily press and, accordingly, the artist was labelled a 'thief' and the artwork
as a 'criminal act' long before he was charged, much less convicted for any
crime. The victim of the crime was Liljevalchs, and since it was run by the
city of Stockholm, the crime was interpreted as one against all inhabitants,
that is to say the taxpayers, of the capital city. To summarize, the daily press
not only questioned if the action was an artwork or a crime but eventually
expanded this to include the question of whether Dan Wolgers was an artist
or not.[46] At the time of this event Wolgers was already well established in
the art world. He had graduated from the Royal Academy of Art in Stockholm
and had held a number of exhibitions in Sweden and abroad.

There were, at the same time, other types of comments on Wolgers'
artwork in the press, which considered it in relation to the art field from a
historical perspective. This kind of art criticism appeared in the daily press
as well as in art journals. The words theft and crime did not appear at all

in these articles, nor did their authors question whether Wolgers was an artist or whether the acts at Liljevalchs were art. Instead, they sought to interpret the further meaning of the work and relate it to other conceptual artworks, as is typical of art and cultural critique. The art journal *Beckerell* described it as an 'almost social-realistic comment' on the '1980s scam businesses, characterized by unsecured loans'.[47] Another writer at the daily paper *Svenska Dagbladet* described Dan Wolgers as a person who actualizes the key question of modern art: 'the personal responsibility'.[48] Yet another commentator contextualized Wolgers' work by pointing to the work of conceptual artists such as that of Lawrence Weiner from the 1960s or Jon Tower's contemporary work.[49] The art critics generally wrote appreciatively about Wolgers' contribution to the exhibition, and did not focus much on the details of the exhibition or on the events at Liljevalchs. They rather directed their main focus to other contemporary and historical artworks and artists. Accordingly, the art historical context was the main subject in their criticism. The positive art critique published in connection to Wolgers' exhibit at Liljevalchs was thus typical of the period, as evaluation, formerly a core feature of art criticism, was less and less emphasized in the late twentieth century.[50]

Mediated re-actions

Besides the articles in the daily and professional press, Dan Wolgers' actions triggered reaction from a range of agents who copied or commented on the event. Their aims differed, with some paying homage, others resorting to mockery. In common, however, was the understanding that the artwork was about theft, and consequently a number of agents stole or tried to steal Wolgers' name, his artistic idea or concept, or his actual possessions. One such reaction came from the art journal *Beckerell* which announced that they would sell the nameplate from the exhibition to the highest bidder. As Wolgers' artwork was about 'emptiness', the journal reported that they had sent one of their 'hitmen' to Stockholm to collect Wolgers' nameplate, and thus make the gallery space completely empty.[51]

Another reaction came on the late-night television show *Nästa Nybroplan* on Swedish state television on 19 November 1992. Under the headline 'To speculate in art' they announced that the provocative artist Dan Wolgers had staged a new coup. In conjunction with this the presenter declared that they had decided to sell Dan Wolgers' private car to the highest bidder during the live broadcast. Simultaneously, a film clip of his car, an ordinary Volvo 245 station wagon, was shown. This was in fact part of the documentation from an artwork Wolgers had made for the gallery Wanås Art that same year. The viewers were invited to fax in their bid. Later on in the

programme, the reporter announced that numerous fax messages had been received. Besides the bids that came in, Wolgers' gallerist Lars Bohman sent the message that he had ten copies of the keys to this car and that they were for sale for 5000 kronor each. Furthermore, the artist Annica Karlsson Rixon, also participating in the Liljevalchs exhibition, announced that she was prepared to trade one part of her artwork *Hetärerna* from the exhibition for Wolgers' car, a clear attempt to promote her own work on television.[52] The TV show *Ikväll Robert Ashberg* on commercial Channel 3 also picked up on Wolgers' work through an interview with the Swedish artist Adalbert (1953–), who claimed that Dan Wolgers had in fact stolen his artwork, a performance where he emptied a gallery in New York. He even claimed that Wolgers stole his explanation or interpretation of the work, that it was about 'emptiness and absence'.[53]

A rather late reaction occurred at the art gallery in Trollhättan at the end of 1993. Between 29 and 30 November that year it held the exhibition *Stölden som konstform* (*Theft as art*). The exhibition was produced by the local artist Göran Vogel-Rödin who wanted to 'create a debate on what is allowed in art' according to the local paper *Trollhättans Tidning*. The installation consisted of a number of posters all of which included the text 'Stölden som konstform' and 'Dan Wolgers'; thus, it appeared that Wolgers was the originator. Furthermore, a photograph of the painting *The Source* by Pablo Picasso was also posted on the wall. This painting had recently been stolen from Moderna Museet in Stockholm, which was reported to be upset by both events.[54] In fact, a letter was sent to members of the Trollhättan municipality from the director of Moderna Museet, Björn Springfeldt, in which he dismissed the event in Trollhättan as an 'intellectual lapse', 'media opportunism', 'morally bankrupt' and 'scandalous'. Moreover, he condemned them for compromising the 'serious, poetic, intellectually and artistic sustainable artistry' of Dan Wolgers.[55] Interestingly enough, the letter was not answered by Vogel-Rödin but by local artist Lill-Britt Rydén. Rydén subsequently dismissed Springfeldt's complaints. The letter is written in a highly agitated tone and contains two lines of argument: the incomprehensibility and lack of artistry and morality in Wolgers' art, and the unfair balance of power between the artists, art critics, museums and media of the capital Stockholm and the artists of the region of Trollhättan.[56] Thus, Wolgers' acts and the reactions of Vogel-Rödin were written into a larger, art political conflict regarding the unequal distribution of funds and media attention between artists in the provinces and those in the capital and between the provincial and capital institutions. By extension it was also a conflict between a modernist and a postmodernist attitude within the art field.

Indeed, the focus of the media critique and its harshness seems to have played a significant role in the legal consequences of Wolgers' acts. As

mentioned, the Stockholm police received two reports on the alleged theft in December the same year. According to the TT News Agency, they were made by two 'ordinary citizens, after having read about the venture in the papers'.[57] Enclosed in the reports were clips from the morning papers *Dagens Nyheter* and *Svenska Dagbladet* from 19 November. Both articles recounted that the benches had been retrieved at a hairdressing salon and that Liljevalchs was going to buy them back. Apparently, these facts spurred the two inform-ants, who were most probably unaware of each other's actions. One did not provide any rationale for her report other than to say that it had happened as it had been written in the papers. However, the other informant, who also referred to the event through media texts, suggested that the happenings were an example of the 'degeneration of the rules of law'.[58]

The police investigated the alleged crime during the spring of 1993 and on 17 September Wolgers pleaded guilty to misappropriation, but not theft, and was sentenced to probation and a total fine of 2400 kronor.[59] The judgment described the acts of the artist as well as the reactions to these acts from Liljevalchs. Nevertheless, the artistic intention and context of display were not foregrounded in the decision at all. Yet in the preliminary investigation it was given extensive space. The main argument for the conviction was that the act had caused the city of Stockholm a loss and had resulted in a profit for Wolgers; the report thereby focused on the economic aspects of the event. The arguments put forward in the judgment were dominated by a description of what had taken place, outlining the measures taken by the artist. Wolgers admitted to the acts but pleaded not guilty, claiming that these acts were not detrimental to the City of Stockholm and that the representatives of Liljevalchs had retrospectively consented to his actions.[60] However, the court focused on the risk or the situation that resulted when the act was made and did not take into account the events and reactions on behalf of the claimant after the act. First the benches had been retrieved and repossessed by the gallery. Second the happening had resulted in an enormous inflow of visitors to the gallery and was successful in economic terms. Moreover the judgment considered the act in terms of economic intentions or possible effects, and not in terms of artistic intention. This is highlighted by the fact that nowhere in the judgment is the act labelled 'art'. Neither Wolgers nor his legal representative argued a defence based on artistic intentions or artistic context and the representatives of the claimant, Liljevalchs, were not heard at the trial. Thus where and in what context the actions and events had taken place was not considered in the legal process.

Historically, the question of intention and mode of production has been critical in legal trials concerning art. A classic example relates to artwork by Constantin Brâncuși who was questioned by US customs laws in 1928 as to whether it should be taxed as an artwork or as metal. In the following

trial modernist aesthetics were discussed, but most important for the verdict concerning the recognition of his work as art was the question of intention and mode of production.[61] However, in the case of Dan Wolgers this was not put forward by any of the parties in the legal process. Instead, the focus in the legal verdict lay closely on the reports of the event in the daily press by general reporters, where the economic aspects were dominant. Another similarity between the court's and the reporters' description of the event is the complete suppression of the agent as an artist and the act as art. Thus aspects raised by art critics and representatives of the art institutions, which acknowledged Wolgers as an artist and put the artwork in a historical and contemporary context, did not appear at all in the legal wordings on the artwork. It is therefore evident that interpretations of the event by experts on art, art theory or art history were excluded and accorded less value in the legal process, while the corresponding interpretations made by general news reporters and non-experts in art in the printed press were included in the legal trial.

Deceiver or truth-teller

My third example is the project by Swedish artist Anna Odell. On the night of 21 January 2009 she stood on the Liljeholms Bridge in the centre of Stockholm. She was lightly dressed and behaved in such a distressed manner that she appeared to be suicidal, and the police were summoned by some passers-by. At the time, Odell was about to finish her education in Art at the University College of Arts, Craft and Design in Stockholm, and this was her graduation project entitled *To Reconstruct a Psychosis*. When the police arrived they decided to drive her to the nearest psychiatric emergency department. There she was given sedatives and put up for the night. The next morning she asked to make a phone call to her brother. He turned up at the hospital 30 minutes later and together with Anna Odell he revealed her identity, which had been unknown until then, and that the events and acts that had taken place were part of an art project and that she was mentally sound. Five days later, on 26 January, the head of the emergency ward at St. Göran hospital reported the event to the police. Once again the evening paper *Aftonbladet* was quick to publish a strongly dismissive article (plate 19).

On the same day that this happened they reported that the hospital would notify the event.[62] The claimants were seven psychiatric nurses involved in Odell's care and treatment. Hearings with the claimants, the defendant and witnesses to the event, that is, other nurses and a doctor at St. Göran, were held in February and March 2009. The trial was held on 24 August and the sentence pronounced on 31 August, when Odell was accused of a fraudulent act and violent resistance.[63]

In the midst of this process, at the end of May, Odell presented the project as part of the graduation exhibition at the University College of Arts, Craft and Design.[64] The displayed artwork consisted of mediations from different phases of the event: a video recording taken on the bridge on 21 January, excerpts from the written medical records, a sound recording from the hospital and filmed interviews with experts on law and medicine. The part of Odell's installation most praised by art critics was the video taken on the Liljeholms Bridge.[65] This part also played a vital role in the trial as Odell argued that, due to the fact that she had been video recorded by her co-worker, she could not be held legally responsible for her acts.[66] Both for the court and for the viewer in the art gallery, the complex mix of documentary and fictional events, staged and authentic acts, was crucial. The acts of the passers-by and the police officers were real responses in the sense that they knew neither that Odell was staging an event nor that they were being filmed. Odell, on the other hand, knew what she was doing and could have halted the happening at any time. She was also aware that all events were being filmed and that if there was any misconduct by the police or passers-by she literally had people watching over her. Thus the filmed sequence at the bridge oscillates on the border between reality and fiction. The notion of proof and evidence runs through the comments by Odell in the media. The project did, in fact, spring from her experience of having been in psychiatric treatment and not being believed. Accordingly, the filmed and taped sequences of the artwork served as proof, just like the medical records, of both her individual experience and the failures or merits of the system.

Some of the reactions later became part of the exhibited artwork; others did not. The medical reports from the hospital were exhibited, but not the comments in daily press, television and radio. The words uttered at the trial were recorded, broadcast on the radio and later made a part of the work, but not the written police reports nor the claimants' testimonies in detail. As pointed out by Max Liljefors, this arbitrariness between art and reality did in fact also permeate the legal verdict as some of Odell's actions were judged to be real while others simulations and thus omitted from the charges (plate 20).[67]

The media coverage of Odell's performance was immense. The first report in the Swedish press appeared on 25 January and the following year more than a thousand news reports, opinion articles, letters to the editor and comments were published in Swedish newspapers.[68] The events were also reported in professional journals on art, politics and cultural affairs, as well as on television and radio, and finally the entire trial was recorded and broadcast on *Radio Sweden*.[69] The speakers in the media came from diverse professions and held a wide range of views. They were general reporters, art critics, art historians, philosophers, politicians, physicians, psychologists,

psychiatric nurses, priests and members of the general public. Anna Odell was also active in the media debate that followed, commenting on the events in several interviews. She also published an article in *Revansch!*, the journal of the Swedish national association for social and mental health, in March the same year.[70]

The media debate followed several threads or aspects of the actions. Besides the legal aspects there were ethical ones in relation to the police, nurses and other patients who were unknowingly included in the performance, in addition to economic aspects, that is the cost to civic society. Finally, the question concerning whether or not it was art came to the fore. Nevertheless, the dominant theme in the media debate that followed was ethics. Indeed, ethics was the major argument for *and* against Odell's acts, the legal verdict aside. Ethics was understood or used for two completely differently purposes, which I would describe as ethics on a micro and macro level. With micro level I refer to the aspects of the individual happenings on the night of 21 January 2009 and the individual persons participating in this event. With macro level I refer instead to the emblematic aspects of the event, where the actions and individuals – Anna Odell, the passers-by, policemen and nurses – served as representatives for different agents in society. This might also be described from an ethical perspective as representing a gulf between the aim and the effect of the project. While the aim was to point to the structural problems, that is the sufferings and the deficiencies in society's treatment of people with psychiatric illness, the immediate effect targeted individual nurses and doctors who were not personally liable for the failures of the organization and regulations that prescribed certain conduct and treatments.[71]

The fiercest critique in the media came from those focusing on ethical aspects of the events on a micro level. This was also the main emphasis of the legal trial. These media articles described Odell's project as a 'sham', 'scandal', 'sabotage', 'coup', 'art stunt', 'pointless', 'abuse' or 'theft' of public funds, and the artist was termed a 'liar', and as 'impertinent' and her act a 'spectacle' or 'play'.[72] They focused on the interpersonal relations, that is the experiences and endurances of the individual men and women who were present on that particular evening either as the passers-by at the bridge, the patrolling police or the psychiatric personnel that met Odell. Even though the latter were carrying out their duties as employees, they were also personally affected. This was spelled out in the press by the chief physician at St. Göran hospital David Eberhard and the priest Annika Borg, among others. Notes written by other psychiatric nurses and members of the general public were also influential in this regard.[73] This was backed up by police reports and interrogations with the nurses and police officers on patrol. They described how strenuous the situation was in general and how they experienced fear and anxiety and also anger and sadness when informed that Odell was not

ill but only acting as part of an art project.[74] Odell's project generated a considerable number of comments from the general public in the press. They were invited to give their opinion in the papers individually or interviewed as a group. Already in the first reports at the end of January the evening paper *Aftonbladet* presented a survey that revealed that 91 per cent of 60,274 people interviewed agreed with the assertion that 'it is not right to misuse healthcare for art's sake'.[75] Indeed, the financial aspects of the project proved to be a principal theme in comments made by the general public in interviews and letters to the editors.[76]

Taken together, those media reports focusing on the macro level ethical aspects were in general positive towards the project and the light it shed on the systemic failures and maltreatment of a vulnerable group of people in society. In these Odell was described as a representative victim of all victims of the system. At the same time, those focusing on the micro level described the individual employees as victims. This theme was especially highlighted in the many comments from the general public in letters to the editors, but also by those from representatives of professionals outside the art world.

Art and media logic

The relation between the art world and mass media has a long history of mutual exchange and dependence. Artists have not only been the subject of reviews and biographical portraits but have consciously used mass media to convey their artistic practice through texts in mainstream media as well as in artist-driven and produced magazines.[77] In some respects the rhetoric and themes in the media coverage of De Geer's, Wolgers' and Odell's art projects tie into a long and established tradition. Already in the early twentieth century, modernist artists and artworks were scorned in the mainstream media as humbug that fooled critics and the general public alike.[78]

In the three cases presented above, those in favour of the artists within the art world such as art critics, curators, art historians, and representatives of galleries, museums and art schools, focused only on the art dimension in their media reporting. A recurrent argument in favour of the artists was to link them to historical predecessors, in short, to inscribe them into an art historical narrative. Those who dismissed them on the other hand – mainly agents outside the art world such as general reporters, politicians, representatives of the law and the general public – did so on the basis of the reality dimension: they focused on the representations and actions themselves and not on the intention or context of production and display, which have historically been vital in trials on art.[79] An important feature in the latter's stance was that art figured as any other news event. One effect of this was the strong focus on actual deeds and the unwillingness to put the individuals

and their acts within an artistic and art historical context. The vocabulary used in the media coverage was the same as for everyday news, i.e. accidents, crimes, politics, big business and entertainment. This was particularly evident with regard to Wolgers' and Odell's artworks. Accordingly, Odell's project was described as a 'scandal night', words typically used when reporting on celebrities involved in parties or fights, and the words 'coup' or 'sham', which are typically used to describe criminal acts, were used for both artworks.[80] This is clearly a way to dramatize and transform art into news; not only is it treated and described like any other act or event, but it is also denominated as such (plate 21).

The case of De Geer differs from the other two in that there were few press articles at the time of the legal process. However some thirty years later, his works became the subject of media hype in the printed press. The articles that did appear at the time of the legal process were factual and the wording employed in the reports lacked the kind of drama and metaphor used for Wolgers and Odell. Moreover, the media commentators in the case of De Geer comprised news reporters, art critics and one lawyer. *Svenska Dagbladet*'s first article on the event included a short comment from De Geer himself, where he says that he had no idea that his actions could have been illegal.[81] Accordingly, there were no comments on De Geer's action by members of the general public or by any other artists in the press.

The three cases studies in this chapter cover a period of forty years where 26 years separate the first and the second cases, and 17 years the second and third. However there are some interesting similarities between them. First, the artists were relatively young and not yet established in the art scene. In the case of De Geer this was given particular emphasis by his legal counsel as a probable reason for the harsh judgement and legal aftermath.[82] Second, all are examples of artists who claim to make a political statement, whose intention is to air larger political questions through artworks. Interestingly enough the notions of politics they represent differ and are characteristic of their respective times. While De Geer's criminal statements via graphic prints concerned realpolitik, that is the US war in Vietnam, Wolgers' act dealt with the politics of the art field. Finally, Odell's act was conceived as a statement on the deficiencies of the welfare system while simultaneously being a re-enactment of a personal experience. There was a significantly greater media reaction to Odell's work, yet the breadth of the articles in their respective periods was equally wide. In addition, all three artists intended to make a political statement on a macro level yet their acts were foremost interpreted on a micro level as individual acts and happenings. According to Hal Foster, contemporary art does not possess the power to make political statements that genuinely challenge prevailing circumstances (although the opposite is sometimes put forward).[83] This might be said to be confirmed

'Psychosis show', Anna Odell in *Expressen*, 2009.

4.4

by the cases of Wolgers and Odell. In the case of De Geer one may conclude that the change in Swedish law in 1971 was possibly influenced by the media and legal turmoil in 1967 and 1968.

Even though these are only three single cases they reveal obvious differences, which might point to more general changes in the relation between the art world and the media in the late twentieth century. An important difference among the three artists and their work is their use of media and mediations. At one end was Odell's artwork which consisted of mediations throughout. The artwork consisted of film, written reports and sound recordings from some selected sequences of an event. Her own actions on the bridge and at the hospital on 21 and 22 January 2009 could be termed an artistic performance. Yet they were not presented as such, neither in situ nor retrospectively. As the staged psychosis enacted by Odell referred to her own experiences many years earlier, the actions may also be considered as a re-mediation or a re-enactment of a lived experience.[84] Thus already in the making and presentation of the artwork there were several layers of mediations and blurred boundaries between real and staged actions, presentation and re-presentation. Following the same logic, Odell actively participated in the media debate that followed her acts. However, neither Odell nor Wolgers appear to have intended to attract an immense media debate. Thus in this respect they are similar. Once the media debate started, however, they acted very differently. While Wolgers avoided the media, Odell willingly complied. She not only gave several interviews, but also published a text herself and later also used media material in different presentations of the work.[85] Odell was therefore actively producing media material by willingly making herself available for interviews, posing for photographs and writing herself.

Dan Wolgers' equally stirring media debate seventeen years earlier, on the contrary, did not include his participation in the production of media texts in the same way. For one thing, there was no documentation of the actual events that could be exhibited or re-mediated in media. Moreover, he considered his artwork as finished when leaving the gallery room empty and did not answer journalists' questions about the artwork from media or communicate any explanation to the gallery. It appears that talking about his intention behind the artwork and expanding on its meaning could even be detrimental. In fact, the ideas behind the work did not reach the press until long after the exhibition and trial were over.[86] At the time, in 1992 and 1993, some reporters found this particularly frustrating and this strengthened the critique against contemporary art as incomprehensible.[87] Indeed, the same delaying effect holds for De Geer. Until 1971 any reproduction of the artworks would have been seen as a criminal act and accordingly very few daily journals reproduced the work visually. Moreover, and unlike the cases

of Wolgers and Odell, there does not seem to have been any pressure from the press to elicit comment on the artwork from the artist in 1967. When a more detailed account of the events reached the printed press in 1999 this was through an article written by the artist himself in relation to an exhibition on the national arena for contemporary art, the public Moderna Museet. Thus, a (written) testimony on the event by the artist was produced at the same time as the artworks in question were formally acknowledged as seminal art of the period by one of the most powerful agents in the art field in Sweden.

De Geer did, however, make use of the media during the legal process. His lawyer exhibited cuttings from two professional journals, *Industria* and *Konstrevy*, to prove to the court that De Geer was indeed regarded as a 'serious artist' within 'professional circles'. Moreover, two current articles from the daily newspaper *Dagens Nyheter* were included in the subsequent appeal. One questioned current Swedish law while the other put De Geer's actions into an art historical context.[88] In addition, the mass media did not prejudge the legal process, nor did they present any contesting or critical views on the legal process. It was the police's version of the event that filled the pages of the daily journals. In 1967 the daily press did not represent the artworks at all. However, De Geer made use of the underground, cultural journal *PUSS* to both publish the artworks themselves and also to seek a selling opportunity for the work. In one and the same issue of *PUSS* in the summer of 1968 there was an article on the legal process which included reproductions of the artworks. The magazine also advertised De Geer's postcards, so called 'Pusscards', which could be bought for 2 kronor each directly from the artist. From the twenty-one different designs one could order a depiction of the print *USA killers* in postcard size.[89]

Overall, the critique against De Geer was quite restrained, with short telegraphic descriptions of the prosecution and verdict. Of the three cases Wolgers seems to have faced the strongest and most negative critique from the media. There were some voices supporting his case, but they were relatively few and only those of individual art critics on the cultural pages of the national newspapers. In the aftermath of Odell's work, representatives of large institutions within the art world, such as the University College of Arts, Crafts and Design; influential artists, and students from other art schools, gave testament that Odell's acts were art and should not be considered as a criminal act.[90] By comparison, such institutional support did exist when Wolgers made his contribution to Liljevalchs in 1992; the letter from the director of Moderna Museet to Göran Vogel-Rödin testifies to this. However, this institutional support from the art world was invisible in the media discourse. The same holds for De Geer. Although it was not known by the general public at the time, the national art gallery Nationalmuseum had

acquired copies of the artwork. Thus in De Geer's case there was a dual reception of his artworks. While the tradition-bound Nationalmuseum with its paramount position in the Swedish art world secretly supported him from the start by acquiring the prints no representatives from this or any other museum or art institution publicly supported his artworks. In fact, the Nationalmuseum completely concealed the fact that they had acquired the prints by cataloguing them as works by 'an unknown master', fearing they would otherwise be confiscated. In the case of Wolgers, on the other hand, no public museum acquired any documentation of the artwork and ensuing lawsuit, and today the majority of the material on this event is in the artist's possession. Odell's work has been exhibited at several museums and galleries since 2009 but whether or not the artworks themselves have been acquired by any art institutions is yet unknown.[91]

This might be interpreted along two different lines. First, it may be an indication of an increasing awareness within the art world of the effects and powers of mass media and a thought-out strategy on their behalf, vis-à-vis mass media. The decisive difference between the media reception of Wolgers and Odell might also imply that knowledge and understanding of postmodern or contemporary art was relatively limited in the general media debate in Sweden in the early 1990s. This may, in turn, be why the words used in the media concerning Wolgers' actions almost exclusively referred to actual deeds. When Odell's acts were considered in the media in 2009, postmodern notions of representation, identity, reality and fiction permeated the art field and the production and reception of culture in general. As a result, Odell's artwork was simultaneously considered as both an artistic statement and a real deed in the press coverage and in the legal processes that followed. This trial was extraordinary in the sense that 'this arbitrariness mars the distinctions drawn by law between reality and representation', as pointed out by Max Liljefors.[92]

It is worth mentioning that an increasing awareness regarding the complex relationship between the art world and media can also be seen. In the cases of Wolgers and Odell, the artists were designated as 'speculative' and were said to have wrongfully sought 'publicity' and 'advertising' through the media. Yet in the media texts produced in 2009 this was also balanced with some self-critique. Thus the 'publicity-hungry', calculating artist was still a theme in the media texts, but this was now combined with a critique of the one-dimensional media system that only focused on the speculative.[93] Media comments, therefore, revealed a shift from a focus on the individuals to a focus on the systemic dimensions of the event and its mediation.

In the cases of Wolgers and Odell the media coverage played a significant role for the artists' oeuvre. Wolgers did not use the media to explain or comment on his work or for artistic purposes. Nevertheless, Liljevalchs

harnessed the significant media attention. The curator Philippe Legros gave many interviews, and when the benches were retrieved, Legros arranged them, without any involvement by Wolgers, in a new space in the gallery together with a large quantity of press clippings and photographs of the benches while placed in the hairdresser's salon. The photographs were in fact produced by the gallery specifically for public display on the gallery wall.[94] In the case of Wolgers, media coverage also generated new artworks. Thus when it was announced that his car was to be auctioned on Swedish television the same year, his promoter was quick to advertise that ten copies of the keys to this car were for sale in the gallery.[95] Moreover, the legal process, influenced to some degree by media reporting, became a part of Wolgers' own oeuvre as on receiving the verdict by mail, he immediately sold the unopened envelope to his gallery, Riis in Oslo, for 20 000 kronor. Thus in both cases the legal processes definitely influenced, and in the former case had a direct effect on, the media's coverage of the artists and their work.

A somewhat different trajectory can be seen in De Geer's case. Indeed, all prints were supposed to have been confiscated by the state and disposed of. However, it is clear that not all copies of the prints met this fate. At the time of their production, and during the legal aftermath, they were impossible to exhibit or sell in mainstream venues like museums and galleries. However, one of the images was sold as a postcard and the ensuing trial brought notoriety to the remaining prints, imbuing them with a revolutionary aura and high economic value, as there were so few copies of the work.

News art

An immediate question with regard to the different media attitudes towards the three artists is how the media in turn formed different discourses or, put differently, how this can be interpreted as the larger question of the mediatization of art. According to media theorist Andreas Hepp 'manifestations of a non-mass media culture such as sculpture, painting and buildings depend upon the mass media if they wish to enter the domain of communicative discourse for a particular public' in media cultures.[96] Despite their differences the three examples presented here clearly show how this has taken place in individual instances within the art world. On a general level, all these cases spurred debates about the notion of art, not only by art critics, but by general reporters, professionals from other fields in society and by members of the general public. Thus in this case the process of adaption did not only include the particular art works which migrated into new context and understandings; in addition the very notion of art adapted in the transition to the pages of news media. Thus the media transformed the notion of art into a news event, and hence it gained relevance to agents outside the art world. By interpreting

the artworks as illegal acts, agents of the news media transformed the production and display of artworks into events that fed directly into the standard pattern of their reporting. It may, therefore, come as no surprise that it was the evening or tabloid press that made the most of these 'art crimes'.

The difference between the broadsheets and tabloids was, however, not so distinct in the late 1960s Sweden. Political colour seemed to be a more decisive factor, as the first journals that represented and defended the artworks were liberal (*Dagens Nyheter*) and left wing (*Aftonbladet*). Wolgers' acts met harsher criticism from the agents within the field of art and cultural production than Odell's. Odell's strongest critics were professionals from other fields and members of the general public. Yet the basic conflict had the same rationale. Especially in the wake of Odell's work many agents outside the art field felt obliged to debate the notion of art. The physician Sven Britton pointed out the similarities between defining art and mental illness while the politician Göran Hägglund interpreted the artwork as an example of the increasing gap between the cultural, financial and political elites and 'ordinary people'.[97]

The latter theme, or the antagonism between the 'ignorant cultural elite' and the general public, was also recurrent in the wake of Wolgers' artwork. This was especially evident in the evening press and provincial daily papers, which described Wolgers' work as 'mocking the audience'.[98] Even the professional art journal *Konsttidningen* voiced the same opinion. They concluded that today's alienation from art is a direct result of artists' disregard for their audience because they live in 'philosophical ivory towers'.[99] This new type of artist and art was also described as being a threat to other, presumably modernist, artists. 'They spit on young artists who studiously exhibit at Vårsalongen', as one reporter put it. It is no more than a 'crazy postmodern prank' he concludes.[100] Yet the most articulate words on the conflict between different aesthetic paradigms can be found in a letter to the director of Moderna Museet from the artist Lill-Britt Rydén, a member of a regional artists' association, written in 1993. The geographical origin of this voice is not arbitrary. On the contrary, there was evidently a distinction between urban and provincial views in Sweden in this respect. This can be discerned in the provincial newspapers, which were in general more dismissive than the national press. Rydén's suspicion and criticism of the contemporary art of Wolgers is partly based on the textual aspect. She writes that it 'applies a verbal key that is pretentious, a meaning that for the uninitiated appears completely incomprehensible'.[101] Furthermore, she scorns the media attention given to Wolgers and contrasts it to the lack of interest shown to the provincial artist by the mass media as well as the museums. She rhetorically asks: 'When did any provincial art gallery in a small town get the attention of the "professional cultural leaders", whose international eyes were rather directed to the big art metropolises abroad?'

The work of the provincial artists is described as unglamorous hardship. She continues: 'They stupidly struggle on with their pictures when in fact the only thing that is needed to get media attention is [to produce] an absurd idea or a parody of an idea.'[102]

To summarize, the media debates about whether these events were compelling artworks or criminal acts, in fact, comprised a much more complex and hardly expressed conflict between two art paradigms. Those critics, artists and art historians who were well read in postmodern theory and art historical writings, pointed to historical as well as contemporary examples in order to contextualize them. The contrary argument was that these acts were not art but illegal or immoral deeds. This was essentially a struggle not only between representatives outside and inside the art world but between different aesthetic paradigms within the art world disguised and presented in the media as a legal and moral debate. In short, it was a struggle between different aesthetic ideals, financial resources and media attention that took its form within the logic and system of media.

Notes

1 S. Kadri, 'The licence of poets and madmen. Judging art since Veronese', in D. McClean (ed.), *The Trials of Art* (London: Ridinghouse, 2007), p. 22.
2 *Dagens Nyheter* (23 November 2014), p. 4.
3 The concept of the 'art world' is based on the idea that the distinction between art and non-art is constructed by diverse agents and institutions. See A. Danto, 'The Artworld', *Journal of Philosophy*, 61:19 (1964), 571–584; G. Dickie, *Art and the Aesthetic. An Institutional Analysis* (Ithaca: Cornell University Press, 1974); S. Thornton, *Seven Days in the Art World* (New York: W.W. Norton, 2008).
4 K. Lundby, 'Introduction', in K. Lundby (ed.), *Mediatization of Communication* (Berlin: De Gruyter Mouton, 2014), pp. 3–10.
5 J. Rancière, *The Politics of Aesthetics* (London: Continuum, 2006), p. 23.
6 For studies on art critique in Swedish press in the twentieth century see B. Schaffer, *Analys och värdering. En studie i svensk konstkritik* (Stockholm: Akademilitteratur, 1982); J.-G. Sjölin (ed.), *Om konstkritik. Studier av konstkritik i svensk dagspress 1990–2000* (Lund: Palmkron, 2003) and A. Kollnitz, *Konstens nationella identitet. Om tysk och österrikisk modernism i svensk konstkritik 1908–1934* (Stockholm: Drau, 2008).
7 A classical example is the publication of the futurist manifesto on the first page of the French newspaper *Le Figaro* 1909. F.-T. Marinetti, 'Le Futurisme', *Le Figaro* (20 February 1909), p. 1.
8 Interview with Carl Johan De Geer, Stockholm 28 September 2016.
9 Anon., 'Lördagens vernissager', *Dagens Nyheter* (29 April 1967), p. 15; Advert for exhibition on Marie Louise and Carl Johan De Geer at Galleri Karlsson, *Svenska Dagbladet* (30 April 1967), p. 30. Information on the size of the editions comes from the artist: 25 (*Skända flaggan*), 25 (*Vägra vapen*) and 50 (*USA mördare*)

copies were produced. Thus in total 100 prints and possibly around 20 test prints were produced. Interview with Carl Johan De Geer, Stockholm, 28 September 2016.

10 Swedish National Archives (Riksarkivet), Stockholm Court (Stockholms råd husrätt), 6 September 1967; Svea Court of Appeal (Svea hovrätt) Verdict 7 June 1968; Swedish Supreme Court (Högsta domstolen), Dnr B458/1968 [1631]. Carl Johan Louis De Geer.

11 Anon., 'Affischer av flaggor beslagtogs', *Svenska Dagbladet* (2 May 1967), pp. 1 and 16; Anon., 'Polis slog till mot konstexpo. Grafiska blad i beslag', *Expressen* (2 May 1967), p. 33; Anon., 'Konstnär bötar för uppvigling', *Expressen* (9 December 1968), p. 8.

12 Anon., 'Affischer av flaggor beslagtogs', p. 1; Anon., 'Polis slog till mot konstexpo', p. 33.

13 Swedish National Archives (Riksarkivet), Memorandum Swedish Supreme Court (Högsta domstolen), Dnr B458/1968 [1631]. Carl Johan Louis De Geer.

14 B. Särnstedt, 'Verkligheten och öververkligheten', *Svenska Dagbladet* (10 May 1967), p. 4.

15 J. Gehlin, 'Om skydd för symboler', *Dagens Nyheter* (3 May 1967), p. 4. Jan Gehlin was at the time alderman.

16 T. Bergmark, 'Konstens demonstranter', *Dagens Nyheter* (11 May 1967), p. 5.

17 R. Johansson, 'Motroten', *Dagens Nyheter* (26 June 1967), p. 5.

18 Anon., 'Konstnär åtalad för flaggskändning', *Svenska Dagbladet* (21 June 1967), p. 15.

19 Anon., 'Målade hakkors på USA-flaggan. Dömd för skymf', *Dagens Nyheter* (8 September 1967), p. 13; Anon. 'Konstnären fick böta. Skymfande av rikssymbol', *Expressen* (7 September 1967), p. 23.

20 Anon., 'Konstnär bötar för uppvigling', p. 8; Ann Lindgren, 'Konstnären som skymfade USA:s flagga bötar 1125', *Aftonbladet* (9 December 1968), p. 12.

21 A search of the archives of Swedish radio and television from 1967 and 1968 has not yielded any results. There could however have been coverage in these media, but as not all broadcasts have been recorded and those which have are not indexed by content in all cases it is an insurmountable task to find reports on the news and elements on the event in debate programmes from the period. For a discussion on the archival status of Swedish television of the 1960s see D. Rynell Åhlén, *Samtida konst på bästa sändningstid. Konst i svensk television 1956–1969* (Lund: Mediehistoriskt Arkiv, 2016). Neither does De Geer recall that he participated in TV or that the event resulted in any new reporting. Interview with Carl Johan De Geer, Stockholm 28 September 2016.

22 Anon., 'Affischer av flagger beslagtogs', p. 1.

23 B. Olvång, 'Censur', *Aftonbladet* (18 November 1976), p. 4. The exhibition was held between 14 November 1976 and 9 January 1977. The accompanying catalogue – U. Liljedahl, *Vad kampen gällde. Norrköpings museum 14.11 1976 – 9.1 1977* (Norrköping: Norrköpings museum, 1976) – did not, however, include any reproductions of De Geer's artworks.

24 Anon., 'Dragkamp om De Geer. Talrik publik hos auktionsverket', *Dagens Nyheter* (17 March 1991), p. B14.

25 Email from curator Martin Sundberg, Norrköpings museum, 29 September 2016. *Skända flaggan* was signed 1967 and numbered 17/25 (NKM 17912), *USA mördare* was signed 1967 but not numbered (NKM 17913) and *Vägra vapen* (*Refuse arms*) was neither signed nor numbered (NKM 17911). *Gult rum* (*Yellow room*) has a separate aquisition number (NKM SK 315).

26 U. Thuland, '1970-talets uppror har blivit museifäigt', *Dagens Industri* (28 May 1999), p. 58; P. Cornell, 'Fridlyst', *Expressen* (1 June 1999), p. 5.

27 Cornell, 'Fridlyst', p. 5. In a later article De Geer himself recounts that Statens konstmuseer bought a copy of 'USA mördare'. C. J. De Geer, 'Visst har konsten sprängkraft!', *Aftonbladet* (22 April 2004), pp. 4–5.

28 Aquisition register of the National Museum of Art (Nationalmuseum) nos. 429/1968, 430/1968 and 431/1968.

29 Swedish National Archives (Riksarkivet), Memorandum; and Judgment at the Swedish Supreme Court (Högsta domstolen), Dnr B458/1968 [1631]. Carl Johan Louis De Geer.

30 Anon., 'Svik fosterlandet. Var onationell!', *PUSS*, 7 (August 1968), 8–9.

31 Anon., 'Fritt fram för svensk mästare i flaggskändning', *Expressen* (19 March 1969), p. 10.

32 L. Nylén, 'Den "olagliga" konsten', *Dagens Nyheter* (21 July 1989), p. 4; Thuland, '1970-talets uppror har blivit museifäigt', p. 58. The latter was a review of the exhibition *Efter majrevolten. Det 'stökiga' 1970-talet* at Moderna Museet in Stockholm.

33 *Efter majrevolten. Det 'stökiga' 1970-talet*, ed. R. von Holten (Stockholm: Moderna Museet, 1999).

34 In 1971 the penalty provisions 16 chap. 7 §, dishonouring national symbol (*skymfande av rikssymbol*) and 19 chap. 10 § dishonoring foreign national symbol (*skymfande av utländsk rikssymbol*) were removed from the Swedish Criminal Code. See also B. von Bahr, 'Nya straff för flaggskändning', *Expressen* (7 January 1969), p. 8.

35 Anon., '… och resterna av ett uppror', *Aftonbladet* (27 October 2000), p. 5.

36 De Geer, 'Visst har konsten sprängkraft!', pp. 4–5.

37 Interview with Carl Johan De Geer, Stockholm 28 September 2016 and email from Lena Rydén, Bukowskis auction house, to the author, 22 December 2016. Bukowskis Moderna Vårauktion 2009, Kat. nr 557.

38 Swedish National Archives (Riksarkivet), Judgment at the Swedish Supreme Court (Högsta domstolen), Dnr B458/1968 [1631]. Carl Johan Louis De Geer.

39 For examples of the latter see De Geer, 'Visst har konsten sprängkraft!', pp. 4–5; N. Forsberg, 'Leklust', *Expressen* (12 April 2014), p. 6.

40 *Ecce Homo/Se människan* (Stockholm: Liljevalchs konsthall, 1992).

41 Liljevalchs archive, Exhibition documents: *Ecce Homo/Se människan*; Stockholm district Court (Stockholms tingsrätt), Verdict DB 1372, 17 September 1993. A. Nordenankar, '"Stulna" bänkar upphittade. Dan Wolgers får behålla betalningen från Auktionsverket', *Dagens Nyheter* (19 December 1992), p. 30. According to Anon., 'Folk i farten', *Dagens Industri* (5 February 1993) the benches were bought back by Liljevalchs for 10 000 SEK.

42 'Konsthallen Liljevalchs soffor stulna och sålda', *TT News Agency* (19 November 1992); Liljevalchs archive, Exhibition documents: *Ecce Homo/Se människan*, Letter to participating artists from Liljevalchs.

43 K. Nilsson, 'Konst eller stöld? Dan Wolgers konstverk. Att sälja museets bänkar', *Aftonbladet* (20 November 1992), p. 14.

44 A. Kullenberg, 'Det här är konst', *Aftonbladet* (21 November 1992), p. 15.

45 The reports were made in December 1992. Stockholm Police archive, Diarieblankett/ official register no. 0103-K259 541–92.

46 'Dan Wolgers. Provokatör eller konstnär?', *TT News Agency* (16 July 1994); 'Årets största egotrippare', *Aftonbladet* (25 November 1992), p. 21; S. Söderhjelm, 'Han är konstens värsting', *Aftonbladet*: Söndagstidningen (6 December 1992), pp. 14–16; T. Hammarström, 'Envar sin egen installatör. Tommy Hammarström om ett föräldraupprror som gått i stå', *Expressen* (25 February 1994), p. 5.

47 J. P. Nilsson, 'Rapport från världen: Stockholm', *Beckerell*, 1 (February/March 1993), 25.

48 J. Åman, 'Wolgers öppnar museet mot gatan', *Svenska Dagbladet* (2 January 1993), p. 22.

49 D. Dahlqvist, 'Soffa på rymmen', *Expressen*: Kultur (28 November 1992), p. 5.

50 J.-G. Sjölin, 'Inledning' and M. Biel, 'Hvem skriver kunstkritik i dagspressen. En kvalitativ undersøkelse av kunstkritikeren i svenk dagpresse', in Sjölin, *Om konstkritik*.

51 Unsigned note, 'Namnskylt säljes!', *Beckerell*, 1 (February/March, 1993), 32. The plate was in fact stolen but was never sold according to the hitman himself, the artist Björn Carnemalm, at the time a student at the Art Academy in Umeå. Email to the author from Björn Carnemalm, 19 January 2015.

52 Television programme *Nästa Nybroplan*. Broadcast on TV1/Sweden, 19 November 1992, at 10.30 p.m.

53 Television programme *Ikväll Robert Ashberg*. Broadcast on TV3/Sweden, 27 November 1992, at 9.00 p.m.

54 L. Bengtsson, '"Stölden som konstform" – en mina eller brandfackla?', *Trollhättans Tidning* (30 November 1993), p. 4; Hammarström, 'Envar sin egen installatör', p. 5.

55 Moderna Museet archive, Dnr 146/93, Letter from Björn Springfeldt, director at Moderna Museet to Göran Vogel- Rödin, Trollhättan Art Gallery and Christer Olsson at the municipality of Trollhättan, 23 November 1993.

56 Moderna Museet archive, Dnr 146/93, Letter from the artist Lill-Britt Rydén to Björn Springfeldt, director of Moderna Museet, 8 December 1993.

57 'Kultur i korthet', *TT News Agency* (22 July 1993).

58 Stockholm district Court (Stockholms tingsrätt), Verdict DB 1372, 17 September 1993; Stockholm Police archive, Official register no. 0103-K259 541–92; Dan Wolgers' archive.

59 Stockholm district Court (Stockholms tingsrätt), Verdict DB 1372, 17 September 1993.

60 Stockholm district Court (Stockholms tingsrätt), Verdict DB 1372, 17 September 1993.

61 D. McClean and A. Avanessian, 'Trials of the title. The trials of Brancusi and Veronese'; and T. de Duve, 'Bird, fish or flying tiger. What's in a name?', in McClean, *The Trials of Art*, pp. 37–63 and pp. 89–101; H. Lydiate, 'What is Art? A Brief Review of International Juridical Interpretations of Art in the Light of the UK Supreme Court's 2011 Judgement in the Star Wars Case: Lucas Film Limited v. Ainsworth', *Journal of International Media and Entertainment Law*, 4:2 (2012–13), 111–147.

62 J. Edgar, 'Konsteleven anmäld för kuppen på psykakuten', *Aftonbladet* (26 January 2009), p. 12.

63 Stockholm district Court (Stockholms tingsrätt), Dept. 4, Unit 42, Lawsuit No. B 3870–09, 31 August 2009. K. Heineman, 'Videoverket är moraliskt försvarbart', *Psykologtidningen*, 8 (2009), 8–9.

64 www.konstfack2009.se/bachelor/bafa/anna-odell/

65 S. Allgård, 'Inte längre okänd kvinna dömd – men läkaretiken undgår luppen', *Paletten*, 3 (2009), 21.

66 Stockholm district Court (Stockholms tingsrätt), Dept. 4, Unit 42, Lawsuit No. B 3870–09, 31 August 2009.

67 M. Liljefors, 'Body and authority in contemporary art: Tehching Hsieh's one-year performances', in Leif Dahlberg (ed.), *Visualizing Law and Authority. Essays on Legal Aesthetics* (Berlin: De Gruyter Mouton, 2012), pp. 210–211.

68 Search in Mediaarkivet database on 30 January 2015. S. Ström, 'Specialarbete. Spela psyksjuk. Överläkaren rasande efter konstelevens kupp', *Aftonbladet* (25 January 2009), p. 10. For more examples see the following notes.

69 http://sverigesradio.se/sida/artikel.aspx?programid=83&artikel=3051051

70 A. Odell, 'Jag ville undersöka offerrollen', *Revansch!*, 3 (2009), 4–5.

71 Allgård, 'Inte längre okänd kvinna dömd', 21.

72 Ström, 'Specialarbete. Spela psyksjuk', p. 10; Edgar, 'Konsteleven anmäld för kuppen på psykakuten', p. 12; P. Sundsten, 'Konstelev spelade psyksjuk – lades in', *Metro* (26 January 2009), p. 4; Anon., 'Sjukhuset anmäler eleven för konst-kuppen', *Aftonbladet* (28 January 2009), p. 24; H. Kjöller, 'Att vara människa. Konst. Poänglös utmaning där mycket står på spel', *Dagens Nyheter* (28 January 2009), p. 4; Anon., '"Galen" konstelev polisanmäld', *Corren* (29 January 2009), p. A24; 'Anders', 'Odell kan skapa en farlig skojtrend', *Metro* (3 September 2009), p. 20.

73 A. Borg, 'Brist på etik gör ingen konstnär', *Kristdemokraten* (8 September 2009); Sundsten, 'Konstelev spelade psyksjuk – lades in', p. 4; D. Eberhard, 'Konstfack-eleven borde klippa sig och skaffa ett jobb', *Dagens Nyheter* (29 January 2009); Kjöller, 'Att vara människa. Konst', p. 4; A. Heberlein, 'Lång över gränsen', *Expressen* (28 January 2009), p. 9; S. Johansson, 'Att vara lättkränkt eller rättrådig, det är frågan', *Läkartidningen*, 36:106 (2009), 2,180; C. Svahn, 'Konstfacks ledning JO-anmäls', *Dagens Nyheter* (31 January 2009), p. 23.

74 Stockholm district Court, Dept. 4, Unit 42, Lawsuit No. B 3870–09, 31 August 2009, Interrogations with police officers and the claimant nurses.

75 Anon., 'Aftonbladets läsare rasar mot Odells psykskandal', *Aftonbladet* (26 January 2009), p. 12.

76 Anon., *Nya Ludvika Tidning* (5 September 2009), p. 12; 'Åsa', 'Anna Odell, ingen kommer att tro dig', *Metro* (28 January 2009), p. 36; 'Mian o Emma', 'Fy på dig, Anna Odell', *Göteborgstidningen* (28 January 2009), p. 36; Arg, 'Anna Odell borde få fängelse', *Metro* (3 September 2009), p. 20.

77 For examples see J. A. Walker, *Art in the Age of Mass Media*, 3th edition (London: Pluto Press, 2001); J. Gibbons, *Art and Advertising* (London: I.B. Tauris, 2005); F. Blazwick and M. af Petersens (eds), *Adventures of the Black Square. Abstract Art and Society 1915–2015* (London: Whitechapel Art Gallery, 2015).

78 See, for example, the critique of futurist and cubist art in American newspapers in the 1910s and the critique of Vasilij Kandinsky in Swedish press between 1916 and 1935. L. Diepeveen, *Mock Modernism. An Anthology of Parodies, Travesties, Frauds, 1910–1935* (Toronto: University of Toronto Press, 2014), pp. 353–380 and A. Kollnitz, *Konstens nationella identitet. Om tysk och österrikisk modernism i svensk konstkritik 1908–1934* (Stockholm: Drau, 2008), pp. 364–369.

79 For historical examples from the Renaissance onwards, see McClean, *The Trials of Art*.

80 'Scandal night' is used in Edgar, 'Konsteleven anmäld för kuppen på psykakuten', p. 12. For examples of the recurring words see notes 36 and 72 above.

81 Anon., 'Affischer av flaggor beslagtogs' (1967), p. 16.

82 Swedish National Archives (Riksarkivet), Judgment at the Swedish Supreme Court (Högsta domstolen), Dnr B458/1968 [1631].

83 H. Foster, *Bad New Days. Art, Criticism, Emergency* (London: Verso, 2015), p. 119.

84 J. D. Bolter and R. Grusin, *Remediation.Understanding New Media* (Cambridge, Mass.: The MIT Press, 1999).

85 The project consisted of different parts in different exhibitions. At the graduation exhibition at Konstfack (12–24 May 2009) the artwork included three parts, filmed sequences from the performance at the bridge and interviews with physicians and a lawyer, copies of the written medical reports and sound recordings from the hospital. At Kalmar museum (13 June – 29 July 2009) and Konsthallen in Luleå (10–31 October 2009) a video part displaying Odell acting sane and insane in a belt bed was included. At Galleri Verkligheten in Umeå (28 January – 11 February 2010) five videos and excerpts from the medical reports and sound recordings from the trial were included. See S. Curman, 'Anna Odell spelade sig själv', *Dagens Nyheter* (9 May 2009), pp. 4–5; S. T. Björling, 'Ny del av Anna Odells verk visas i Kalmar', *Dagens Nyheter* (14 June 2009), pp. 2–3; 'Anna Odell ställer ut i Luleå', *TT News Agency* (11 June 2009).

86 The correspondence between the other participating artists and Liljevalchs confirm that the economic aspect was indeed a key question at the time. The exhibitions were preceded with much correspondence negotiating costs of materials and other productions costs. Liljevalchs archive, Exhibition documents: *Ecce Homo/Se människan*.

87 Kullenberg, 'Det här är konst', p. 15; Anon., 'Konstnär sålde museets bänkar', *Dagens Nyheter* (19 November 1992), p. 6.

88	Regular appeal to the Supreme Court from the lawyer Rolf Moberg, 4 July 1967. See Swedish National Archives (Riksarkivet), Judgment at the Swedish Supreme Court (Högsta domstolen), Dnr B458/1968 [1631]. See *Industria* (September 1967), 78 and T. Rasmusson, 'Nästan alla tycker om dem', *Konstrevy*, 3 (June 1968), 141.

89	Adverts for Pusscards, *PUSS*, 7 (August 1968), 24.

90	G. Bandolin, M. Bärtås, M. Lewandowska, O. Glemme, A. Creutz and T. Elovsson, 'Vi stöttar vår konststudent', *Dagens Nyheter* (9 February, 2009), pp. 4–5; I. Björkman, 'Debatten om Konstfack. Vår utredning visar att Konstfack gjorde fel', *Dagens Nyheter* (3 March 2009), p. 6; M. L. De Geer, 'Konstfacks rektor gjorde rätt!', *Dagens Nyheter* (7 May 2009), p. 4; Anon., 'Marschera för konsten på lördag', *Dagens Nyheter* (22 May 2009), p. 2.

91	The author has tried to get in contact with the artist on this matter without success, through email, telephone and ordinary mail. On the basis of searches in the major art museums in Sweden it appears that they have not been acquired by any of the larger public institutions (Nationalmuseum, Moderna Museet, Göteborgs konstmuseum).

92	Liljefors, 'Body and authority in contemporary art', p. 211.

93	Anon., 'Lumpen uselhet är också konst?', *Sala Allehanda* (20 November 1992), p. 14; Anon., 'Liljevalchs soffor stals a PR-sugen konstnär', *Borlänge Tidning* (20 November 1992), p. 28; O. Karlsson, 'När kultureliten driver med publiken', *Arvika Nyheter* (27 November 1992), p. 20; TT News Agency, 'Konstnären Dan Wolgers slår till igen. Liljevalchs soffor stulna och sålda', *Folkbladet* (20 November 1992), p. 36; Hammarström, 'Envar sin egen installatör', p. 5; U. Stahre, 'Psykfejande konststudent gör en Lars Vilks', *Aftonbladet* (27 January 2009), p. 4; A. Ekström, 'Notes', *Sydsvenskan* (29 January 2009), p. 5; Anon., 'Vansinnigt påhitt', *Dala-Demokraten* (29 January 2009), p. 25; S. Allgård, 'Angeläget belysa psykvård i resurskris', *Svenska Dagbladet* (3 February 2009), p. 6. There was one such comment regarding the media debate on Wolgers' work. See B. Rubin, 'Drevet mot Wolgers', *Dagens Nyheter* (24 November 1992), p. 6.

94	Liljevalchs archive, Exhibition documents: *Ecce Homo/Se människan,*; telephone interview with Philippe Legros, 23 January 2015.

95	Television programme, *Nästa Nybroplan*. Broadcast on TV1/Sweden, 19 November 1992, at 10.30 p.m.

96	A. Hepp, *Cultures of Mediatization* (Cambridge: Polity Press, 2013 [2011]), p. 21.

97	S. Britton, 'Konst och psykiatri', *Läkartidningen*, 15–16 (2009), 1,113; G. Hägglund, 'Sveriges radikala elit har blivit den nya överheten', *Dagens Nyheter* (17 September 2009), p. 5.

98	Karlsson, 'När kultureliten driver med publiken', p. 20; H. Lagher, 'Lundell gör en Wolgers', *Expressen* (11 January 1993), p. 4.

99	S. Å. Stålnacke, 'Människans ansikte', *Konsttidningen*, 1–2 (1992), 3.

100	Lagher, 'Lundell gör en Wolgers', p. 4.

101	Moderna Museet archive, Dnr 146/93, Letter from the artist Lill-Britt Rydén to Björn Springfeldt, director, Moderna Museet, 8 December 1993.

102	Moderna Museet archive, Dnr 146/93, Letter from the artist Lill-Britt Rydén to Björn Springfeldt, director, Moderna Museet, 8 December 1993.

Bibliography

A Decade of I-Deas. The Encyclopedia of the '80s, ed. John Godfrey (Harmondsworth: Penguin, 1990).

Ades, Dawn, *Photomontage* (New York: Pantheon Books, 1986 [1976]).

Ahlstrand, Jan Torsten, 'Den punkterade zeppelinaren eller "konkretistfiaskot" i Stockholm 1930', in *Otto G. Carlsund och konkretistfiaskot i Stockholm 1930* (Halmstad: Mjellby konstmuseum, 2004).

Allgård, Sophie, 'Angeläget belysa psykvård i resurskris', *Svenska Dagbladet* (3 February 2009), p. 6.

Allgård, Sophie, 'Inte längre okänd kvinna dömd – men läkaretiken undgår luppen', *Paletten*, 3 (2009), 21.

Åman, Jan, 'Wolgers öppnar museet mot gatan', *Svenska Dagbladet* (2 January 1993), p. 22.

Anders', 'Odell kan skapa en farlig skojtrend', *Metro* (3 September 2009), p. 20.

Andersen, Charlotte, *Modefotografi. En genres anatomi* (Copenhagen: Museum Tusculum Press, 2006).

Andersen, Hans Christian, *Fairy Tales* (London: Sampson Low, Marston, Low and Searle, 1872).

Anna Odell ställer ut i Luleå', *TT News Agency* (11 June 2009).

Anon., 'Affischer av flaggor beslagtogs', *Svenska Dagbladet* (2 May 1967), pp. 1 and 16.

Anon., 'Aftonbladets läsare rasar mot Odells psykskandal', *Aftonbladet* (26 January 2009), p. 12.

Anon., 'Dragkamp om De Geer. Talrik publik hos auktionsverket', *Dagens Nyheter* (17 March 1991), p. B14.

Anon., 'En konstnär om butiksskyltningen', *Butikskultur*, 1 (1936), 14.

Anon., 'Folk i farten', *Dagens Industri* (5 February 1993).

Anon., 'Fritt fram för svensk mästare i flaggskändning', *Expressen* (19 March 1969), p. 10.

Anon., 'Funkisvernissage', *Dagens Nyheter* (19 August 1930), p. 7.

Anon., '"Galen" konstelev polisanmäld', *Corren* (29 January 2009), p. A24.

Anon., 'Issey Miyake. Sewing a Second Skin', *Artforum* (February 1982), pp. 56–57.

Anon., 'Kamp mot den kapitalistiska rationaliseringen', *Ny Dag* (30 May 1930), p. 4.

Anon., 'Konstnär åtalad för flaggskändning', *Svenska Dagbladet* (21 June 1967), p. 15.

Anon., 'Konstnär bötar för uppvigling', *Expressen* (9 December 1968), p. 8.

Anon., 'Konstnär sålde museets bänkar', *Dagens Nyheter* (19 November 1992), p. 6.

Anon., 'Konstnären fick böta. Skymfande av rikssymbol', *Expressen* (7 September 1967), p. 23.

Anon., 'Liljevalchs soffor stals av PR-sugen konstnär', *Borlänge Tidning* (20 November 1992), p. 28.

Anon., 'Lördagens vernissager', *Dagens Nyheter* (29 April 1967), p. 15.

Anon., 'Lumpen uselhet är också konst?', *Sala Allehanda* (20 November 1992), p. 14.

Anon., 'Målade hakkors på USA-flaggan. Dömd för skymf', *Dagens Nyheter* (8 September 1967), p. 13.

Anon., 'Marschera för konsten på lördag', *Dagens Nyheter* (22 May 2009), p. 2.

Anon., 'Med vilka varor skola vi skylta?', *Butikskultur*, 5 (1937), 8.

Anon., 'Namnskylt säljes!', *Beckerell*, 1 (February/March 1993), 32.

Anon., '… och resterna av ett uppror', *Aftonbladet* (27 October 2000), p. 5.

Anon., 'Polis slog till mot konstexpo. Grafiska blad i beslag', *Expressen* (2 May 1967), p. 33.

Anon., 'Sjukhuset anmäler eleven för konstkuppen', *Aftonbladet* (28 January 2009), p. 24.

Anon., 'Svik fosterlandet. Var onationell!', *PUSS*, 7 (August 1968), 8–9.

Anon., 'Vansinningt påhitt', *Dala-Demokraten* (29 January 2009), p. 25.

Arbus, Diane and Thomas Southall, *Diane Arbus. Magazine Works*, ed. Doon Arbus and Marvin Israel (New York: Bloomsbury, 1984).

'Årets största egotrippare', *Aftonbladet* (25 November 1992), p. 21.

Arg', 'Anna Odell borde få fängelse', *Metro* (3 September 2009), p. 20.

Art & Advertising. Commercial Photography by Artists at ICP', International Centre for Photography, New York, *Artforum* (November 1986), p. 136.

Åsa', 'Anna Odell, ingen kommer att tro dig', *Metro* (28 January 2009), p. 36.

Ashford Down, H., 'The theory and practice of window dressing', in H. Ashford Down, (ed.), *The Art of Window Display* (London: Sir Isaac Pitman & Sons, 1931).

Ashford Down, H. (ed.), *The Art of Window Display* (London: Sir Isaac Pitman & Sons, 1931).

Asplund, Karl, '-Ismer', *Svenska Dagbladet* (20 August 1930), p. 7.

Bahr, Björn von, 'Nya straff för flaggskändning', *Expressen* (7 January 1969), p. 8.

Bal, Mieke, 'Telling objects. A narrative perspective on collecting', in John Elsner and Roger Cardinal (eds), *The Cultures of Collecting* (London: Reaktion Books, 1994).

Bal, Mieke, *Travelling Concepts in the Humanities. A Rough Guide* (Toronto: University of Toronto Press, 2002).

Ball, Hugo, 'Dadamanifest', in Gunnar Qvarnström (ed.), *Moderna manifest 1. Futurism och dadaism* (Stockholm: Almqvist & Wiksell, 1973).

Banash, David S., 'From Advertising to the Avant-garde. Rethinking the Invention of Collage', *Postmodern Culture*, 14:2 (January 2004), unpaginated.

Bandolin, Gunilla, Magnus Bärtås, Marysia Lewandowska, Olof Glemme, Andrea Creutz and Thomas Elovsson, 'Vi stöttar vår konststudent', *Dagens Nyheter* (9 February 2009), pp. 4–5.

Bann, Stephen, 'Against photographic exceptionalism', in Tanya Sheehan and Andrés Mario Zervignòn (eds), *Photography and Its Origins* (London: Routledge, 2015).

Barr, Alfred H. (ed.), *Fantastic Art Dada Surrealism* (New York: Museum of Modern Art, 1936).

Borthes, Roland, 'The rhetoric of the image', in *Image/Music/Text* (London: Fontana Press, 1977).

Barthes, Roland, *The Fashion System* (Berkeley: University of California Press, 1990).

Becker, Howard S., *Art Worlds* (Berkeley: University of California Press, 1982).

Bede, Cuthbert, *Photographic Pleasures. Popularly Portrayed with Pen and Pencil* (London: Thomas McLean, 1855).

Belting, Hans, *Art History after Modernism* (Chicago: University of Chicago Press, 2003).

Belting, Hans, 'Image, Medium, Body. A New Approach to Iconography', *Critical Inquiry*, 31 (2005), 302–319.

Belting, Hans, *An Anthropology of Images. Picture, Medium, Body* (Princeton, N.J. and Oxford: Princeton University Press, 2011).

Bengtsson, Lisbeth, '"Stölden som konstform" – en mina eller brandfackla?', *Trollhättans Tidning* (30 November 1993), p. 4.

Benjamin, Walter, 'Art in the age of mechanical reproduction', in Hannah Arendt (ed.), *Illuminations* (New York: Schocken Books, 1969).

Bergman, Bosse, *Handelsplats, shopping, stadsliv. En historik om butiksformer, säljritualer och det moderna stadslivets trivialisering* (Stockholm: Symposion, 2003).

Bergmark, Torsten, 'Konstens demonstranter', *Dagens Nyheter* (11 May 1967), p. 5.

Biel, Martin, 'Hvem skriver kunstkritik i dagspressen. En kvalitativ undersøkelse av kunstkritikeren i svenk dagpresse', in Jan-Gunnar Sjölin (ed.), *Om konstkritik. Studier av konstkritik i svensk dagspress 1990–2000* (Lund: Palmkron, 2003).

Billow, Anders, 'Fotografiens reklamvärde är dess sanningsvärde', *Svensk Reklam. Svenska Reklamförbundets årsbok*, 3 (1931), 117–148.

Birger, 'Svenska Dagbladet skriver om Tom Björklund', *Kompanirullan*, 2 (1961), 27.

Björklund, Tom, 'Reklamen tjänar samhället', *Svensk Reklam. Svenska Reklamförbundets årsbok*, 6 (1937), 7–10.

Björklund, Tom, 'Samhälle och reklam', *Futurum*, 4 (1937), 231.

Björklund, Tom, *Reklamen i svensk marknad 1920–1965*, 2 vols (Stockholm: PA Norstedt & Söners förlag, 1967).

Björkman, Ivar, 'Debatten om Konstfack. Vår utredning visar att Konstfack gjorde fel', *Dagens Nyheter* (3 March 2009), p. 6.

Björling, Sanna Tove, 'Ny del av Anna Odells verk visas i Kalmar', *Dagens Nyheter* (14 June 2009), pp. 2–3.

Blazwick, Fiona and Magnus af Petersens (eds), *Adventures of the Black Square. Abstract Art and Society 1915–2015* (London: Whitechapel Art Gallery, 2015).

Bolter, Jay David and Richard Grusin, *Remediation. Understanding New Media* (Cambridge, Mass.: The MIT Press, 1999).

Borg, Annika, 'Brist på etik gör ingen konstnär', *Kristdemokraten* (8 September 2009).

Bosson, Viveka, 'En resa genom Otto G. Carlsunds liv och konst', in *Otto G. Carlsund och konkretistfiaskot i Stockholm 1930* (Halmstad: Mjellby konstmuseum, 2004).

Bourdieu, Pierre and Yvette Delsaut, 'Le Couturier et sa griffe. Contribution à une Théorie de la Magie', *Actes de la Recherche en Sciences Sociales*, 1:1 (1975), 7–36.

Bowallius, Marie-Louise, 'Tradition och förnyelse i svensk grafisk form 1910–1950', in Cecilia Widenheim and Eva Rudberg (eds), *Utopi och verklighet. Svensk Modernism 1900–1960* (Stockholm: Norstedts, 2000).

Braive, Michel François, *L'Age de la photographie. De Niépce à nos jours* (Bruxelles: Éditions de la Connaissance, 1965) [*The Era of the Photograph. A Social History*, 1966].

Bredekamp, Horst, *Darwins Korallen. Frühe Evolutionsmodelle und die Tradition der Naturgeschichte* (Berlin: K. Wagenbach, 2005).

Britton, Sven, 'Konst och psykiatri', *Läkartidningen*, 15–16 (2009), 1,113.

Brooks, Rosetta, 'Double-Page Spread. Fashion and Advertising Photography', *Camerawork* (January/February 1980), 1–3.

Brooks, Rosetta, 'Gilbert & George Shake Hands with the Devil', *Artforum* (Summer 1984), pp. 56–60.

Buchloh, Benjamin H. D., 'From Faktura to factography', in Richard Bolton (ed.), *The Contest of Meaning. Critical Histories of Photography* (Cambridge, Mass.: The MIT Press, 1993).

Burman Baines, Barbara, Ian Jeffrey and Judith Williamson, 'Three responses to "Shots of Style" at the V&A', *Camerawork*, 252 (December 1985), 8–10.

Carroll, Lewis, *Alice's Adventures in Wonderland*. With forty-two illustrations by John Tenniel (London: Macmillan & Co., 1866 [1865]).

Carroll, Lewis, *The Hunting of the Snark* (London: Macmillan Publishers, 1876).

Caroll, Lewis, 'Photography extraordinary', in Vicki Goldberg (ed.), *Photography in Print. Writings from 1816 to the Present* (Albuquerque: University of New Mexico Press, 1981).

Casson, Herbert, *Twelve Tips on Window Display* (London: Efficiency Magazine, 1924).

Casson, Herbert N., *Reklamens konst i 294 punkter* (Stockholm: Natur och Kultur, 1930).

Casson, Herbert N., *Tolv tips för fönsterskyltning* (Stockholm: Lindqvist förlag, 1938).

Chandler, David, *Out of Fashion. Photographs by Nick Knight and Cindy Palmano*. Catalogue from The Photographers' Gallery, April to 27 May 1989.

Cornell, Peter, 'Fridlyst', *Expressen* (1 June 1999), p. 5.

Cowling, Elizabeth, *The Magic Mirror. Dada and Surrealism from a Private Collection* (Edinburgh: Scottish National Gallery of Modern Art, 1988).

Crimp, Douglas, 'Pictures', *October*, 8 (Spring 1979), 75–88.

Curman, Sofia, 'Anna Odell spelade sig själv', *Dagens Nyheter* (9 May 2009), pp. 4–5.

Dahlgren, Anna. *Fotografiska drömmar och digitala illusioner. Bruket av bearbetade fotografier i svensk dagspress, reklam, propaganda och konst under 1990-talet* (Stehag: Brutus Östlings förlag Symposion, 2005).

Dahlgren, Anna, 'Mode+fotografi=Bidrag till den svenska modefotografins tidiga historia', in Louise Wallenberg and Dirk Gindt (eds), *Mode. En introduktion* (Stockholm: Raster förlag, 2009).

Dahlqvist, Dennis, 'Soffa på rymmen', *Expressen*: Kultur (28 November 1992), p. 5.

Dahlström, Oskar, 'Den nya typografiens skapare', *Svensk Reklam: Svenska Reklam-förbundets årsbok*, 4 (1932), 77–88.

Danto, Arthur, 'The Artworld', *Journal of Philosophy*, 61:19 (1964), 571–584.

Dan Wolgers: provokatör eller konstnär?', *TT News Agency* (16 July 1994).

'Den nya sakligheten i skyltfönstret', *Handelsdekoratören. Månatlig Tidskrift för Skyltning* (June 1928), 12–13.

'Den svenska kapitalismens propagandautställning 1930 blev idag högtidligen öppnad', *Ny Dag* (16 May 1930), pp. 1 and 3.

Det elektriska ljuset på Stockholmsutställningen 1930 (Stockholm: J. Folcker & G. Nilsson, 1930).

Di Bello, Patrizia, *Women's Albums and Photography in Victorian England. Ladies, Mothers, Flirts* (Farnham: Ashgate, 2007).

Dickens, Charles, *The Life and Adventures of Martin Chuzzlewit* (London: Chapman & Hall, 1844).

Dickie, George, *Art and the Aesthetic: An Institutional Analysis* (Ithaca: Cornell University Press, 1974).

Diepeveen, Leonard, *Mock Modernism. An Anthology of Parodies, Travesties, Frauds, 1910–1935* (Toronto: University of Toronto Press, 2014).

Downing, George Henry, R.B.A., *Art Applied to Window Display* (Aylesbury: Granville Works, 1929).

Ducros, Françoise, 'The dream of beauty. Fashion and fantasy', in Michel Frizot (ed.), *A New History of Photography* (Cologne: Könemann, 1998).

Duka, John, 'Clothing as Architecture at M.I.T', *New York Times* (17 May 1982), p. 10.

Duncan, Carol, *Civilizing Rituals. Inside Public Art Museums* (London: Routledge, 1995).

Duve, Thierry de, 'Bird, fish or flying tiger. What's in a name?', in Daniel McClean (ed.) *The Trials of Art* (London: Ridinghouse, 2007).

Eberhard, David, 'Konstfackeleven borde klippa sig och skaffa ett jobb', *Dagens Nyheter* (29 January 2009).

Ecce Homo/Se människan (Stockholm: Liljevalchs konsthall, 1992).

Edgar, Johan, 'Konsteleven anmäld för kuppen på psykakuten', *Aftonbladet* (26 January 2009), p. 12.

Edwards, Elizabeth and Janice Hart (eds), *Photographs, Objects, Histories. On the Materiality of Images* (London: Routledge, 2004).

Edwards, Folke, *Från modernism till postmodernism. Svensk konst 1900–2000* (Lund: Signum, 2000).

Ekström, Anders, *Representation och materialitet. Introduktioner till kulturhistorien* (Nora: Nya Doxa, 2009).

Ekström, Anders, Solveig Jülich and Pelle Snickars (eds), *1897. Mediehistorier kring Stockholmsutställningen* (Stockholm: Mediehistoriskt arkiv, 2005).

Ekström, Andreas, 'Notes', *Sydsvenskan* (29 January 2009), p. 5.

Elkins, James, 'First introduction. Starting points', in James Elkins, Gustav Frank and Sunil Manghani (eds), *Farewell to Visual Studies* (University Park, Pa.: The Pennsylvania State University Press, 2015).

Elkins, James, Gustav Frank and Sunil Manghani (eds), *Farewell to Visual Studies* (University Park, Pa.: The Pennsylvania State University Press, 2015).

Entwistle, Joan and Agnes Rocamora, 'The Field of Fashion Realized. A Case Study of London Fashion Week', *Sociology*, 40:4 (2006), 735–751.

Ernst, Wolfgang, 'Let There Be Irony. Cultural History and Media Archeology in Parallel Lines', *Art History*, 28:5 (November 2005), 582–603.

Feery, Loughlin L. M., *Konsten att skylta* (Stockholm: Natur och Kultur, 1922) [English original *Modern Window Display* (London: Cassell's Business Handbooks, 1922)].

Flood, Richard, 'Intimate Architecture. Contemporary Clothing Design Hayden Gallery Massachusetts Institute of Technology' (review), *Artforum* (November 1982), pp. 78–79.

Folcker, Ivan, *Det elektriska ljuset på Stockholmsutställningen 1930* (Stockholm: Svenska föreningen för ljuskultur, 1930).

Forsberg, Nils, 'Leklust', *Expressen* (12 April, 2014), p. 6.

Foster, Hal, *Bad New Days. Art, Criticism, Emergency* (London: Verso, 2015).

Frank, Gustav, 'Affect, agency, and aporia. An indiscipline with endemic ambivalence and lack of pictures', in James Elkins, Gustav Frank and Sunil Manghani(eds), *Farewell to Visual Studies* (University Park, Pa.: The Pennsylvania State University Press, 2015).

Frizot, Michel (ed.), *A New History of Photography* (Cologne: Könemann, 1998).

G. T., 'Stockholmsutställningen – "en modernistisk Värnamo marknad!"', *Skånska Dagbladet* (17 May 1930), p. 4.

Gaensheimer, Susanne and Sophie von Olfers (eds), *Not in Fashion. Photography and Fashion in the 1990s* (Bielefeld, Ger.: Kerber, 2011).

Gaehtgens, Thomas W. and Louis Marchesano, *Display and Art History. The Düsseldorf Gallery and Its Catalogue* (Los Angeles: Getty Research Institute, 2011).

Garner, Philippe, 'The celebration of the fashion image. Photograph as market commodity and research tool', in Eugénie Shinkle (ed.), *Fashion as Photograph. Viewing and Reviewing Images of Fashion* (London: I.B. Tauris, 2008).

Garnert, Jan, *Anden i lampan. Etnologiska perspektiv på ljus och mörker* (Stockholm: Carlsson, 1993).

Geer, Carl Johan de, 'Visst har konsten sprängkraft!', *Aftonbladet* (22 April 2004), pp. 4–5.

Geer, Marianne Lindberg de, 'Konstfacks rektor gjorde rätt!', *Dagens Nyheter* (7 May 2009), p. 4.

Gehlin, Jan, 'Om skydd för symboler', *Dagens Nyheter* (3 May 1967), p. 4.

Gerczy, Adam and Vicki Karaminas (eds), *Fashion and Art* (London: Bloomsbury, 2012).

Gernsheim, Helmut and Alison Gernsheim, *The History of Photography. From the Earliest Use of the Camera Obscura in the Eleventh Century up to 1914* (London: Oxford University Press, 1955).

Giedion, Siegfried, *Mechanization Takes Command. A Contribution to Anonymous History* (New York: Oxford University Press, 1948).

Gitelman, Lisa, *Always Already New. Media, History and the Data of Culture* (Cambridge, Mass.: The MIT Press, 2006).

Gitelman, Lisa and Geoffrey B. Pingree (eds), *New Media 1740–1915* (Cambridge, Mass.: The MIT Press, 2003).

Gibbons, Joan, *Art and Advertising* (London: I.B.Tauris, 2005).

Green, Rachel, *Internet Art* (London: Thames & Hudson, 2004).

Green-Lewis, Jennifer, 'Playing with Pictures. The Art of Victorian Photocollage', *Victorian Studies*, 53:2 (Winter 2011), 383–385.

Habermas, Jürgen, *The Structural Transformation of the Public Sphere. An Inquiry into a Category of Bourgeois Society*; translated by Thomas Burger with the assistance of Frederick Lawrence (Cambridge: Polity Press, 1989) [*Strukturwandel der Öffentlichkeit. Untersuchungen zu einer Kategorie der bürgerlichen Gesellschaft*, Neuwied, Berlin: Luchterhand, 1962].

Hall Duncan, Nancy, *A History of Fashion Photography* (New York: Alpine Book Company, 1979).

Hammarström, Tommy, 'Envar sin egen installatör. Tommy Hammarström om ett föräldrauppror som gått i stå', *Expressen* (25 February 1994), p. 5.

Han., 'Sju – ismer framföras i frihet', *Stockholms-Tidningen* (19 August 1930), pp. 1 and 18.

Hannavy, John (ed.), *Encyclopedia of Nineteenth-Century Photography*, 2 vols (London: Routledge, 2008).

Haran, Barnaby, 'Magic windows. Frederick Kiesler's displays for Saks Fifth Avenue, New York in 1928', in John C. Welchman (ed.), *Sculpture and the Vitrine* (Farnham: Ashgate, 2013).

Harnesk, Paul, *Vem är vem? Stockholmsdelen* (Stockholm: Vem är vem bokförlag, 1945).

Harnesk, Paul, *Vem är vem? Stor-Stockholm* (Stockhom: Vem är vem bokförlag, 1962).

Hart, Janice, 'What's Wrong with Fashion Photography? (Apart From Being Sexist, Racist and Capitalist)', *Creative Camera*, 252 (December 1985), 27–29.

Harvard, Jonas and Patrik Lundell (eds), *1800-talets mediesystem* (Stockholm: Kungliga biblioteket, 2010).

Hassner, Rune, *Bilder för miljoner. Bildtryck och massframställda bilder från de första blockböckerna, oljetrycken och fotografierna till den moderna pressens nyhetsbilder och fotoreportage* (Stockholm: Sveriges radio, 1977).

Hausmann, Raoul, *Courrier Dada* (Paris: Le TerrainVague, 1958).

Hausmann, Raoul, 'Photomontage', in David Evans (ed.), *Approproriation* (Cambridge, Mass.: The MIT Press, 2009 [originally published in *a bis z*, May 1931]).

Hebdige, Dick, 'The Bottom Line on Planet Obe. Squaring Up to The Face', *Ten8*, 19(1985), 43.

Heberlein, Ann, 'Lång över gränsen', *Expressen* (28 January 2009), p. 9.

Heineman, Kajsa, 'Videoverket är moraliskt försvarbart', *Psykologtidningen*, 8 (2009), 8–9.

Hélion, Jean, 'Préface', *Internationell utställning av post-kubistisk konst 19 aug. – 30 sept., Parkrestaurangen, Stockholmsutställningen 1930* (Stockholm: Bröderna Lagerström, 1930).

Hemmet, Konstindustrien, Stockholmsutställningen 1930 (Stockholm: Nordisk Rotogravyr, 1930).

Hepp, Andreas, *Cultures of Mediatization* (Cambridge: Polity Press, 2013 [2011]).

Henisch, Heinz K. and Bridget A. Henisch, *The Photographic Experience 1839–1914: Images and Attitudes* (University Park, Pa.: The Pennsylvania State University Press, 1994).

Hennessy, Richard, 'What's All This About Photography?', *Artforum* (May 1979), pp. 20–25.

Hermansson, Kenth, *I persuadörernas verkstad. Marknadsföring i Sverige 1920–1965. En studie av ord och handling hos marknadens aktörer* (Stockholm: Acta Universitatis Stockholmiensis, Stockholm Studies in Economic History 36, 2002).

'Histories. Bildwissenschaft', in James Elkins, Gustav Frank and Sunil Manghani (eds), *Farewell to Visual Studies* (University Park, Pa.: The Pennsylvania State University Press, 2015).

Hjarvard, Stig, *The Mediatization of Culture and Society* (London: Routledge, 2013).

Hofeldt, Miranda, 'The Bouverie Album', in Elizabeth Siegel (ed.), *Playing with Pictures. The Art of Victorian Photocollage* (Chicago: The Art Institute of Chicago, 2010).

Hofeldt, Miranda, 'The Gough Album', in Elizabeth Siegel (ed.), *Playing with Pictures. The Art of Victorian Photocollage* (Chicago: The Art Institute of Chicago, 2010).

Holborn, Mark, 'Image of a Second Skin', *Artforum* (November 1988), pp. 118–121.

Hopkins, Claude C., *Mitt liv i reklamens tjänst. En vägledning i vetenskaplig reklam*, translated by T. Björklund (Stockholm: Natur och Kultur, 1928).

Hoppe, Ragnar, 'En internationell utställning av post-kubistisk konst i Stockholm', *Konstrevy*, 4 (1930), 151–155.

Hudak, Brittany M., 'Assembling identity. The photo-collage album of Kate E. Gough (1856–1948)'. Master's thesis (University of Cincinnati, 2004).

Huhtamo, Erkki and Jussi Parikka (eds), *Media Archaeology. Approaches, Applications and Implications* (Berkeley: University of California Press, 2011).

Hägglund, Göran, 'Sveriges radikala elit har blivit den nya överheten', *Dagens Nyheter* (17 September 2009), p. 5.

Internationell utställning av post-kubistisk konst 19 aug. – 30 sept., Parkrestaurangen, Stockholmsutställningen 1930 (Stockholm: Bröderna Lagerström, 1930).

Jay, Martin, 'Scopic regimes of modernity', in Hal Foster (ed.), *Vision and Visuality* (Seattle: Bay Press, 1988).

Jenkins, Henry, *Convergence Culture: Where Old and New Media Collide* (New York: New York University Press, 2006).

Jobling, Paul, *Fashion Spreads. Words and Images in Fashion Photography Since 1980* (London: Berg, 2010).

Johansson, Rune, 'Motroten', *Dagens Nyheter* (26 June 1967), p. 5.

Johansson, Stefan, 'Att vara lättkränkt eller rättrådig, det är frågan', *Läkartidningen*, 36:106 (2009), 2,180.

Jülich, Solveig, Patrik Lundell and Pelle Snickars (eds), *Mediernas kulturhistoria* (Stockholm: Mediehistoriskt arkiv, 2009).

Kadri, Sadakat, 'The license of poets and madmen. Judging art since Veronese', in Daniel McClean (ed.), *The Trials of Art* (London: Ridinghouse, 2007).

Karlholm, Dan, *Art of Illusion. The Representation of Art History in Nineteenth-century Germany and Beyond* (Bern: Peter Lang, 2004).

Karlsson, Olle, 'När kultureliten driver med publiken', *Arvika Nyheter* (27 November 1992), p. 20.

Kawamura, Yuniya, *The Japanese Revolution in Paris Fashion* (Oxford: Berg, 2004).

Kholeif, Omar, Séamus McCormack and Emily Butler (eds), *Electronic Superhighway. From Experiments in Art and Technology to Art After the Internet* (London: Whitechapel Gallery, 2016).

Kiaer, Christina, *Imagine No Possessions. The Socialist Objects of Russian Constructivism* (Cambridge, Mass.: The MIT Press, 2005).

Kiesler, Frederick, *Contemporary Art Applied to the Store and its Display* (London, Philadelphia: Sir I. Pitman & Sons, 1930).

Kismaric, Susan and Eva Respini, *Fashioning Fiction in Photography Since 1990* (New York: Museum of Modern Art, 2004).

Kismaric, Susan and Eva Respini, 'Fashioning fiction in photography since 1990', in Eugénie Shinkle (ed.), *Fashion as Photograph. Viewing and Reviewing Images of Fashion* (London: I.B. Tauris, 2008).

Kjöller, Hanne, 'Att vara människa. Konst. Poänglös utmaning där mycket står på spel', *Dagens Nyheter* (28 January 2009), p. 4.

Klonk, Charlotte, 'Patterns of Attention: From Shop Windows to Gallery Rooms in Early Twentieth-Century Berlin', *Art History*, 28:4 (September 2005), 468–496.

Kollnitz, Andrea, *Konstens nationella identitet. Om tysk och österrikisk modernism i svensk konstkritik 1908–1934* (Stockholm: Drau, 2008).

'Konsthallen Liljevalchs soffor stulna och sålda', *TT News Agency* (19 November 1992).

Kopytoff, Igor, 'The cultural biography of things. Commodification as process', in Arjun Appadurai (ed.), *The Social Life of Things. Commodities in Cultural Perspective* (Cambridge: Cambridge University Press, 1986).

Kozloff, Max, 'The Extravagant Depression. John Gutmann's Photographs of the Thirties', *Artforum* (November 1982), pp. 34–41.

Kozloff, Max, 'A Double Portrait of Cecil Beaton', *Artforum* (October 1986), pp. 118–124.

Kracauer, Siegfried, 'The mass ornament', in Thomas Y. Levin (ed.), *The Mass Ornament. Weimar Essays* (Cambridge, Mass.: Harvard University Press, 1995 ['Das Ornament der Masse', *Frankfurter Zeitung*, 71:420 (9 June 1927 and 71:423 (10 June 1927)].

Kramer, Hilton, 'The Dubious Art of Fashion Photography', *New York Times* (28 December 1975), p. 100.

Krause Wahl, Antje, 'Page by page. Fashion and photography in the magazine', in Susanne Gaensheimer and Sophie von Olfers (eds), *Not in Fashion. Photography and Fashion in the 90s* (Bielefeld, Ger.: Kerber, 2011).

Kuc, Kamila and Joanna Zylinska (eds), *Photomediations. A Reader* (London: Open Humanities Press, 2016).

Kullenberg, Annette, 'Det här är konst', *Aftonbladet* (21 November 1992), p. 15.

Kultur i korthet', *TT News Agency* (22 July 1993).

Lagher, Håkan, 'Lundell gör en Wolgers', *Expressen* (11 January 1993), p. 4.

Lamoree, Jhim, José Teunissen and Hanka van der Voet (eds), *Everything but Clothes. Fashion, Photography, Magazines* (Arnhem: ArtEZ Press, 2015).

Langford, Martha, *Suspended Conversations. The Afterlife of Memory in Photographic Albums* (Montreal & Kingston: McGill-Queen's University Press, 2001).

Lärkner, Bengt, '1900–1950', in Lena Johannesson (ed.), *Konst och visuell kultur i Sverige 1810–2000* (Stockholm: Signum, 2007).

Laver, James, *Manners and Morals in the Age of Optimism* (New York: Harper & Row, 1966).

Lavin, Maud, *Clean New World. Culture, Politics, and Graphic Design* (Cambridge, Mass.: The MIT Press, 2001).

Larsson, Ivan, *Kortfattad handledning i skyltning* (Kristinehamn: Kristinehamns praktiska skola, 1930).

Laurin, Carl G., 'Postfunkis. Carl Laurin risar 1930 års utställning', *Svenska Dagbladet* (25 September 1930), pp. 3 and 24.

Lears, Jackson, 'Uneasy Courtship. Modern Art and Modern Advertising', *American Quarterly*, 39:1 (1987), 133–154.

Lenning, Einar, 'Reklamen och tidsandan', *Svensk Reklam. Svenska Reklamförbundets årsbok*, 3 (1931), 81–88.

Liebmann, Lisa, 'Yves Saint Laurent', Metropolitan Museum of Art (review), *Artforum* (May 1984), pp. 81–82.

Liljedahl, Ulf, *Vad kampen gällde. Norrköpings museum 14.11 1976 – 9.1 1977* (Norrköping: Norrköpings museum, 1976).

Liljefors, Max, 'Body and authority in contemporary Art: Tehching Hsieh's one-year performances', in Leif Dahlberg (ed.), *Visualizing Law and Authority. Essays on Legal Aesthetics* (Berlin: De Gruyter Mouton, 2012).

Linder, Mark, 'Wild Kingdom', in R. E. Somol (ed.), *Autonomy and Ideology. Positioning an Avant-Garde in America* (New York: The Monacelli Press, 1997).

Lindgren, Ann, 'Konstnären som skymfade USA:s flagga bötar 1125', *Aftonbladet* (9 December 1968), p. 12.

Lodder, Christina, *Russian Constructivism* (New Haven: Yale University Press, 1983).

Lomax, Susan, 'The view from the shop. Window display, the shopper and the formulation of theory', in John Benson and Laura Ugolini (eds), *Cultures of Selling. Perspectives on Consumption and Society since 1700* (Burlington: Ashgate, 2006).

Lundby, Knut, 'Introduction', in Knut Lundby (ed.), *Mediatization of Communication* (Berlin: De Gruyter Mouton, 2014).

Lundby, Knut (ed.), *Mediatization of Communication* (Berlin: De Gruyter Mouton, 2014).

Lundkvist, Oscar, 'Skyltfönsterteknikens principer', *Butikskultur*, 1 (1932), 10.

Lydiate, Henry, 'What is Art? A Brief Review of International Juridical Interpretations of Art in the Light of the UK Supreme Court's 2011 Judgement in the Star Wars Case: Lucas Film Limited v. Ainsworth', *Journal of International Media and Entertainment Law*, 4:2 (2012–13), 111–147.

Lynge-Jorlén, Ane, 'Between Frivolity and Art: Contemporary Fashion Magazines', *Fashion Theory. The Journal of Dress, Body & Culture*, 16 (2012), 7–28.

Maas, Jeremy, *The Victorian Art World in Photographs* (London: Barrie & Jenkins, 1984).

Mammi, Allesanda, 'Ida Panicelli. Interviewed by Allesandra Mammi', *Artforum* (September 1993), pp. 180–181.

Manghani, Sunil, *Image Studies* (London: Routledge, 2013).

Manghani, Sunil, Arthur Piper and Jon Simons, *Images. A Reader* (London: Sage, 2006).

Manghani, Sunil, 'Visual studies, or This is not a diagram', in James Elkins, Gustav Frank and Sunil Manghani (eds), *Farewell to Visual Studies* (University Park, Pa.: The Pennsylvania State University Press, 2015).

Marinetti, F.-T., 'Le Futurisme', *Le Figaro* (20 February 1909), p. 1.

Mascoll, Gunnar, 'Konkreta konstens sju skolor', *Stockholms-Tidningen* (25 August 1930), p. 6.

McCauley, Elisabeth Anne, *A. A. E. Disdéri and the Carte-de-visite Portrait Photograph* (New Haven and London: Yale University Press, 1985).

McCauley, Elisabeth Anne, *Industrial Madness. Commercial Photography in Paris 1848–1871* (New Haven and London: Yale University Press, 1994).

McClean, Daniel (ed.), *The Trials of Art* (London: Ridinghouse, 2007).

McClean, Daniel and Armen Avanessian, 'Trials of the title. The trials of Brancusi and Veronese', in Daniel McClean (ed.), *The Trials of Art* (London: Ridinghouse, 2007).

McMaster, Juliet, '"That Mighty Art of Black-and-White". Linley Sambourne, *Punch* and the Royal Academy', *British Art Journal*, 9:2 (2008), 62–76.

McPhee, Constance C. and Nadine M. Orenstein, *Infinite Jest. Caricature and Satire from Leonardo to Levine* (New Haven: Yale University Press/Metropolitan Museum of Art, 2011).

McQueen, Alison, *Empress Eugénie and the Arts. Politics and Visual Culture in the Nineteenth Century* (Farnham: Ashgate, 2011).

Mian o Emma', 'Fy på dig, Anna Odell', *Göteborgstidningen* (28 January 2009), p. 36.

Mitchell, W. J. T., 'What is an Image?', *New Literary History*, 15:3 (1984), 503–537.

Mitchell, W. J. T., *Picture Theory. Essays on Verbal and Visual Representation* (Chicago: University of Chicago Press, 1994).

Mitchell, W. J. T., 'Showing Seeing. A Critique of Visual Culture', *Journal of Visual Culture*, 1:2 (2002), 165–181.

Mitchell, W. J. T., 'There are no Visual Media', *Journal of Visual Culture*, 4:2 (2005), 257–266.

Morris, Bernadine, '2 Centuries of Fashion as an Art Form', *New York Times* (20 October 1971), p. 42.

Moxey, Keith, 'Visual Studies and the Iconic Turn', *Journal of Visual Culture*, 7:2 (2008), 131–146.

Moxey, Keith, *Visual Time. The Image in History* (Durham, N.C.: Duke University Press, 2013).

Muir, Robin, 'A subversion genre', *Addressing the Century. 100 years of Art and Fashion* (London: Hayward Gallery, 1999).

Newhall, Beaumont, *The History of Photography* (New York: Museum of Modern Art, 2006 [1937/1982]).

Nickerson, Camilla and Neville Wakefield, *Fashion. Photography of the Nineties* (Zürich: Scalo, 1998).

Nilsson, John Peter, 'Rapport från världen. Stockholm', *Beckerell*, 1 (February/March 1993), 25.

Nilsson, Kerstin, 'Konst eller stöld? Dan Wolgers konstverk. Att sälja museets bänkar', *Aftonbladet* (20 November 1992), p. 14.

Nilsson, Louise, *Färger, former, ljus. Svensk reklam och reklampsykologi, 1900–1930* (Uppsala: Acta Universitatis Upsaliensis, 2010).

Nordenankar, Agneta, '"Stulna" bänkar upphittade. Dan Wolgers får behålla betalningen från Auktionsverket', *Dagens Nyheter* (19 December 1992), p. 30.

Nuto, 'Från utställningsmasten. Ny frälsning', *Dagens Nyheter* (20 August 1930), p. 9.

Nylén, Leif, 'Den "olagliga" konsten', *Dagens Nyheter* (21 July 1989), p. 4.

Nyaste konsten', *Svenska Dagbladet* (22 August 1930), p. 8.

Några sammanförande synpunkter på modern skyltning', *Butikskultur*, 2 (1932), 16.

Näsström, Gustaf, 'Plejaden i Parkrestaurangen', *Stockholms Dagblad* (2 September 1930), p. 11.

O'Brian, Glenn, 'Like Art', *Artforum* (March 1986), p. 9.

Odell, Anna, 'Jag ville undersöka offerrollen', *Revansch!*, 3 (2009), 4–5.

Olvång, Bengt, 'Censur', *Aftonbladet* (18 November 1976), p. 4.

Papageorge, Tod, 'From Walker Evans to Robert Frank. A Legacy Recieved, Embraced and Transformed', *Artforum* (April 1981), pp. 33–37.

Paul, Christiane, *Digital Art* (London: Thames & Hudson, 2008).

Paulsson, Gregor, *Vackrare Vardagsvara* (Stockholm: Svenska slöjdföreningen, 1919).

Paulsson, Gregor, *Stockholmsutställningens program. Föredrag i Svenska slöjdföreningen 25 oktober* 1928.

Paulsson, Gregor, *Redogörelse för Stockholmsutställningen 1930*, till verkställande utskottet för Stockholmsutställningen, 1937.

Pellerin, Denis and Brian May. *The Poor Man's Picture Gallery. Stereoscopy versus Paintings in the Victorian Era* (London: London Stereoscopic Company, 2014).

Pepper, Terence, 'Reviewing the Reviews of "Cecil Beaton – The authorized biography" by Hugo Vickers', *Creative Camera*, 252 (December 1985), 11–12.

Pettersson, Elis, 'Ett par arrangemang för skyltfönster utan bakgrund', *Butikskultur*, 5 (1934), 6.

Pettersson, Elis, *Hur ska jag skylta i mitt fönster. Råd och anvisningar utarbetade för svensk specerihandels tidning* (Stockholm: Hebos förlag, 1934).

Phillpot, Clive, 'Art Magazines and Magazine Art', *Artforum* (February 1980), pp. 52–54.

Plagens, Peter, 'Cut Me Up, Paste Me Down', *Art in America*, 98:4 (April 2010), 41–42.

Point', '"Ismernas" mångfald på Funkis', *Aftonbladet* (19 August 1930), p. 5.

Pollock, Griselda, *Vision and Difference. Femininity, Feminism, and the Histories of Art* (London: Routledge, 1988).

Poschardt, Ulf, Marion de Beaupré and Stéphane Baumet, *Archeology of Elegance, 1980–2000. 20 ans de photographie de mode* (Paris: Flammarion, 2002).

Prager, Arthur, 'The Artists Amuse Themselves. Victorian Painters and *Punch*', *Notes in the History of Art*, 1:3 (1982), 24–28.

Pusch, Gerhard, 'Några reflektioner angående skyltfönstrens utformning', *Butikskultur*, 3 (1932), 2.

På vandringsutställning. Svenskt måleri från tjugo år', *Svenska Dagbladet* (22 September 1930), p. 6

Rancière, Jaques, *The Politics of Aesthetics* (London: Continuum, 2006).

Rasmusson, Torkel, 'Nästan alla tycker om dem', *Konstrevy*, 3 (June 1968), 141.

Ratcliff, Carter, 'Fashion, Style and Art', *Art in America* (July/August 1979), 91–97

Riegels Melchior, Marie, 'Introduction. Understanding fashion and dress museology', in Marie Riegels Melchior and Birgitta Svensson (eds), *Fashion and Museums* (London: Bloomsbury Academic, 2014).

Rosenberg, Einar, 'Geometrisk tavelkonst på Funkis', *Social-Demokraten* (20 August 1930), unpaginated.

Rosenberg, Harald, 'Våra skyltfönster av idag', *Svensk Reklam. Svenska Reklamförbundets årsbok*, 2 (1930), 103–120.

Rosenberg, Harald, 'Butiken och varan', *Form. Svenska Slöjdföreningens Tidskrift*, 28:2 (1932), 42–53.

Roscoe Hartigan, Lynda, 'The House That Collage Built', *American Art*, 7:3 (Summer 1993), 88–91.

Rosler, Martha, 'In, around, and afterthoughts (on documentary photography)', in Richard Bolton (ed.), *Contest of Meaning. Critical Histories of Photography* (Cambridge, Mass.: The MIT Press, 1992).

Rubin, Birgitta, 'Drevet mot Wolgers', *Dagens Nyheter* (24 November 1992), p. 6.

Rudberg, Eva, *The Stockholm Exhibition 1930. Modernism's Breakthrough in Swedish Architecture* (Stockholm: Stockholmia, 1999).

Ruch, Michael, *New Media in Late Twentieth-century Art* (London: Thames & Hudson, 2005).

Ruskin, John, *Lectures on Architecture and Painting* (London: Routledge, 1854).

Rynell Åhlén, David. *Samtida konst på bästa sändningstid. Konst i svensk television 1956–1969* (Lund: Mediehistoriskt Arkiv, 2016).

Sagne, Jean, 'Composite cartes', in Michel Frizot (ed.), *A New History of Photography* (Cologne: Könemann, 1998).

Sandberg, Mark B., *Living Pictures, Missing Persons. Mannequins, Museums and Modernity* (Princeton: Princeton University Press, 2003).

Särnstedt, Bo, 'Verkligheten och öververkligheten', *Svenska Dagbladet* (10 May 1967), p. 4.

Schaffer, Barbro, *Analys och värdering. En studie i svensk konstkritik 1930–1935* (Stockholm: Akademilitteratur, 1982).

Scharf, Aaron, *Art and Photography* (Harmondsworth: Penguin, 1975 [1968]).

Shefer, Elaine, *Birds, Cages and Women in Victorian and Pre-Raphaelite Art* (New York: Peter Lang, 1990).

Shinkle, Eugénie, 'Introduction', in Eugénie Shinkle (ed.), *Fashion as Photograph. Viewing and Reviewing Images of Fashion* (London: I.B. Tauris, 2008).

Sidlauskas, Susan, *Intimate Architecture. Contemporary Clothing Design*, 15 May – 27 June 1982, Hayden Gallery (Cambridge, Mass.: Massachusetts Institute of Technology, 1982).

Siegel, Elizabeth, 'Society cutups', in Elizabeth Siegel (ed.), *Playing with Pictures. The Art of Victorian Photocollage* (Chicago: The Art Institute of Chicago, 2010).

Siegel, Elizabeth (ed.), *Playing with Pictures. The Art of Victorian Photocollage* (Chicago: The Art Institute of Chicago, 2010).

Sischy, Ingrid and Germano Celant, 'Editors' letter', *Artforum* (February 1982), pp. 34–35.

Sjölin, Jan Gunnar (ed.), *Om konstkritik. Studier av konstkritik i svensk dagspress 1990–2000* (Lund: Palmkron, 2003).

Sjölin, Jan-Gunnar, 'Inledning', in Jan-Gunnar Sjölin (ed.), *Om konstkritik. Studier av konstkritik i svensk dagspress 1990–2000* (Lund: Palmkron, 2003).

Skyltning, första brevet, brevkurs i Sveriges Köpmannaförbunds regi (Stockholm: 1934).

'Skyltningens psykologi' (ur Merch. Rec.), *Reklamen. Skandinavisk tidskrift för reklam och fönsterdekoration*, 1 (1923), 4.

Sobieszek, Robert A., 'Composite Imagery and the Origins of Photomontage. Part I. The Naturalistic Strain', *Artforum* (September 1978), pp. 58–65.

Sobieszek, Robert A., 'Composite Imagery and the Origins of Photomontage. Part II. The Formalist Strain', *Artforum* (October 1978), pp. 40–45.

Söderhjelm, Simone, 'Han är konstens värsting', *Aftonbladet*: Söndagstidningen (6 December 1992), pp. 14–16.

Solomon Godeau, Abigail, *Photography at the Dock. Essays on Photographic History, Institutions, and Practices* (Minneapolis: University of Minnesota Press, 1991).

Sontag, Susan, 'The Avedon Eye. Looking with Avedon', *Vogue* (April 1979), pp. 507–508.

Sontag, Susan, *On Photography* (London: Penguin Books, 1979).

Spiekerman, Uwe, 'Display windows and window displays in German cities of the nineteenth century. Towards a history of a commercial breakthrough', in Clemens Wischermann and Elliot Shore (eds), *Advertising and the European City. Historical Perspectives* (Aldershot: Ashgate, 2000).

Spielmann, Marion Harry, *The History of Punch* (London: Cassel and Company, 1895).

Squiers, Carol, 'Slouch Stretch Smile Leap', *Artforum* (November 1980), pp. 46–54.

Stahre, Ulrika, 'Psykfejande konststudent gör en Lars Vilks', *Aftonbladet* (27 January 2009), p. 4.

Stålnacke, Stig Å., 'Människans ansikte', *Konsttidningen*, 1–2 (1992), 3.

Staniszewski, Anne, *The Power of Display. A History of Exhibition Installations at the Museum of Modern Art* (Cambridge, Mass.: The MIT Press, 1998).

Steele, Valerie, *Japan Fashion Now* (New Haven: Yale University Press, 2010).

Steinworth, Karl, 'The Arrested Glance', *Photographis*, 15 (1980), 8–9.

Stockholmsutställningen 1930. Huvudkatalog (Uppsala: Almqvist & Wiksell, 1930).

Strengell, Gustaf, *Den nya annonsen. En studie av den moderna reklamens väsen* (Stockholm: Bonnier, 1924).

Ström, Sofia, 'Specialarbete. Spela psyksjuk. Överläkaren rasande efter konstelevens kupp', *Aftonbladet* (25 January 2009), p. 10.

Suga, Yasuko, 'Modernism, Commercialism and Display Design in Britain. The Reinmann School and Studios of Industrial and Commercial Art', *Journal of Design History*, 2:19 (2006), 137–154.

Sundsten, Petter, 'Konstelev spelade psyksjuk – lades in', *Metro* (30 January 2009), p. 4.

Svahn, Clas, 'Konstfacks ledning JO-anmäls', *Dagens Nyheter* (31 January 2009), p. 23.

Szarkowski, John, *The Photographer's Eye* (New York: Museum of Modern Art, 1966).

Te Heesen, Anke, *The Newspaper Clipping. A Modern Paper Object* (Manchester: Manchester University Press, 2014).

Thomas, Abraham, 'Irony and mythology. The fashion magazine reconsidered', in Sonnet Stanfill (ed.), *80s Fashion. Club to Catwalk* (London: Victoria and Albert Museum, 2013).

Thornton, Gene, 'Fashion photography. An art of democracy', in *Fashion Photography. Six Decades* (New York: Emily Lowe Gallery, Hofstra University, Hempstead, 1976).

Thornton, Sarah, *Seven Days in the Art World* (New York: W.W. Norton, 2008).

Thuland, Ulf, '1970-talets uppror har blivit museifäigt', *Dagens Industri* (28 May 1999), p. 58.

Trott, F. S. 'The display man as artist', in H. Ashford Down (ed.), *The Art of Window Display* (London: Sir Isaac Pitman and Sons, 1931).

TT News Agency, 'Konstnären Dan Wolgers slår till igen. Liljevalchs soffor stulna och sålda', *Folkbladet* (20 November 1992), p. 36.

Turbeville, Deborah, *Wallflower* (London: Quartet Books, 1978).

Turner, Jane (ed.), *The Dictionary of Art*, 34 vols (London: Macmillan Publishers, 1996).

Ungewitter, Harry, 'Fotografiet i reklamens tjänst', in *Svensk Reklam: Svenska Reklamförbundets årsbok*, 2 (1930), 75–86.

Vermorel, Fred, 'Review of *The Face* exhibition', *Creative Camera*, 247/248 (July/August 1985), 66–68.

Verwoert, Jan, *Wolfgang Tillmans* (Phaidon: London, 2002).

Wåhlin, Hans, 'Stockholmsutställningens principer', *Sydsvenska Dagbladet* (11 September 1929), p. 7.

Wåhlin, Hans, 'Konst vid sidan av konsten', *Aftonbladet* (29 August 1930), p. 3.

Walden, Keith, 'Speaking Modern. Language, Culture, and Hegemony in Grocery Window Displays 1887–1920', *Canadian Historical Review*, 70:3 (1989), 285–310.

Walker, John A., *Art in the Age of Mass Media*, 3rd edition (London: Pluto Press, 2001).

Ward, Gerald W. R., *The Grove Encyclopedia of Materials and Techniques in Art* (Oxford: Oxford University Press, 2008).

Ward, Janet, *Weimar Surfaces* (Berkeley: University of California Press, 2001).

Warner, Marina, 'Parlour Made', *Creative Camera*, 315 (April/May 1992), 29–32.

Warner Marian, Mary, *Photography. A Cultural History* (London: Laurence King, 2002).

Wawrzyniak, Martynka (ed.), *Purple Anthology. 1992–2006* (New York: Rizzoli, 2008).

Wells, Liz (ed.), *Photography. A Critical Introduction*, 5th edition (London: Routledge, 2015 [1996]).

Westerbeck Jr., Colin L., 'Photography Now', *Artforum* (January 1979), pp. 20–23.

Wilke, Jürgen, 'Art. Multiplied mediatization', in Knut Lundby (ed.), *Mediatization of Communication* (Berlin: De Gruyter Mouton, 2014).

Williams, Val, 'A Heady Relationship. Fashion Photography and the Museum 1979 to the Present', *Fashion Theory. The Journal of Dress, Body & Culture*, 12 (2008), 197–218.

Wilson, William, 'Turned Out' [Richard Avedon], *Artforum* (September 1985), p. 7.

Wilson, William, 'Turned Out', *Artforum* (October 1985), p. 8

Zacharopoulos, Denys, 'Times, Fashion, Morals, Passion', *Artforum* (October 1987), p. 148.

Interviews

Bergman, Gösta, lawyer of Dan Wolgers, telephone interview 20 January 2015.

Carnemalm, Björn, artist, email interview 19 January 2015.

Geer, Carl Johan De, artist, personal interview, Stockholm 28 September 2016.

Gunnarsson, Annika, curator Moderna Museet, email interview 12 February 2016.

Legros, Philippe, former curator at Liljevalchs, telephone interview 23 January 2015.

Nilsson, John Peter, curator Moderna Museet, email interview 16 January 2015.

Rydén, Lena, Bukowskis auction house, email interview 22 December 2016.

Sundberg, Martin, curator at Norrköpings konstmuseum, email interview 29 September 2016.

Wolgers, Dan, artist, personal interview, Stockholm 5 February 2015.

Archives

Dan Wolgers

Official register no. 0103-K259 541 – 92, Stockholm Police archive.

Verdict DB 1372 Stockholms tingsrätt, 17 September 1993.

Press clippings.

Liljevalchs

Exhibition documents: *Ecce Homo/Se människan.*

Moderna Museet

Dnr 146/93, Letter from Björn Springfeldt, director, Moderna Museet to Göran Vogel-Rödin, Trollhättan Art Gallery and Christer Olsson at the municipality of Trollhättan, 23 November 1993.

Dnr 146/93, Letter from the artist Lill-Britt Rydén to Björn Springfeldt, director, Moderna Museet, 8 December 1993.

National museum

Accessionsliggare Carl Johan De Geer.

Stockholm district Court (Stockholms tingsrätt)

DB 1372, Verdict, 17 September 1993.
Dept. 4, Unit 42, Lawsuit No., B 3870–09, 31 August 2009.

Stockholm Police

Diarieblankett/official register no. 0103-K259 541–92.

Swedish National Archives (Riksarkivet)

Stockholm Court (Stockholms rådhusrätt), 6 September 1967.
Svea Court of Appeal (Svea hovrätt), Verdict 7 June 1968.
Swedish Supreme Court (Högsta domstolen), Dnr B458/1968 [1631]: Memorandum; Judgment.

Television and radio

Radio Sweden, Anna Odell's trial. http://sverigesradio.se/sida/artikel.aspx?programi d=83&artikel=3051051
Television programme *Nästa Nybroplan*. Broadcast on TV1/Sweden, 19 November 1992, at 10.30 p.m.
Television programme *Ikväll Robert Ashberg*. Broadcast on TV3/Sweden, 27 November 1992, at 9.00 p.m.

Websites

Blanchard, Tamsin, 'A wink and a smile', *Guardian* (25 March 2001) [www.theguardian.com/theobserver/2001/mar/25/features.magazine37]
Fraenkel Gallery [https://fraenkelgallery.com/gallery]
International Centre for Photography [www.icp.org/about]
Konstfack, Anna Odell [http://www.konstfack2009.se/bachelor/bafa/anna-odell/]
Liveauctioners, Robert Mapplethorpe [www.liveauctioneers.com/item/8063590_robert-mapplethorpe-lisa-lyon-1982]
Metro Pictures [www.metropictures.com/info/]
Photographers Gallery [http://thephotographersgallery.org.uk/history]
Robert Miller Gallery [www.robertmillergallery.com/#!about/c1b1x]
Ronald Feldman Fine Arts [www.feldmangallery.com/pages/home_frame.html]
Roversi, Paolo [www.paoloroversi.com/images/pdf/biography.pdf]
Show Studio [http://showstudio.com/contributor/mark_lebon]
Vogue [www.vogue.co.uk/spy/biographies/nick-knight-biography]
Zabriskie Gallery [www.zabriskiegallery.com/about]

Index

Page numbers in *italic* indicate illustrations.
Artworks and books can be found under the author or producer's name.
Exhibitions are listed under their title.
'n.' after a page reference indicates the number of a note at that page.